# Watercolor–
## The Spirit
## Of Spontaneity

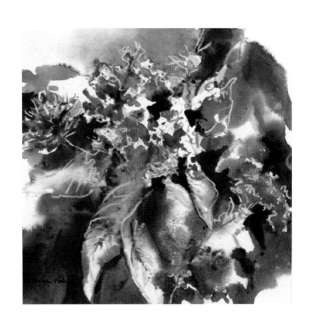

# Watercolor-
# The Spirit Of Spontaneity

## Thirty-four demonstrations designed to inspire the adventurous artist

### By Karlyn Holman

Karlyn's Gallery Publishing
Washburn, Wisconsin
www.karlynsgallerypublishing.com

# About the Author

Barbara Houser

**K**arlyn has had a studio-gallery since 1968 and enjoys a full schedule of teaching workshops and painting in her studio. Karlyn has always lived on the shores of Lake Superior and has derived inspiration for her watercolor paintings from the beauty of that area, as well as from her travels around the world. Her paintings have been described as realism based on abstract structure, yet they remain experimental in nature. She has illustrated four children's picture books, one illustrated book, a 160-page book titled *Watercolor Fun and Free* and a 184-page book titled *Searching for the Artist within*. Karlyn has taught on location all over Europe, Central America, Asia, New Zealand and on three cruises in the Caribbean. She has an MA in Art from the University of Wisconsin. She taught art at the college level for ten years and currently teaches high-energy watercolor workshops around the world. Karlyn's enthusiastic and humorous teaching style makes beginners feel comfortable yet challenges advanced students.

Karlyn and her husband, Gary, have three adult children, and seven grandchildren, and are both natives of Washburn, Wisconsin, a small village on the south shore of Lake Superior. Visit her on the web at www.karlynholman.com.

Karlyn's Gallery Publishing
318 West Bayfield Street
Washburn, WI 54891
715-373-2922
www.karlynsgallerypublishing.com

10 9 8 7 6 5 4 3 2
Edited by Teresa Wagner
Cover design, interior design and page layout by Rebecca Wygonik
Photography by Karlyn Holman and Rebecca Wygonik

Printed in the United States of America by
Service Printers of Duluth, Minnesota

Library of Congress Control Number: 2007920144

ISBN 978-0-9792218-0-4 (hardcover with wire-o, alk. paper)
ISBN 978-0-9792218-1-1 (perfect bound paperback, alk. paper)
ISBN 978-0-9792218-2-8 (DVD companion)

# Acknowledgments

**I** Dedicate this book to the memory of my mother and father who encouraged me to be an artist.

I would like to thank the following people:

First of all, I would like to acknowledge the tremendous help from my graphic designer Becky Wygonik. She has worked magic with her technical knowledge and photographic skills. Her comprehensive research and innovative ideas have truly brought this book to completion.

Terri Wagner for her friendship and her thoughtful and capable editorial advice.

Bonnie Broitzman, Pauline Hailwood, Karen Knutson, Susan Luzier, Barbara McFarland and Douglass Thomas, who generously shared their art and knowledge in their demonstrations.

Beverly Dehn, Sara Muender, Joyce Gow, Paul Dermanis, Stella Canfield, Carol Carryer and Bridget Austin for sharing their inspiring artwork.

Belynda Bilbough, Peggy Dollinger, Barbara Hauser, Sharon St. Germain and all my students for their encouragement, enthusiasm, and helpful ideas.

Sandy Isely for her great organizational skills and tremendous patience. She keeps the gallery running smoothly and makes it possible for me to devote time to writing.

## Metric Conversion Chart

| To convert | to | multiply by |
|---|---|---|
| Inches | Centimeters | 2.54 |
| Centimeters | Inches | 0.4 |
| Feet | Centimeters | 30.5 |
| Centimeters | Feet | 0.03 |
| Yards | Meters | 0.9 |
| Meters | Yards | 1.1 |
| Sq. Inches | Sq. Centimeters | 6.45 |
| Sq. Centimeters | Sq. Inches | 0.16 |

# The Spirit of Spontaneity

This book is about achieving greater freedom of expression and letting your intuition play a large role in your paintings. To accomplish this, you need guidance, encouragement and inspiration. This book presents thirty-four demonstrations and ideas by guest artists to help you in this quest.

I cannot emphasize enough the importance of letting water be your friend. The ability to move color on a wet surface is a key ingredient in creating a spontaneous spirit in your artwork. Wetting your paper for a first wash of color takes away the intimidation you may feel when facing a white sheet of paper. Whether you are working on a wet into wet underpainting or simply wetting selected areas, the flowing, moving energy of paint in water allows you to make your painting glow with vibrancy and inner radiance. The fluidity of paint in water can create atmospheric effects that would be impossible to achieve in any other way.

A wet into wet underpainting is the best way to achieve a loose, free look. Wetting the paper and applying the transparent color onto the glistening surface is addicting. The wet into wet patterns of color produce a unity and an excitement that will lead you in new directions. Pretty soon, you will be lifting the color, adding more color, adding textural devices, scratching the surface, throwing in salt, or washing away the color with a sprayer. As you continue to experiment, you will discover new ways to enhance the surface. Eventually, you may experience "intuitive accidents," unconscious inspirations that could lead you to new creative paths.

Spontaneous, more intuitive paintings, by their very nature, usually have a little mystery to them—a little left unsaid. This sense of mystery actually invites the viewer to become emotionally involved in interpreting your painting.

# 1. Seeking Inspiration 14

22" x 30" Karlyn Holman

# 2. Understanding Compositional Elements of Design 54

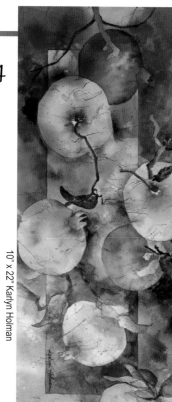

10" x 22" Karlyn Holman

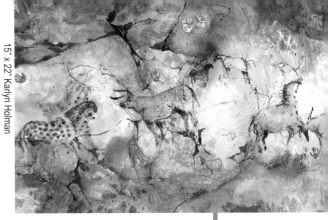

15" x 22" Karlyn Holman

# 3. Pushing the Boundaries of Traditional Watercolor 136

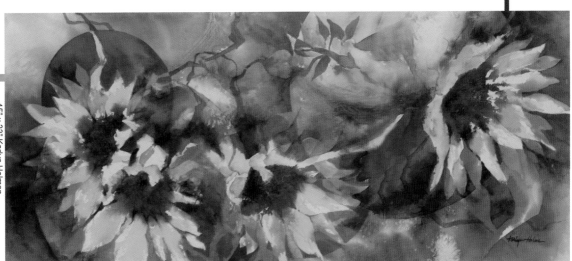

15" x 33" Karlyn Holman

# Directory of Demonstrations

This directory is designed to be "user friendly" so you can easily access the ideas that interest you. Although the book is organized in a linear fashion, you always have the option of skipping around because all the demonstrations are cross-referenced. Similar to using a cookbook, you can follow the basic recipe, but add or substitute different ingredients to come up with a new creation. While these demonstrations are quite formalized, I really urge you to use them as a springboard to discover your own expression. Challenge yourself to move beyond these suggestions and find your own interpretation. Achieving spontaneity is a lot like making up a recipe; instead of adding the same old ingredients, throw in something different and maybe instead of the usual, you will come up with the extraordinary. Bon Appetit.

Demo 1
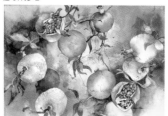
Finding an Intriguing Subject
P. 18-19

Demo 2

Layered Approach
P. 22

Demo 3
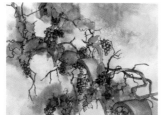
Starting with Warm Colors
P. 24-25

Demo 4

Going Beyond the Boundaries of Realism
P. 28-31

Demo 5

Moving in Close and Personal
P. 34-35

Demo 6
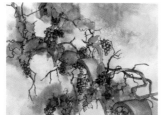
Transferring an Ink Jet Image
P. 37

Demo 7
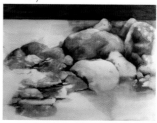
Transferring an Ink Jet Image
P. 38

Demo 8
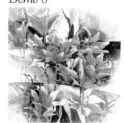
Transferring an Ink Jet Image
P. 40

Demo 9
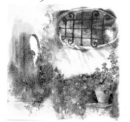
Transferring an Ink Jet Image
P. 41

Demo 10
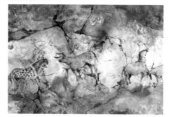
Celebrating Prehistoric Art
P. 51-53

Demo 11
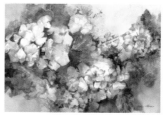
Finding the Path of Light-Planned Approach
P. 61-63

Demo 12
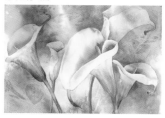
Finding the Path of Light-Random Approach
P. 66-67

Demo 13
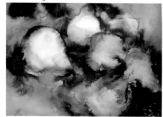
Using Gum Arabic for a Resist
P. 69

Demo 14

The Meditative-Intuitive Approach
P. 70-71

Demo 15
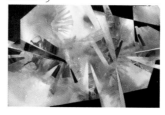
Planning Your Painting with Values
P. 76-79

Demo 16
Line As Color
P. 82-83

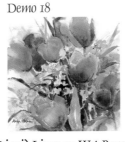

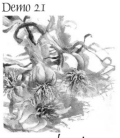
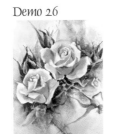

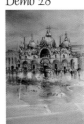
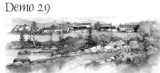
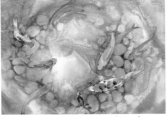

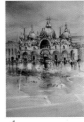

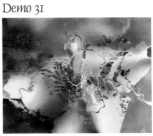

# Introduction

Developing a "spirit of spontaneity" is an exciting prospect, but how can one teach spontaneity? In my journey as an artist, I have learned that by following some very specific step-by-step instructions and trusting in myself, "spontaneity" can be achieved with planning. This book presents thirty-four planned demonstrations that can be combined with your own style and used as stepping-stones to a new level. I have organized the book like a cookbook to allow you freedom to jump right in and try any idea, knowing that the cross-referencing will direct you to the technical details you may need to finish your paintings. Exploring technical instruction, investing in some materials and, most of all, giving yourself permission to try some new ideas is all that is necessary. You do not need to be born with some divine talent; you have the creativity to paint right now.

Most of the demonstrations in this book were created either *en plein air*, directly from a still life or from a photographic reference. Photographs can serve as a catalyst or a departure point for a painting. Many times a photograph truly captures a moment in time. Often, I will file photos and years later will see something in the photo that I did not notice earlier. Whatever you use for your inspiration, I hope the ideas presented in this book will inspire you to add new techniques to your repertoire that will enhance your skill level and lead you on the path to a more spontaneous and free style of painting.

Growing up in a "little town on the big lake" was a great experience; however, there were no art stores, museums, art classes or any experiential ways to be involved in

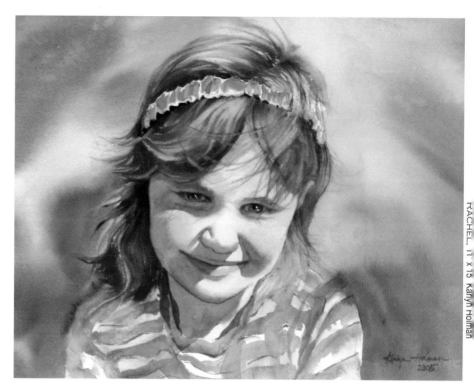

RACHEL, 11" x 15" Karlyn Holman

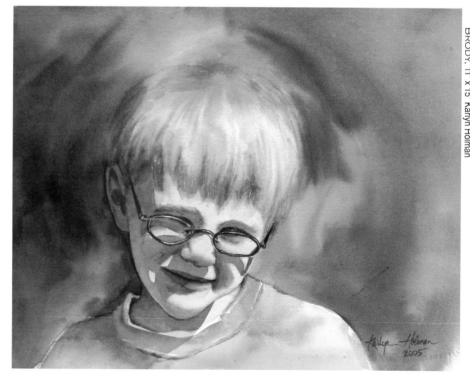

BRODY, 11" x 15" Karlyn Holman

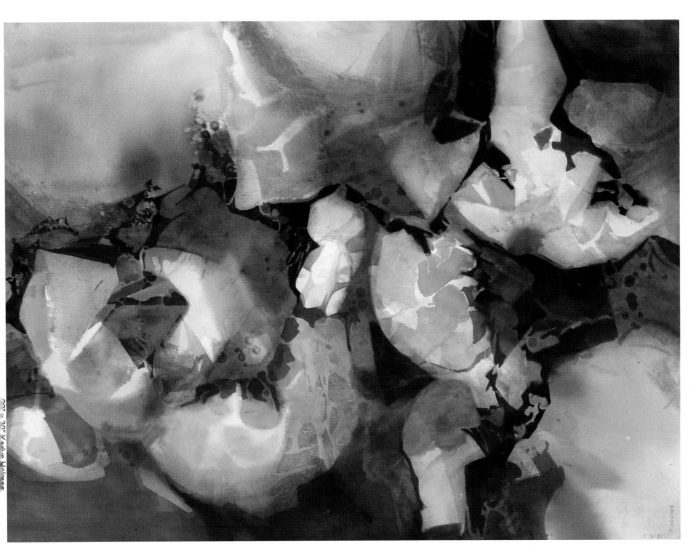

the art world. Thank goodness there were books and, best of all, parents who were very encouraging. I took my first formal art class when I enrolled in college and entered the art world with no preconceptions of what constitutes "art". I had traveled down my own path of self-discovery. We each have unique life experiences and educational training that helps to carve out who we are as an artist. Whether you start as a child or an adult is not important; what matters is finding the motivation to develop your own artistic expression. Painting is a language without words. You can communicate with color, line, shape and all the elements of design. Painting is also about seeing, creating and discovering expressive ideas. This book presents a series of demonstrations that may work as a catalyst to help you along your artistic journey.

I have always had an interest in both realism and abstraction. Although my art training included abstract expressionism, like many artists, I began my artistic journey by following a very traditional and realistic approach to painting. Eventually, my interest in realism started to weaken and I found myself attracted to a more expressive and experimental style of working. I wanted more freedom…more joy…more surprises... more excitement. We all have a strong desire to grow and change as artists, which means that we sometimes have to take risks. Taking these risks may be uncomfortable, but our willingness to experiment means that we are willing to venture into the unknown and open the door to a new way of seeing the world. This book is primarily focused on watercolor techniques; however, there are many ideas and techniques that involve "mixed media". The surprises and exhilaration you can feel when new avenues open up is exciting and fulfilling. This book will feature the use of watercolor crayons, watercolor pencils, acrylics, some collage paper, pen and ink and other media.

Paint to please yourself and you will find that there are many admirers out there. If you simply focus on pleasing yourself, your paintings will reflect this joy. Don't compare yourself to others and their artwork; look at your own progress. View all criticism of your work as constructive, not destructive, and remember that each success or failure will expand your artistic vision. Above all, give yourself permission to play.

# Materials

*If you are interested in pushing your boundaries and opening your soul to become a more playful and spontaneous artist, you probably already have a lot of painting supplies. As you play with the ideas presented in this book, consider experimenting with the supplies you already have on hand. The following materials are what I commonly use and are presented solely for your information. Feel free to take risks and enjoy a new approach to creative expression using whatever materials you may choose.*

## Paint

My personal palette is mostly made up of transparent colors, although I do have a large selection of other colors to play with. I never limit myself when it comes to exploring new avenues of expression using color. The only caution I would advise is to use artist quality pigments so your work will have archival permanence. Learn everything you can about the properties of your paints—are they staining or non-staining; do they granulate; are they opaque?

We have Sir Isaac Newton to thank for inventing the color wheel, and now that we have many round palettes to choose from, it really makes good sense to place your colors in the same sequence as the color wheel. On my round palette, my colors are placed strategically in their proper positions, and they are arranged both harmonically and in complements, the same as on a color wheel. You need to research the specific quality of each color and

arrange each one carefully. For example, an easy choice would be to put orange between yellow and red. Some colors require more research. A warm blue such as French ultramarine blue should be placed between cobalt blue and primary red. Once you learn the basic properties of the various colors, your palette becomes your most effective tool for creativity and you don't have to reinvent the wheel every time you select a color.

## Brushes

My favorite brushes are synthetic. They are so sturdy that you can actually use them to push the paint around or lift it out when necessary. My brushes range from a generous wash brush (1 ½" to 2"), a selection of round brushes (#18, #10 and #6), a one-inch flat brush, and a #3 script brush for details. I use natural brushes, such as an oriental brush made out of squirrel hair, for throwing the paint because a natural brush releases the paint, whereas a synthetic brush holds the paint.

## Paper

I use Arches® 140# bright white in both cold press and hot press surfaces. I usually wet the paper on both sides so I can keep the paper wet longer and thereby have a longer time to play with the wet color. I do not recommend soaking the paper and then stapling it to a board because you are eliminating the sizing-rich surface. This surface is what allows your colors to move around freely in a wet-into-wet underpainting. When the sizing is eliminated, the colors do not move as well because they are absorbed into the paper too quickly. I seldom use watercolor blocks because they are not standard sizes and require custom mats for framing. When I am feeling adventurous, I will use any paper such as Yupo, watercolor canvas, masa—whatever strikes my fancy.

# Erasers

I use the Factis™ eraser when I am drawing on my watercolor paper. It cleans well without abrading the surface.

# Spray Bottles

A spray bottle is an essential piece of equipment that allows you to keep your painting surface wet, enables you to move the paint around and is especially helpful when softening edges to create a vignette style. When your painting is wet, you can completely remove the color from your paper by spraying it off.

# Adhesives

There are many times when you will need an adhesive to glue down collage papers. My favorite choices are Yes! Paste™ and matte medium. When I want to work with watercolors, I use Yes! Paste™ because this archival paste allows you to glue down everything from thick paper to thin paper, and when the glue dries, it leaves a workable surface to continue painting. When working with acrylics, matte medium is excellent glue. Matte medium will, however, leave a surface that will resist watercolors.

To use Yes! Paste™ effectively, you need to prepare the glue so the consistency will accommodate the thickness of the paper you are using. Right out of the jar, Yes! Paste™ is very thick and can be used to adhere very heavy papers. However, with a little patience and a small amount of water added to the surface of the paste in the jar, you can slowly thin down the top layer of the paste to a smooth, creamy solution. I use a one-inch flat brush and slowly rub the surface of the paste until the water blends with the paste to become a slurry. Do not rush this step and do not dig into the paste; just activate the top layer. If you have any excess mixed glue in the jar, simply allow it to soak into the rest of the glue. The next time you need thinned glue, the glue will activate in a short time.

Claim your own studio space and set it up so you always feel invited or seduced into your own sanctuary. Simply organize all the materials you may be inclined to use for mixed media, so when a painting calls for more enrichment, you know where to find the materials you need. Now add natural light or full-spectrum lighting to your workspace and you are ready to venture into the unknown.

This is a photo of my transparent watercolor palette illustrating the specific colors used in this book. The wet colors in the mixing area represent a full spectrum of harmonic hues. Using this circular selection of harmonic colors will result in a fresh and clean underpainting.

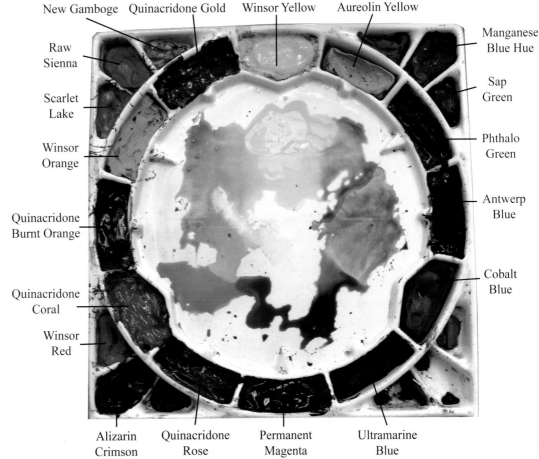

New Gamboge  Quinacridone Gold  Winsor Yellow  Aureolin Yellow

Raw Sienna

Scarlet Lake

Winsor Orange

Quinacridone Burnt Orange

Quinacridone Coral

Winsor Red

Alizarin Crimson  Quinacridone Rose  Permanent Magenta  Ultramarine Blue

Manganese Blue Hue

Sap Green

Phthalo Green

Antwerp Blue

Cobalt Blue

# 1

## Seeking Inspiration

*E*very painting starts with an idea, whether we generate it in our "mind's eye" or we observe it in our everyday lives. Once we begin to collect these ideas, we are free to start sketching or drawing. Painting is a reflection of our passions, and our ideas will emerge through the use of color, line, shape, movement and value. Painting a picture can really be this easy.

The subject is only the beginning or the seed of a painting. The real challenge to working spontaneously is developing the ability to use your technical expertise to take you beyond your comfort zone. The ideas presented in this section are intended to serve as starting points for new visions of creativity. Rather than trying to capture a literal interpretation of a photograph, break out of the frame and work towards your own personal expression.

Everyday subjects like flowers or apples can be great inspirations for painting. Visiting a prehistoric cave or walking through a rain forest can open your eyes to entirely new subjects. A display of artichokes at a farmers market could suddenly inspire you to pick up your brushes and begin painting. If you frequently paint the same subject all the time, a change of subject matter may breathe new excitement into your work. If you paint realistically, try abstraction. If you paint only flowers, try a landscape. If you always paint in a horizontal format, try a vertical format. Keep your mind and eyes open to the world around you.

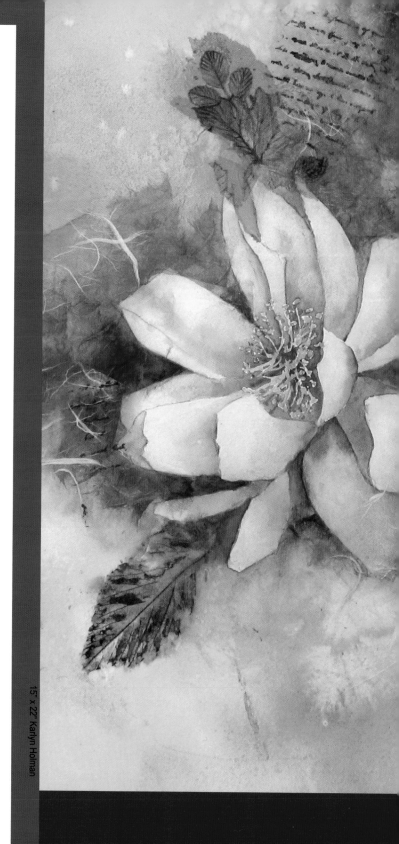

15" x 22" Karlyn Holman

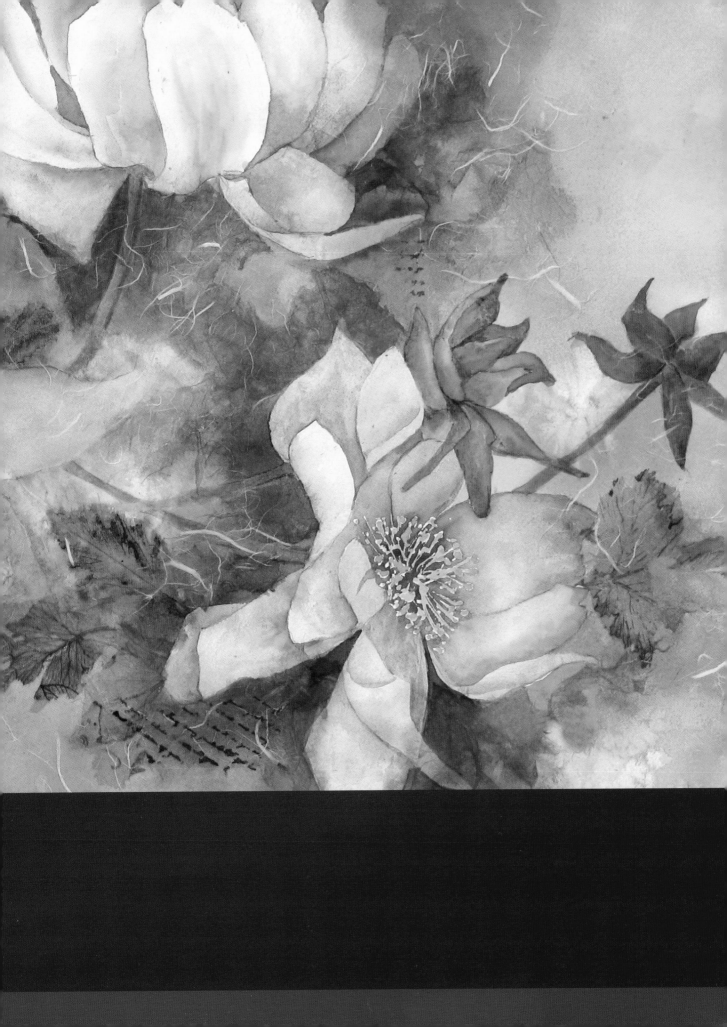

# Finding an intriguing subject

*One day while strolling through the Venice fish market, I noticed boxes of colorful pomegranates. I took several photographs and before long, fascinated by the colors and textures of this "seeded apple", I embarked on an entire series of paintings based on this intriguing subject. I wanted to avoid a traditional still-life interpretation and focus on capturing the essence of the subject through shape and color. I gave myself permission to float the shapes on the paper in an effort to create a visually pleasing composition. The results were several paintings that captured the essence of the pomegranates, unlimited by a literal interpretation.*

*To someone who grew up in the Midwest, pomegranates seem very exotic. Now, I have learned that this beautiful fruit has many health benefits and has been cultivated since pre-historic times.*

Karlyn Holman

Karlyn Holman

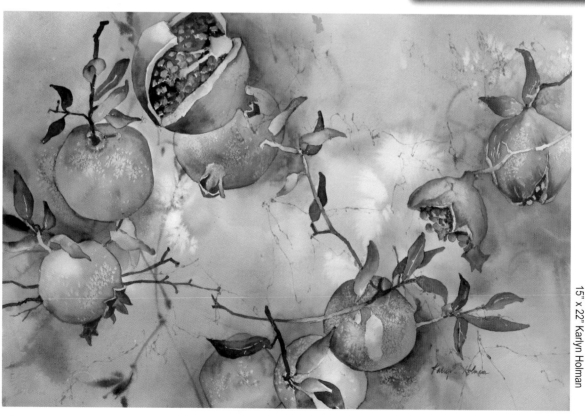

15" x 22" Karlyn Holman

This painting of pomegranates has a pleasing background that shows the harmonic colors repeated three times (pages 18-19).

Once you begin interpreting your subjects without literally following a photograph, you will begin to see more and more possibilities for subject matter. Sketch in the contours of your subject, ignoring details. Explore all the different angles of your subject, overlap shapes and be sure to anchor some of the shapes all the way to the edge of the paper. Try cutting the fruit open for a different perspective and to vary the size of the shapes. Add the outline of leaves and stems to create linear movement. As you become familiar with how to create textures and shapes, you will realize that you have developed a visual language that will enable you to describe and interpret a wealth of different subjects.

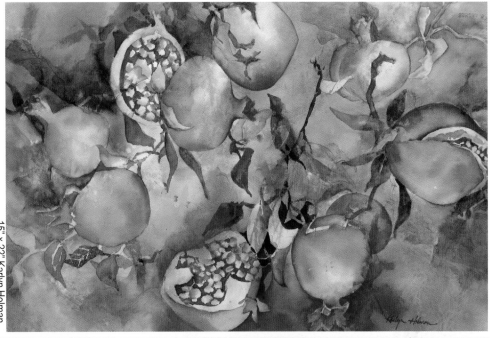

15" x 22" Karlyn Holman

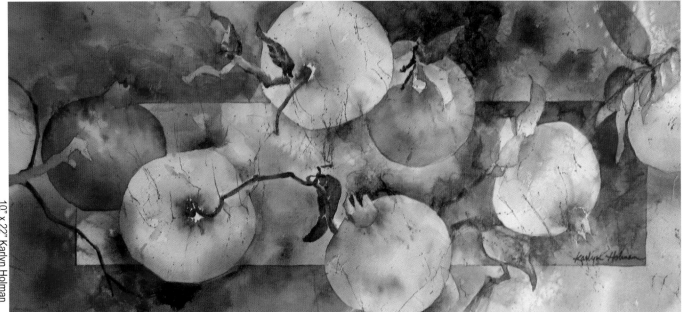

10" x 22" Karlyn Holman

This interpretation involved adding a simple rectangle to connect the shapes. The use of this geometric shape allowed me to reverse darks around the outside of the rectangle on the left portion of the painting and add darks to the inside of the rectangle on the right portion of the panting (designing with shapes, pages 96-97).

Select a "circle of color" from your palette that features colors from all the primaries. I began with Winsor yellow, quinacridone gold, quinacridone coral and Antwerp blue.

*Work in limited harmonic colors–as the paint mixes on the wet paper, new colors will emerge*

Winsor Yellow ← Quinacridone Gold ← Quin. Coral ←

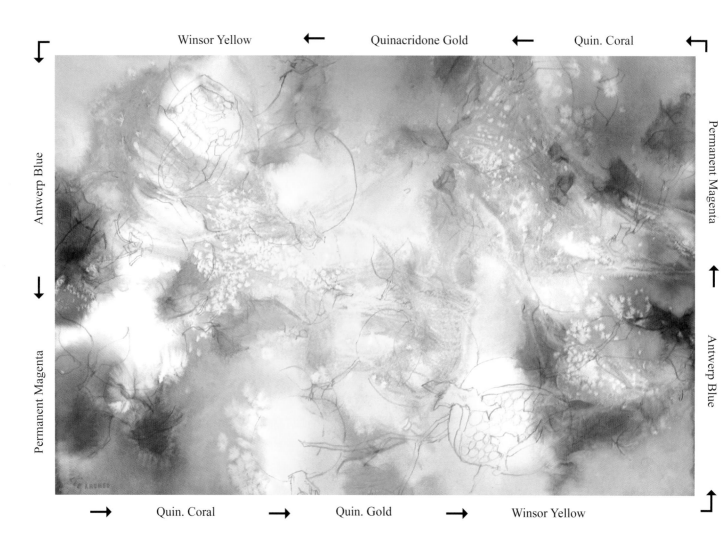

Antwerp Blue

Permanent Magenta

Permanent Magenta

Antwerp Blue

→ Quin. Coral → Quin. Gold → Winsor Yellow

Wet the paper on both sides and begin painting negatively around the shapes you drew. Do not paint anything that you have drawn. Each color has an inherent value. The yellows will form the light values and the red and blue will form the mid-tone values. As you circle your subject, try to complete the cycle of color at least twice, even three times, thus creating echoes of colors in random areas. It is imperative that your paper is wet enough so the color is free to seep into the drawn shapes. If necessary, use a fine mister to keep the surface wet. As you paint around your subjects, remember, this is the background, so when you paint on one side of a shape, be sure to continue to the other side of each object. For example, you do not want one side of a pomegranate red and the other side blue. This attention to detail will add harmony and balance. If you like the look of collage, try adding some white, Thai unryu paper as I did in this painting (collage, page 153). Salt can also be added in the light areas for some texture.

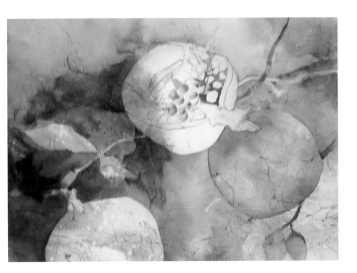

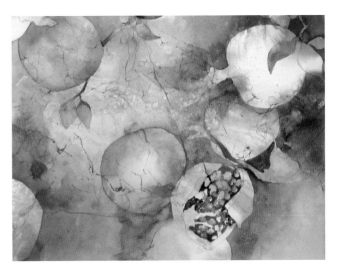

Allow the underpainting to dry. To finish, you may choose to paint around a shape (negatively) or to paint the shape itself (positively). While working on the background, use the same colors, but in a richer value to complete the painting. When working on the positive shapes, pull warm colors into the cool areas and cool colors into some of the warm areas. Remember to push the values: dark against light and light against dark. Be creative and use this playtime to experiment and stretch yourself beyond the limits of the actual photograph.

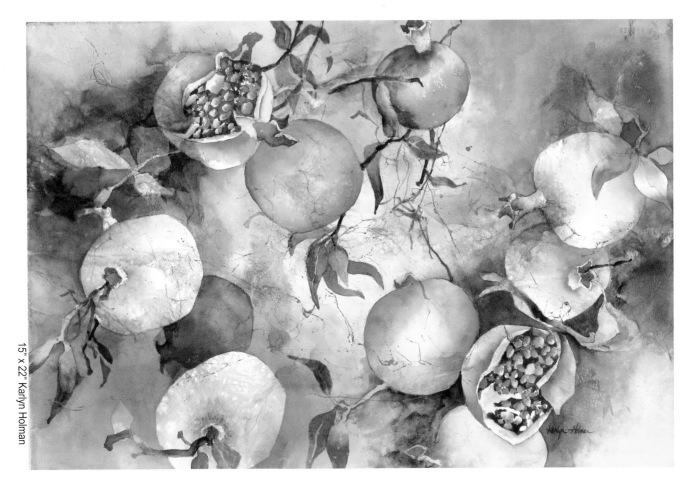

15" x 22" Karlyn Holman

In this painting, the colors in the background are repeated in the subject. For example, purple pomegranates were added in the yellow background and yellow pomegranates were added in the purple background. To achieve harmonic enrichment, red was layered over the blue to create a warm purple. Glazing yellow over the red produced vibrant oranges. Adding warm colors in the white shapes also intensified the warm dominance.

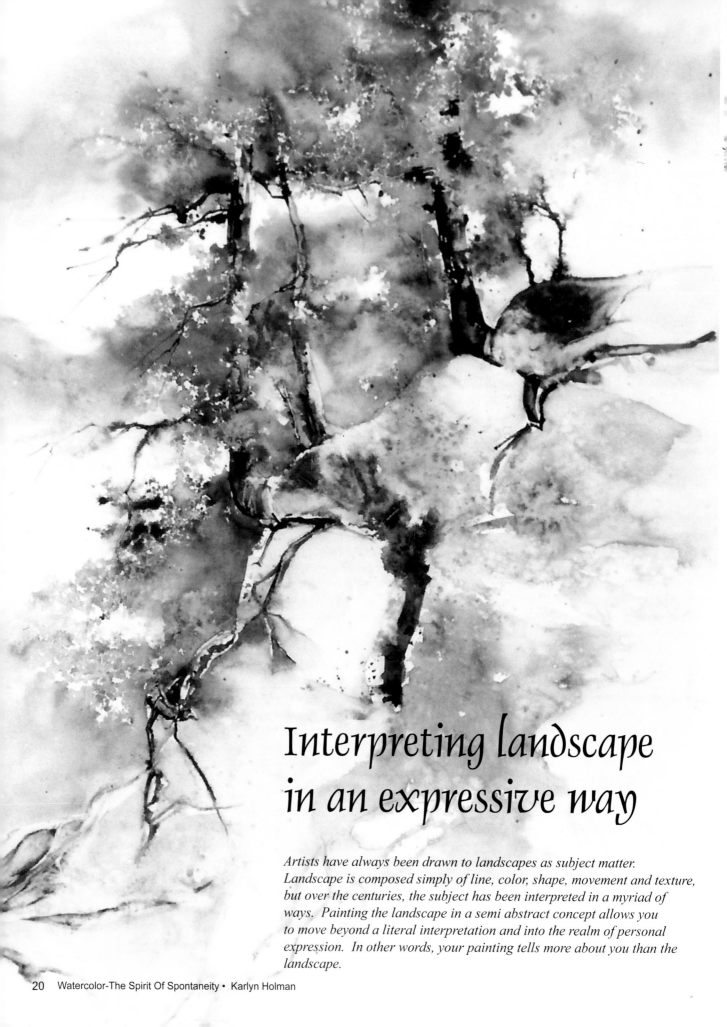

# Interpreting landscape in an expressive way

*Artists have always been drawn to landscapes as subject matter. Landscape is composed simply of line, color, shape, movement and texture, but over the centuries, the subject has been interpreted in a myriad of ways. Painting the landscape in a semi abstract concept allows you to move beyond a literal interpretation and into the realm of personal expression. In other words, your painting tells more about you than the landscape.*

# Literal approaches to en plein air painting

In a literal interpretation, painting on location is both rewarding and educational. You can observe the scene before you and with a pen or pencil, begin to sketch what you see. This is a quick thirty-minute sketch of a 2500-year-old Umbrian village in Italy.

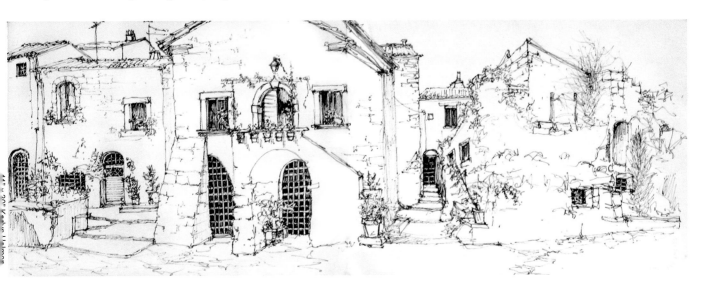

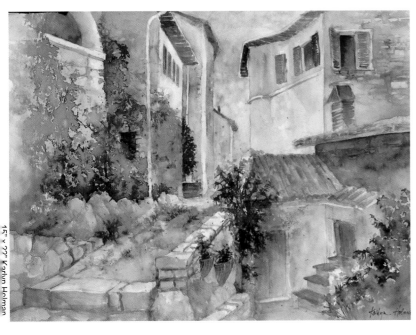

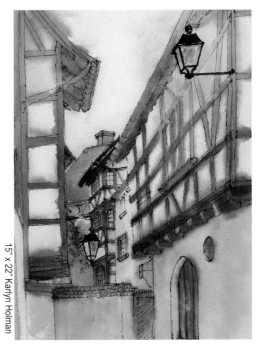

Another traditional approach is to actually try to capture the light and shadows of the subject, thereby imparting a three-dimensional look to your finished painting. This painting was done on a rainy day in Umbria, Italy.

You can record your observations on location by drawing the images in pen and then quickly adding color, keeping the interpretation sketchy and personal. In this sketch of a street on a rainy day in Strasbourg, France, the pen lines really define the composition and the color is merely decorative.

# Layered approach

*One of my favorite approaches to en plein air painting is a layered approach using complementary colors. After the drawing is complete, to capture "a moment in time," this traditional approach using complementary colors such as cobalt blue and permanent magenta interpret the cast shadows on dry paper. The warm colors are then layered over the cool underpainting. (This approach and others are demonstrated in my first book, Watercolor Fun and Free, pages 96-147.)*

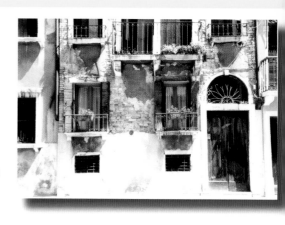

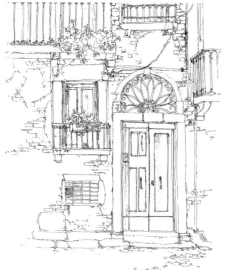

Sketch with permanent pen

*This simple close-up of a door in Venice is a perfect subject for using a layered approach to capturing the immediacy of the light touching the subject.*

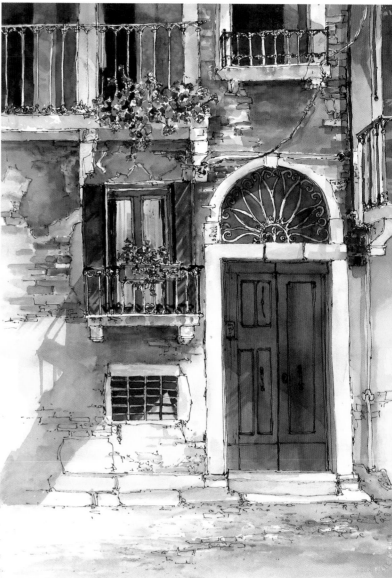

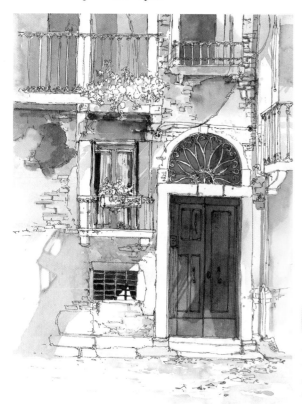

Values in cobalt blue and permanent magenta capture the cast shadows.

Warm colors such as raw sienna, quinacridone burnt orange, quinacridone gold and Winsor orange are layered over the shadow layer.

# Direct approach

The same scene could be interpreted more expressively without the preliminary extensive drawing and value planning. This painting was done on hot press paper using watercolor pencils and Caran d'ache® crayons were added for linear effect (pages 82-89).

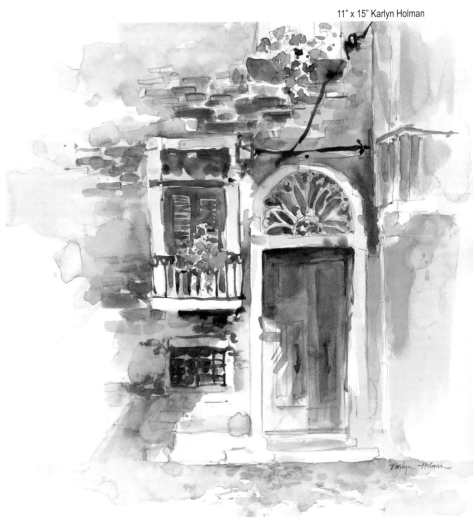

11" x 15" Karlyn Holman

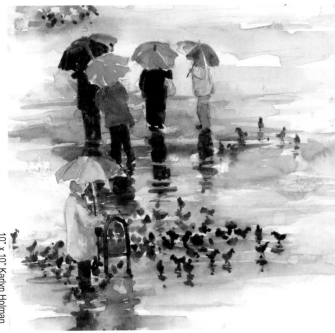

10" x 10" Karlyn Holman

A spontaneous and joyfully colored sketch captured this rainy day scene at St. Mark's Square in Venice. Using hot press paper, very little planning and minimal concern for detail, I was able to capture the impression of a specific moment in time.

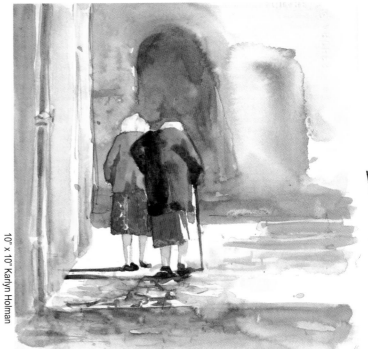

10" x 10" Karlyn Holman

These women walking along the cobblestone streets in Italy were a perfect subject to quickly sketch with watercolor on hot press paper.

23

# Starting with warm colors

*The layered approach is particularly beautiful when you reverse the traditional approach of starting with the cast shadows and start with the warm colors. I began this painting of the little village of San Martino, Italy using only warm colors and later added a few cool colors to gray the darks.*

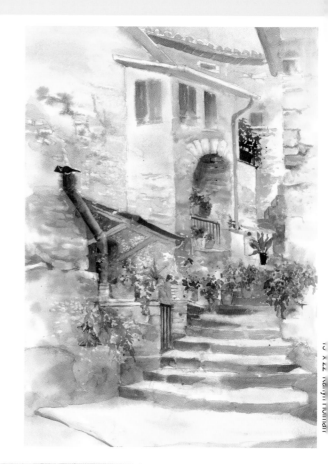

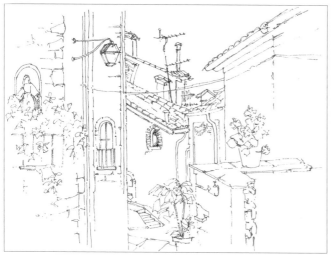

Karlyn Holman

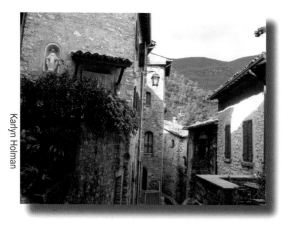

The quiet street was full of symbols that conveyed a medieval theme, I emphasized the most interesting features like the Madonna, the hanging light, the rooflines and antennas and edited out many of the doorways and windows. Editing is always the key to a more personal, expressive interpretation.

*This painting was painted en plein air in Scheggino, Italy. My co-instructor Pauline Hailwood from New Zealand shared this delightful color triad of new gamboge, scarlet lake and manganese blue. This combination of colors is all that I used to interpret the soft, warm and cool grays of this medieval village.*

The paper was wet on both sides and beginning with the white paper near the center, the colors of new gamboge, then scarlet lake and finally manganese blue were painted all the way to the edge of the paper using a circular movement (focus of light, pages 130-133).

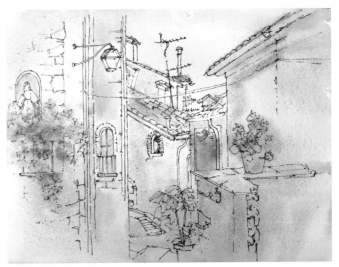

These colors do not mix together actively so it is important to tip and spray the colors until they blend together and create a glow. I sprayed more water to open up a path of white leading towards the Madonna.

While the paint was still wet, manganese blue and scarlet lake were used to interpret the shadows. These colors were applied in both their pure forms and in stages of mixed variations. The foliage was suggested by first tapping new gamboge and then adding manganese blue over the yellow to form the greens (page 121 and 156). Scarlet lake and new gamboge were mixed together to suggest the tile color. Salt was added just as the sheen was leaving the paper.

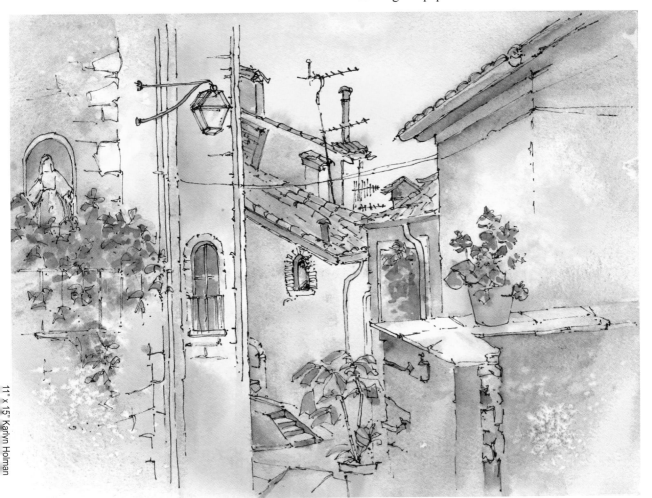

11" x 15" Karlyn Holman

The painting was completed on dry paper by layering color so some crisp edges could be defined.

# Working in an Alla prima approach

*Alla prima literally means, "first time". This is a time-honored approach used to capture the essence of a subject, by working in the moment with no under drawing until you have expressed what drew you to paint the scene in the first place. This direct way of working often produces a spontaneous and fresh look that has an immediacy that invites viewers to form their own interpretations.*

Bonnie Broitzman painted this semi abstract interpretation *en plein air* in Umbria, Italy. Bonnie assists me on many of my International on location adventures. After many precise landscape interpretations, Bonnie wanted to capture the shapes and memories of this scene in a more spontaneous approach. She wanted to capture the delightful interplay of the white and dark shapes linked throughout her composition. She purposely played with the shapes of wash on the line, arched doorways, chimneys and other descriptive symbols that would help invoke this quaint little hilltop village. Bonnie started with a wet wash and finished a short time later by emphasizing both positive and negative shapes and crisp edges.

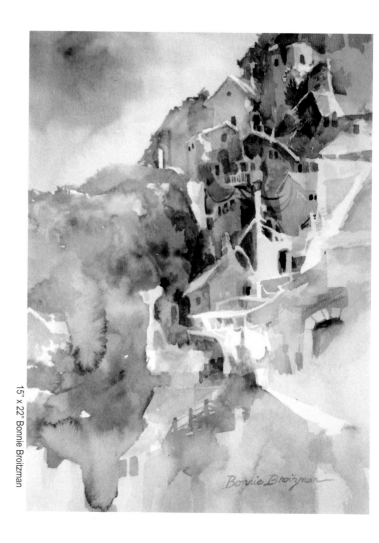

15" x 22" Bonnie Broitzman

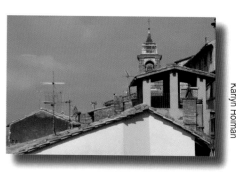

Karlyn Holman

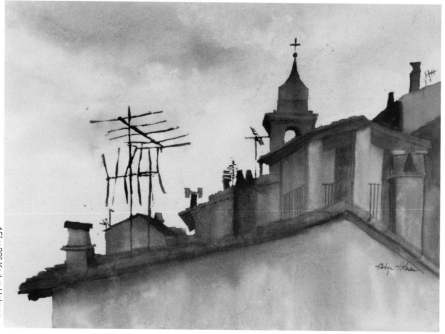

15" x 22" Karlyn Holman

This view from the terrace of a little coffee shop on top of a hillside in Umbria was composed of many great shapes. Instead of treating each shape separately, I combined them all into one wet-into-wet shape, thus drawing more attention to the chimneys and antennas.

Idea sketches will help you begin to understand an interpretive approach to a more spontaneous looking landscape. Your finished painting will suggest the actual elements of nature—wind and erosion, extreme heat and cold, drenching rains and the many other activities that occur everyday in nature. As you work with line, value and movement, you will discover your own visual vocabulary. You will move beyond the actual landscape into a panorama of possibilities. As you observe the landscape, look for shapes, textures and patterns of movement—angles in rocks, shapes in clouds, tree roots clinging to a rocky shoreline, patterns in buildings or any visual ideas that inspire you. Highlight some areas and put less emphasis on others.

*Free yourself from the realism of your subject*

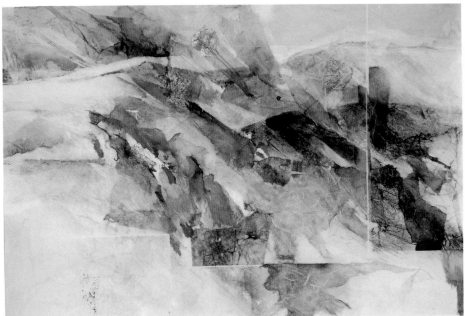

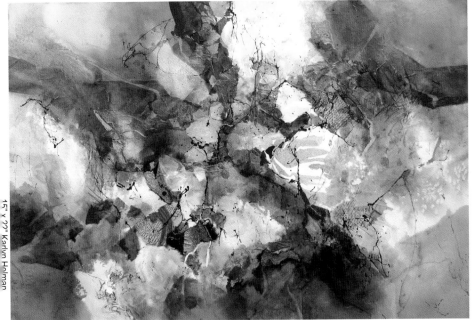

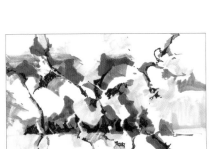

This spontaneous idea sketch of a rocky shoreline completed en plein air was later used as a starting point for a painting. Your recollection of the scene and not the scene itself comes into play to help you paint a fresher, more spontaneous interpretation. Because you have distanced yourself, you can take more liberties and develop a more expressive and personal vision. You are free to go beyond the boundaries of realism and interpret the landscape in new and exciting ways.

# Going beyond the boundaries of realism

*Try to capture the essence of a moment in time in nature. Let the textures appear—be open to surprises and unpredictable happenings. Create a spontaneous image instead of a meticulously realistic rendition. Rejoice rather than render!*

*The fun is about to begin—do not sketch anything on your paper*

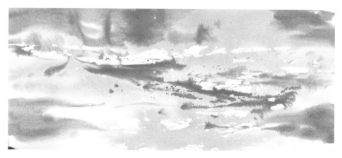

I. Begin by wetting the back of the paper and then **selectively** wetting the front of the paper, leaving some random white areas. These dry areas on the paper will become the white shapes. Remember to wet about ninety percent of the paper. Only a few selective areas are left dry!

2. To insure that you save those random white shapes, you will need to throw the yellow onto the paper. Also throw some red and extend this warm color all the way to the edges of the paper. Be sure to really wet the remaining ninety percent of the surface. The wetness is the key to achieving glowing color.

3. Bring the cobalt blue in from the outer edges to create a cool contrast. Spray and tip the paper so the colors glow into a graded wash.

4. Place random and varied shapes of 10-gram white unryu paper onto the surface to form the darks. This lightweight archival paper will begin to absorb the color. As you add the varied pieces, be sure to link the movement within the design from edge to edge. Spray with your fine mister to help the paper absorb the color more completely.

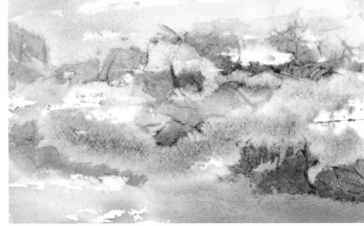

5. Next, stretch out gauze and place it on the wet paper to create linear movement. Keep spraying with your fine mister to keep the paper wet. Be sure that the linear movement interlocks with the dark shapes.

6. If you want to simulate rock-forms, add ripped up pieces of waxed paper. This is the time to try anything that will imitate the exciting textures found in nature. You are trying to simulate the same drama nature imposes on a landscape. Try scratching the surface with a stick or your fingernails—dry some areas with your hairdryer—spray excess water onto the surface to wash away color—try whatever pops into your imagination. This is your creative playtime.

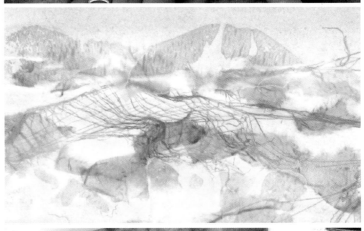

7. Now you can have fun intensifying the colors. Try using colors like Antwerp blue or quinacridone gold to step up the values. Paint on the papers and on the gauze and even paint some of the white shapes. Eventually you will want to tip the paper so the colors run under the wax paper. As a final touch, before letting the painting dry completely, try sprinkling some salt on the light areas for transitional texture.

Stamping    Cool colors    Several layers of glazing
to create distant hills

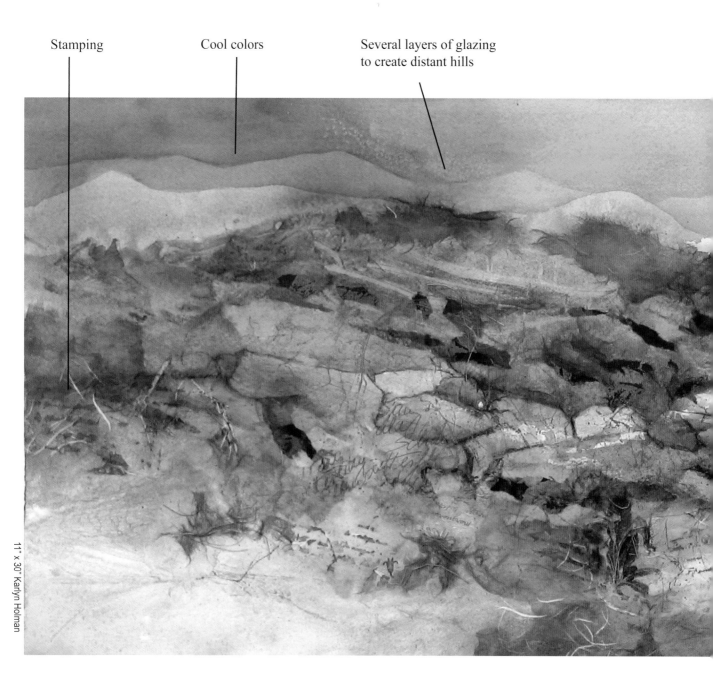

11" x 30" Karlyn Holman

8. Remove the waxed paper, salt and gauze and leave the unryu paper in place. Glue the unryu paper down with Yes! Paste™ (pages 13 and 156). At this time take a moment to step back and evaluate your progress.

9. Add hills in the background by glazing color over the dry paper using the same color range (warm to cool) and adding as many layers as you like to create a sense of distance. As you move towards completing your painting, use aerial or atmospheric perspective (pages 114-115) to accentuate the drama of a sun source. In the areas closest to the light source, keep the colors predominantly warm, and as you move to the edges of the paper, keep the colors predominately cool.

Gold webbing spray     Warm colors     Add 10 gram Unryu paper over the finished painting to add extra highlights

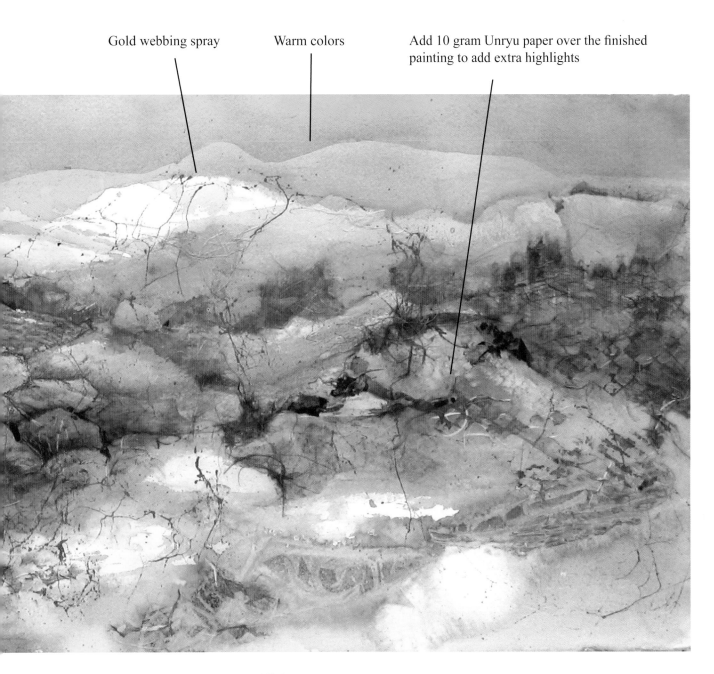

IO. Work with lost and found edges, dark and light shapes, and try to save the white shapes as long as possible. If necessary, you can wet the white shapes and tone them if they are too harsh. Gradually, you can add more and more realism until you are pleased with your composition. Try not to go too far with the finishing. Remember, less is more.

# Superimposing a new reality

*You can take the previous lesson a step further by simply penciling in an idea sketch over your underpainting.*

The shapes in both these paintings were originally nothing more than the playful lines on the small 2" x 3" "doodle" above. Once I drew the shapes in pencil over the underpainting, I was free to find edges and lose edges, define rocky shapes and enjoy the freedom of exploring a more expressive and spontaneous interpretation of the landscape.

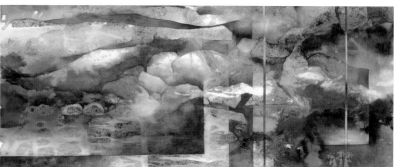

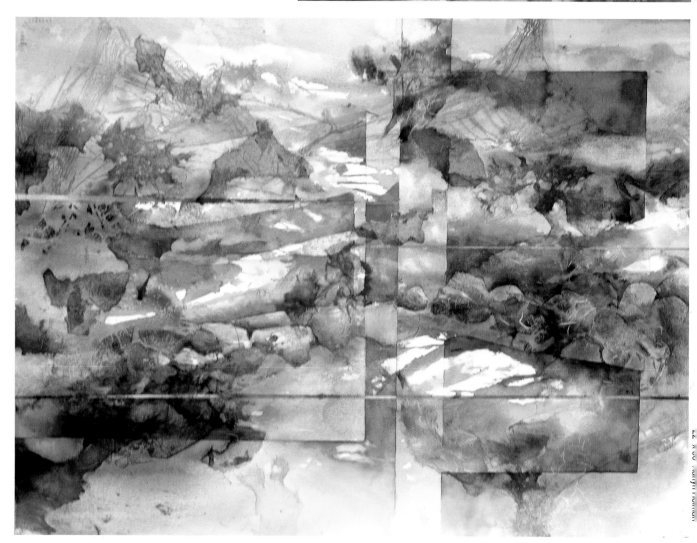

# Using an unusual background

Brenda Schwartz, a third generation marine artist from Alaska, has very cleverly combined marine imagery with preserved navigational charts. She creates all these images on site while traveling around Southeast Alaska and the Pacific Northwest. Brenda has visited and experienced the remote and beautiful tributaries and inlets of Southeast Alaska and loves to express her love for this part of the country through her paintings.

The whites form a path of light (pages 60-75) that integrates beautifully with the marine image.

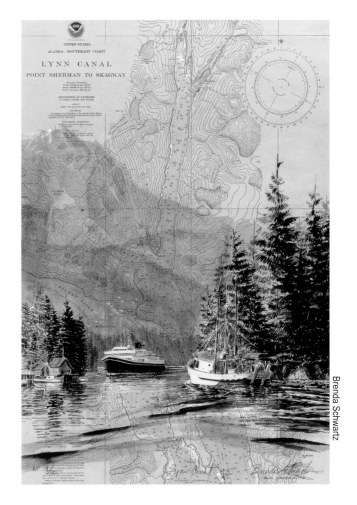

Brenda Schwartz

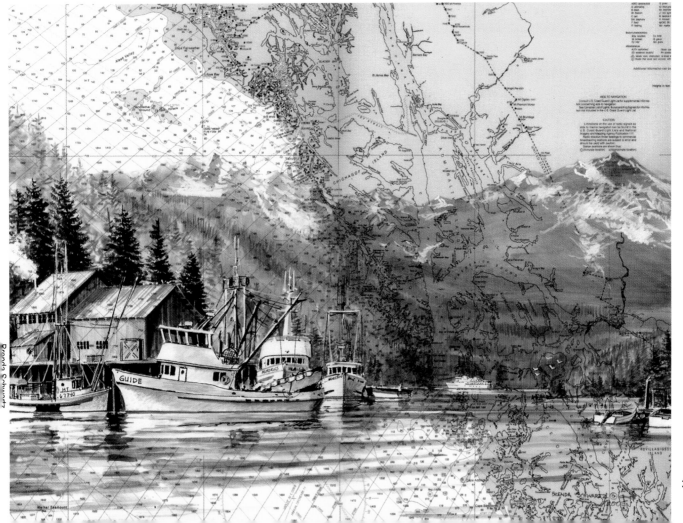

# Moving in close and personal

*Using close imagery is more personal than viewing your subject from a distance. Just looking around your environment may surprise you. Fragments or sections of your photographs create infinite possibilities. A subject like a rocky shoreline is beautiful, but move in close focus and you will be amazed at how the subject changes into an abstract study of color, light and shape. Moving in close up really makes you aware of the ageless struggle of nature's forces on the earth and helps you to reinterpret the subject.*

*A perfect way to find inspiration is to take an intriguing image and focus in closely. You can do this using your digital camera, your computer or photographs. Far too often, we float the images in the center of the paper. When you move in close up, the image moves to the edge of the paper and even partly off the paper, linking and anchoring the design. Try moving in close up and you will see a magical transformation.*

Karlyn Holman

You may begin to envision a new reality by making a viewfinder and looking for new compositions within the image.

Select a segment of your image as a focal point. Start with a pencil sketch, wet your paper on both sides and let the fun begin.

Choose earthy colors like raw sienna, quinacridone gold, and Winsor orange. Try using color sanding (page 86) to add textured color.

While the paint is still wet, use quinacridone burnt orange to establish a pattern of dark shapes.

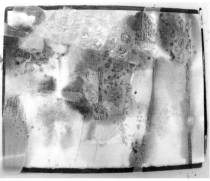

Add cobalt blue over the orange to create random dark values.

Drop Isopropyl alcohol onto the wet surface from the end of a brush handle to form the spots. The alcohol spots are white when they hit the surface, but often turn dark later.

This is a good time to add texturizing agents like bubble wrap and wax paper. Be sure to tip the paper so the colors run under these papers.

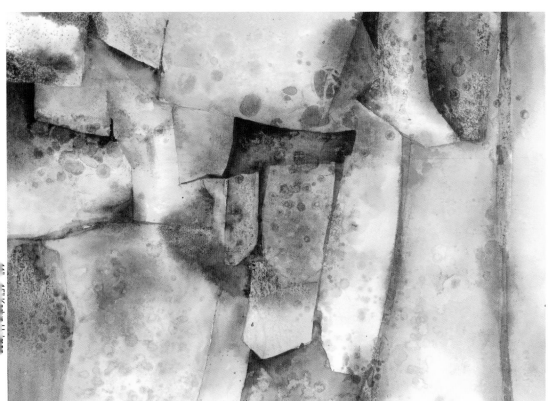

Remove all the texturizing devises and finish the painting on dry paper by adding some selected darks. Layering colors over the rocky shapes can add enhancement; for example, cool over warm, bright over dull, warm over cool, etc.

# Transferring an ink jet image

As artists, we can easily spend all our energy trying to reproduce the visual reality of a photograph. Why not take the photograph and use it as a departure point. By taking a photograph and by reversing and literally fragmenting the image, you begin to free yourself from the more traditional literal approach. The spontaneity of this technique acts as a catalyst for ideas. This creative playtime can prove to be a stepping-stone to a whole new direction in your work.

Each artist needs to be a collector of visual ideas. These collections are sometimes called "swipe files". The technique of transferring images to paper will open new avenues of interpretation of these images and provide a perfect way to reinvent a subject. This process will also allow you to use any vintage or precious memorabilia without having to destroy the actual photographs. Think of all the fun you could have playing with and reinterpreting meaningful memorabilia like old family portraits, photos of travel adventures or scenes from outrageous parties.

Karlyn Holman

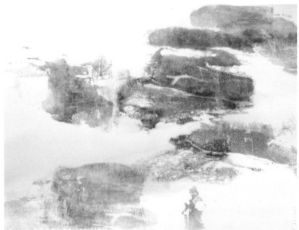

Selected areas of this original image were transferred onto hot press paper leaving generous white areas.

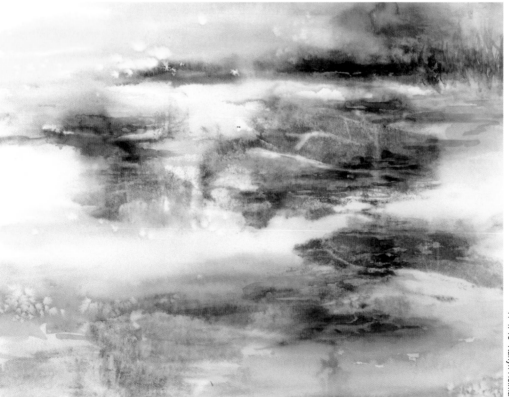

To finish the painting, additional layers of color were added over the transfer.

11" x 15" Karlyn Holman

Select a non-photo quality paper (the lighter, the better) and copy the image using an **ink jet printer**. Heat-set laser prints or copies will not work. Place the image face down on a dry, smooth-surfaced paper. All the paintings using this transfer technique were done on hot press paper.

To transfer the image, apply firm pressure using a flat, stiff brush. Dip the brush in gin, vodka or whiskey and wipe the excess away before you apply pressure. Isopropyl alcohol will not work for this technique. Do only a small section at a time and be sure to **burnish well** with your brush. As the spirit-soaked inkjet image transfers to the paper, the part actually transferred will become transparent, thus allowing you to see how much of the original image remains. Images are reversed when transferred, so if you have any writing or letters, they must be reversed before you transfer them. Once you complete the transfer, the alcohol will dry quickly and you can begin to paint immediately.

After selectively transferring parts of the original photograph, try using a permanent pen and adding watercolor to intensify the image. This painting is an example of a vignette style of working (pages 120-129).

> *Always consider the archival quality of the ink you are using to transfer your images. Because so many people are printing their digital photos using ink-jet technology, the printing industry has improved the quality and longevity of inks.*

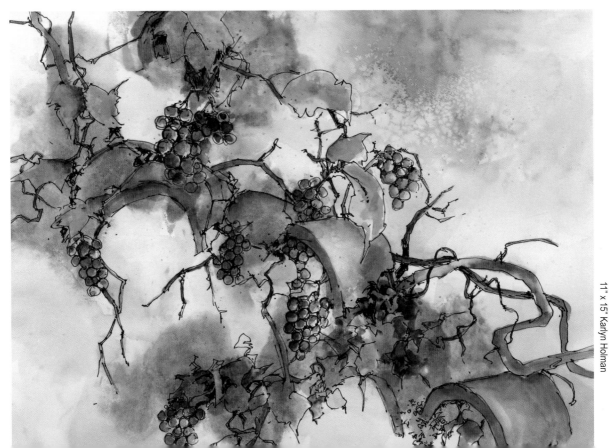

11" x 15" Karlyn Holman

# Instant results-a catalyst for inspiration

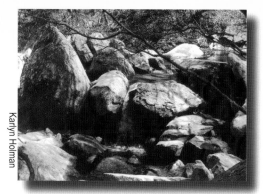

Karlyn Holman

To protect your painting from any fading, use an archival varnish or medium to seal the surface. An acrylic varnish with UV (ultraviolet) protection is most desirable.

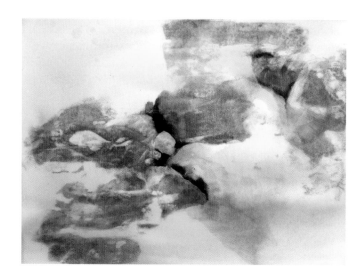

This initial stage of the transfer again shows the zigzag composition and white spaces.

I created a focus of light (pages 24-25) by wetting the paper and adding Winsor yellow, permanent rose and cobalt blue, working from warm in the center to cool on the edges.

Adding selected negative darks on dry paper completed the painting.

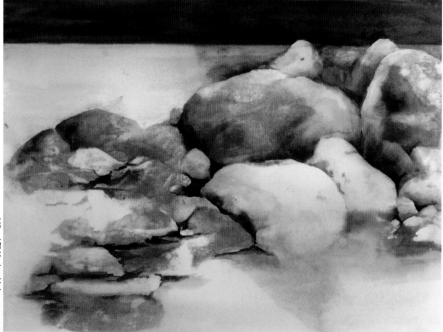

11" x 15" Karlyn Holman

Karlyn Holman

Karlyn Holman

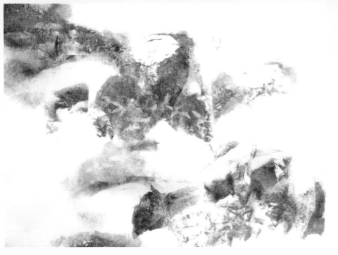

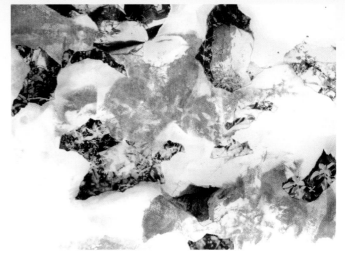

When you are transferring your design, consider using a zigzag composition, maintaining areas of white. Using this format allows you more flexibility to add color later. This transfer contains elements from two photo references.

The remaining translucent image of the original transfer was so beautiful, I decided to use it as collage paper. I ripped the ink jet image up and added various shapes to the painting. After moving the pieces around, I selected the final composition and glued the shapes to the paper with Yes! Paste™ (pages 13 and 157).

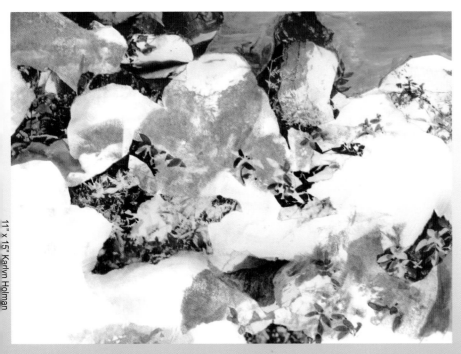

11" x 15" Karlyn Holman

After the Yes! Paste™ dried, I added more color, choosing green as an accent.

# Tic Tac Toe

*Using a tic tac toe format is a fun and easy way to start a painting. For variation, choose equal sized squares or any linear division that appeals to you. Create a focal point by transferring your image over the point where two lines actually intersect. You may consider transferring another part of an image at another intersecting point. Now, let the lines give you permission to play with light and dark shapes in seemingly random areas (pages 96-97).*

Karlyn Holman

Karlyn Holman

Think about rhythm, repetition and variation as you finish the painting. You may decide to fragment some of the shapes. As a final step, selectively add darks on dry paper.

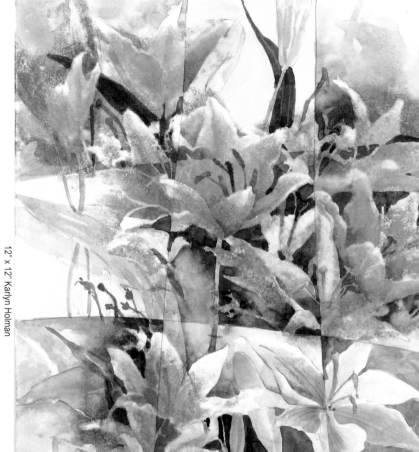

12" x 12" Karlyn Holman

# Design a montage of ink jet images

*A montage is an art form consisting of a selection of images that are combined to form one painting. The word montage literally means, "putting together."*

Begin your montage by selecting images that are related. For this demonstration, I chose photographs taken in the courtyard at the La Romita School of Art in Italy. The ambience of this medieval monastery changes with the time of the day and the season. The 4" x 6" images were first printed on a portable digital ink jet printer using lightweight paper and then transferred onto hot press paper.

10" x 10" Karlyn Holman

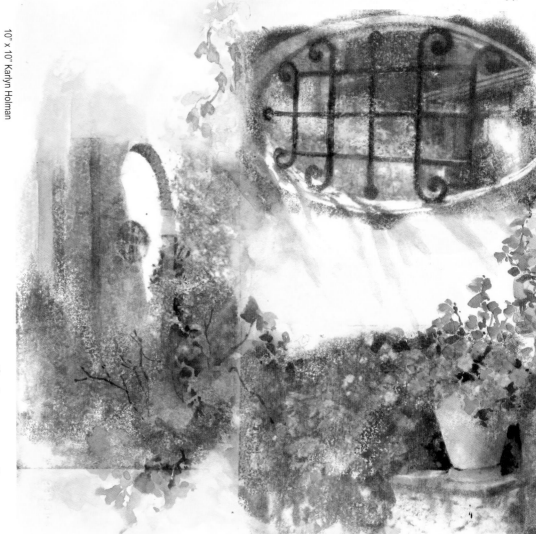

The challenge to finishing a montage is to find a way to unify all the elements of the painting. There are many ways to do this such as adding darks, interlocking the shapes and unifying the colors. For this painting, I added more foliage, cast shadows and a unifying warm glaze to meld the images together.

# Telling a visual story using vintage photographs

Archival photographs are an inspiring catalyst for a painting. Dig out those old vintage photos and transfer an ink jet copy of the image onto a smooth surface. To personalize these special images, add memorabilia like letters, stamps, poems, sayings or even found objects like buttons and tickets. After you transfer the ink jet image, consider gluing down the image itself to create added depth. The Internet is a great resource for finding artifacts to enrich your story.

> *Be sure to coat the final image with matte medium or acrylic spray with UV (ultraviolet) protection to seal the surface.*

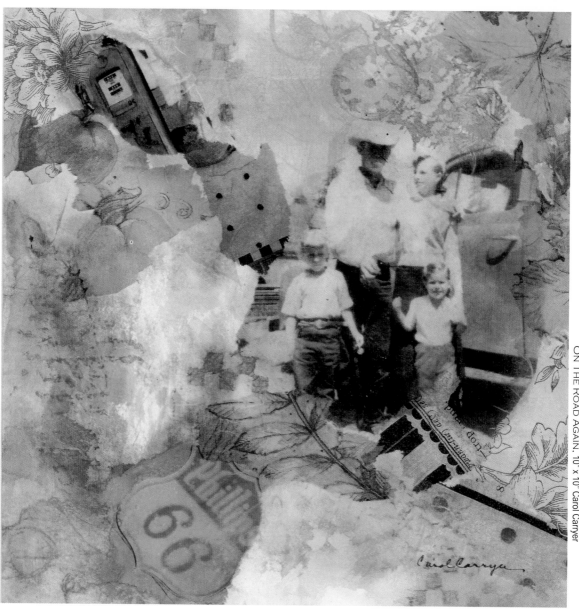

ON THE ROAD AGAIN, 10" x 10" Carol Carryer

Carol Carryer relived many wonderful memories while creating this work of mixed media.

"My Daddy was a professional rodeo cowboy-a calf roper and a bull dogger. For thirteen years, our family traveled from May until September, from rodeo to rodeo until the season ended. We came back to New Mexico for the winter months and my Daddy worked on building Route 66. Playing with the memorabilia I used to create this work of mixed media connected me to a very important and meaningful time in my life. Sharing this work with members of my family has been a joyful experience and has inspired me to embark on a new creative journey creating nostalgic compositions for myself and others."

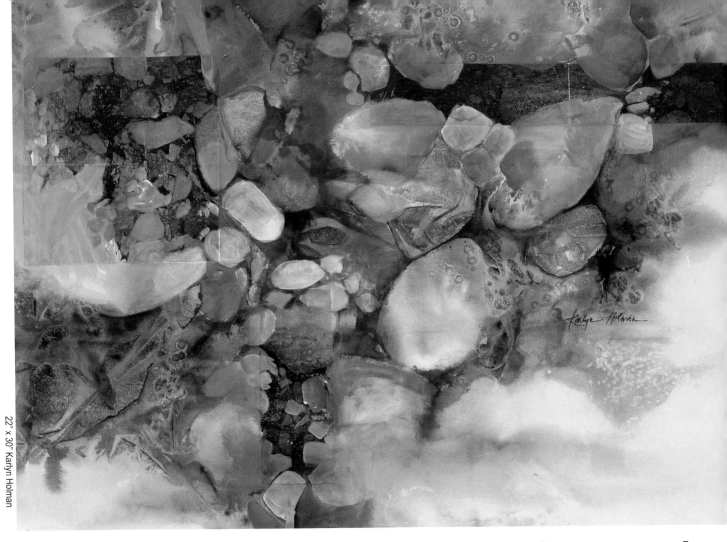

# Starting with an inspirational photograph

You never know where or when inspiration might suddenly appear. That is exactly what happened while I was sorting through my photographs from a trip to Spain and came across this photo of a marble pillar. The colors and rock-like shapes of the composition intrigued me, so I took the photograph and copied and enlarged it several times on a laser printer. For the techniques used in this painting, a laser image was necessary because laser copies are polymer plastic and, therefore, are waterproof. Ink jet images will dissolve in water. I cut the laser photocopies into a variety of shapes and glued them down with matte medium. I wet the paper and began a wet-into-wet underpainting, using transparent acrylic paint and later finished the work on dry paper with opaque color.

Try finding an inspirational photograph, one with colors or shapes or unique elements that appeal to you. Make several color copies of the photo so you can cut and repeat some of the shapes or colors. Move the images around on the picture surface until you are satisfied with the composition and then glue them down. Use Yes! Paste™ (pages 13 and 157) if you are working with watercolor and matte medium if you are working with acrylic paints.

# Reinterpreting a familiar subject

*Butterflies as a subject are a bit cliché; we see them on refrigerator magnets, napkins, towels—everywhere. The concept of painting butterflies seemed too "common" to become involved with, so I ignored this subject for years. My lofty attitude was changed when a beautiful, perfectly intact butterfly appeared at the doorstep to my studio.*

*I picked up this incredibly beautiful object and was absolutely overwhelmed by the colors. The next day, another perfect butterfly was lying by my car door. I decided that the spirit world was reaching out and maybe I should reconsider my lofty attitude. I realized how expressive and intriguing these creatures really are and how they lend themselves to the exploration of unlimited patterns, colors and textures.*

*My mother loved and collected butterflies all her life. After my mother passed away, I found that painting these beautiful creatures was a healing way for me to rediscover the beautiful spirit of my Mom.*

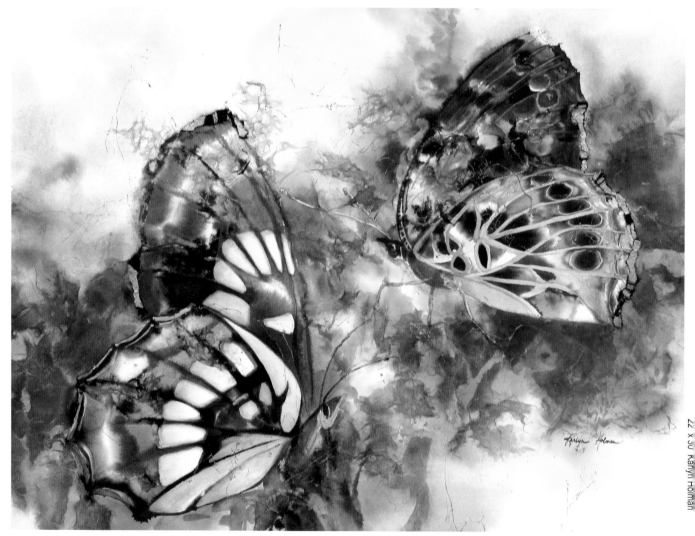

22" X 30" Karlyn Holman

This painting started with a wet-into-wet underpainting. Color was freely added and while the color was wet, ten-gram white Thai unryu paper was pressed into the paint.

After the underpainting dried, these papers were glued into place with thinned-down Yes! Paste™ (pages 13 and 157). More collage papers and paint were added to finish the painting.

I began drawing idea sketches. The more sketches I made, the more I became intrigued with painting this subject. Each painting inspired another painting and pretty soon, I was working in a very dedicated series. First, I worked only with watercolor and collage on Arches® 140# cold press paper. Combining watercolor with collage seemed like the perfect marriage for this subject.

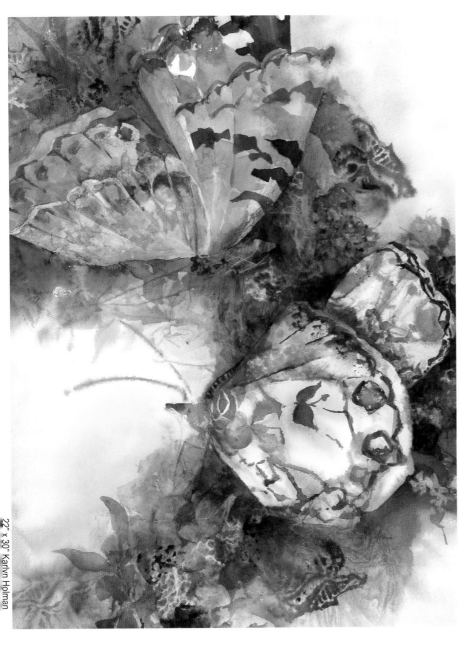

22" x 30" Karlyn Holman

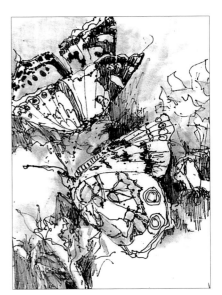

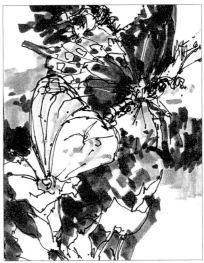

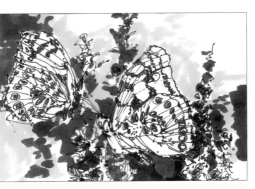

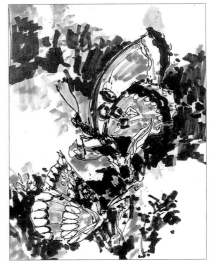

Then, the collage paper itself became an obsession. I started to collect papers with metallic textures and vibrating colors. I could almost paint the butterflies with the paper alone. This photo shows some of the papers that really intrigued me:

- My favorite, a paper with strings in it called Lace with Threads (made in Thailand)
- Marble (made in Thailand)
- Momi (made in Thailand)
- A lacy paper called Ogura (made in Japan)

These various paper surfaces not only added color and texture, they added mystery and intrigue. Once you decide on the paper and colors, you are ready to give flight to your butterfly. Glue these papers using Yes! Paste™ (page 157).

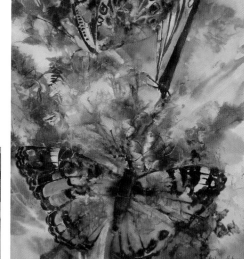

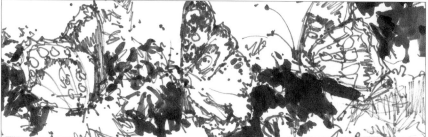

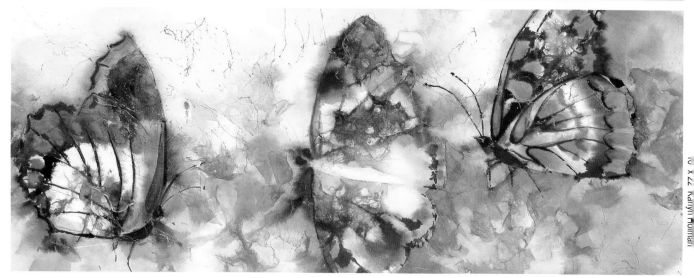

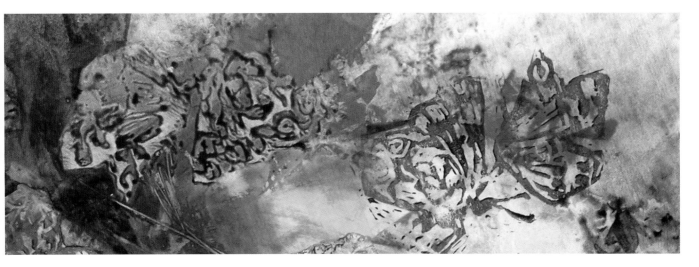

As this butterfly series evolved, I found myself exploring the use of acrylics and the effects of stamping to enhance my interpretation of this subject. The shift into acrylics also moved the paintings into a more abstract form.

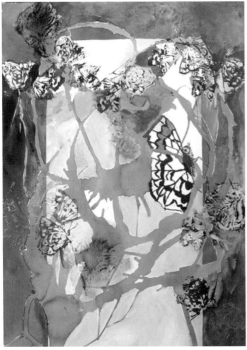

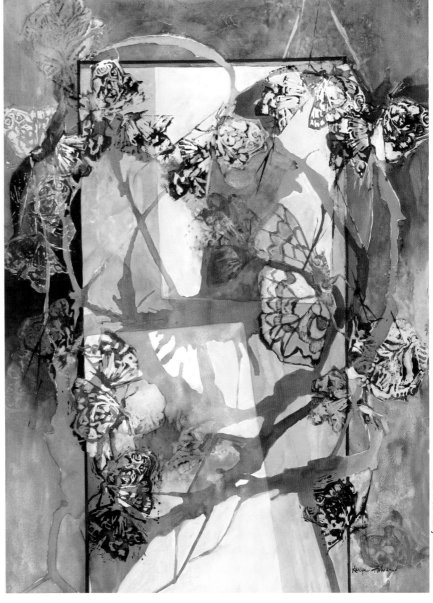

When working on this series, my goal was to give myself permission to explore acrylics with as much variety as possible. Acrylics allowed me to use transparent and opaque washes of color. When my image became too busy, a wash of thinned-opaque color would solve the problem by adding a veil of soft light color. Stamping with opaque color also added the visual contrast I needed to finish the paintings. I felt that my time spent experimenting was an invaluable learning experience.

22" x 30" Karlyn Holman

# Stamping–an ancient technique revisited

22" x 30" Karlyn Holman

Stamping is an art form that goes back thousands of years to ancient Chinese times. Originally stamps (or seals) were only used by royalty. Today, stamping has become a popular art form. Chinese artists frequently use stamps to sign their paintings.

Many artists use stamps to add visual excitement and to enrich their paintings. Stamping is a fabulous way to make marks on your paper. The term "rubber stamp" infers that you are going to imprint the same thing over and over. Actually, you can use a single stamp in an incredible variety of ways. You can start with a few marks, move the stamp around, turn it upside down, change the color or change the pressure, thereby creating an entirely different look each time. Start a collection of stamps and on days when you looking for inspiration, these stamps can save the day. Return to the playful child within as you stamp and design shapes into a free-flowing composition. Explore the art of stamping and you will discover exciting and unintentional bits of inspiration.

Stamping is such a popular hobby that interesting and beautiful stamps are available everywhere. Found objects also may be used as stamps. Look around your environment and see if you can find some object that will make an interesting mark. Experiment with leaves, mushroom tops, shells, pine needles and other things found in nature.

Stamps also can be made from many household items. For example, try using a potato, an eraser, a sponge, a wine cork or soft linoleum. All you need to carve out an image is an inexpensive lino cutter found in hobby stores. Draw the image you desire on your chosen surface and cut away the negative shapes. You can also use the tool as a line instrument and directly cut into the linoleum to create linear designs.

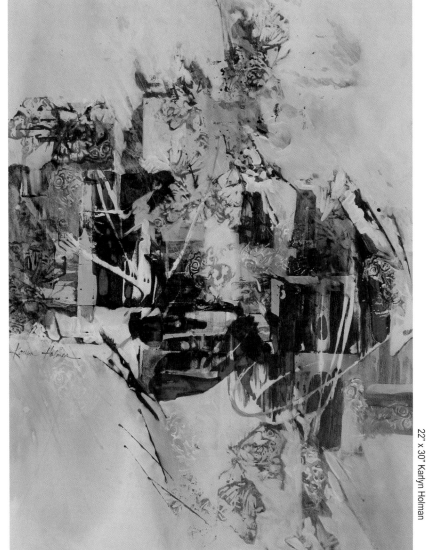

22" x 30" Karlyn Holman

Stamp from a cork (page 155).

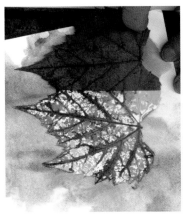

Stamp from a leaf (page 155).

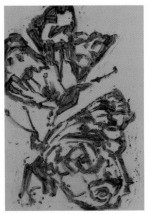

Marker drawing on linoleum block.

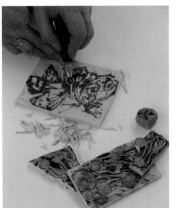

Cutting a linoleum block with a "V" shaped cutter.

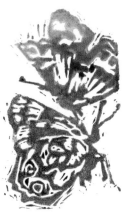

Watercolor stamp

# Celebrating prehistoric art

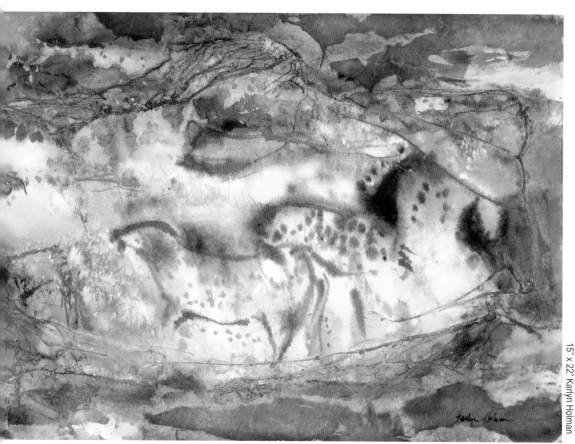

*My first introduction to cave paintings was in southwestern France at the Pech Merle caves. When I descended underground and viewed the actual paintings for the first time, I experienced an intense feeling of déjà vu and a strong personal connection with those images. This experience inspired me to begin a whole new body of work studying and interpreting cave paintings.*

15" x 22" Karlyn Holman

This painting was inspired by a visit to the Pech Merle cave in Southwestern France. The realization that these drawings were made 24,000 years ago is awe-inspiring. This incredible cave has been called an art gallery in a palace of nature.

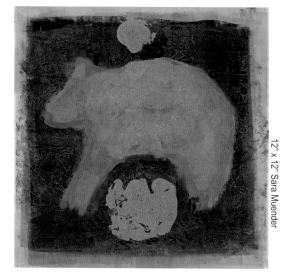

12" x 12" Sara Muender

*"Yogi, B.C"*. Sara Muender created this monotype, a one-of-a-kind image created by painting oil-based inks directly onto a Plexiglas plate and transferring the image with a press to Stonehenge 100% rag printmaking paper. Copper inks were then applied with a palette knife.

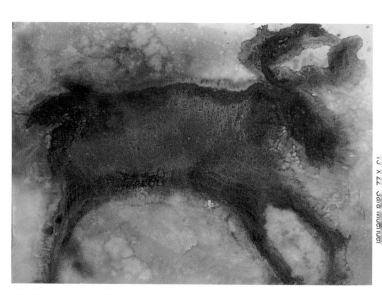

15" x 22" Sara Muender

*"Bullwinkle, B.C"*. Sara Muender created this humorous and yet mysterious watercolor interpretation of impressionistic cave art using Arches cold pressed paper.

# A modern day interpretation of a cave painting

Reinterpreting the art of our ancestors is a great lesson to explore with young children. I have shared this idea with many young artists and the resulting paintings are marvelous. The joy children experience as they apply color freely on the surface of the paper is reflected in the naïve, fresh quality of their work. In sharing this lesson with children, I find that not only are their results fantastic, but the symbols they create are instinctively similar to those used by prehistoric people. As I continue to research prehistoric art, I find that the primal marks and symbols used by children bear an uncanny resemblance to those used by their ancestors.

Begin the painting by spraying black lines with webbing spray on a dry surface (page 157). If you spray the lines on a wet surface, the lines will expand and form thicker lines. Similar to our prehistoric ancestors who saw animals in the configurations of the rocks, the children discovered animals in the lines created by the webbing spray and began to add their own primal marks, reflecting an instinctive connection with our ancestors.

Wet both sides of the paper to allow more time to play with colors, shapes and textures. By keeping the center area lighter in value, you will set the stage for a center of interest. Select earth colors like burnt sienna and raw sienna and allow them to mingle on the wet surface. Add a cool color, such as cobalt blue, to gray the wet mixture.

Consider adding gauze for more linear effects (page 154).

Waxed paper placed over the wet surface creates rock-like textures.

Now, add more color and tip the paper so the color will run under and around the waxed paper and the gauze. Salt will create the eroded textures you see on the walls of the cave.

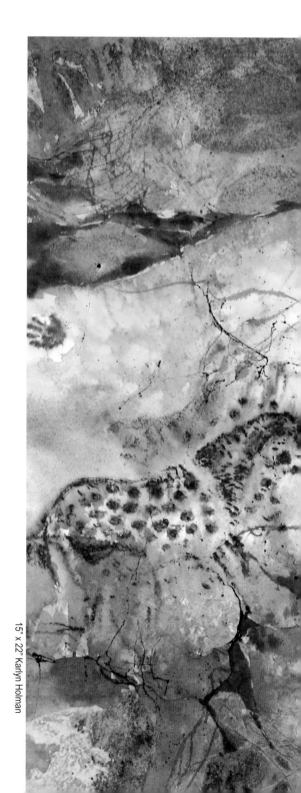

15" x 22" Karlyn Holman

Now, imagine yourself in a damp, dark cave and begin to visualize the textures, shapes and patterns created by the elements of nature. The walls are leaking, the rocks are crumbling, and the evidence of living creatures past and present is everywhere. Tip your painting and allow the colors to bleed. Add more color and allow it to run under the waxed paper and into the gauze. Never in my wildest dreams did I imagine that I would find inspiration from a past culture in a dank, dark cave. The joy I find in the celebration of the past, present and future all coming together in this linear style is a complete surprise.

With masking

Without masking

The little handprints were stamped on dry paper using a craft store rubber stamp. By stamping masking with the handprint, you will save the white of the paper and create a stencil effect when you paint over the dried masking. Color sanding (pages 86 and 153) was added for textural effects. I used colored pencils to draw some of the images and simply drew in others with a script brush loaded with rich paint.

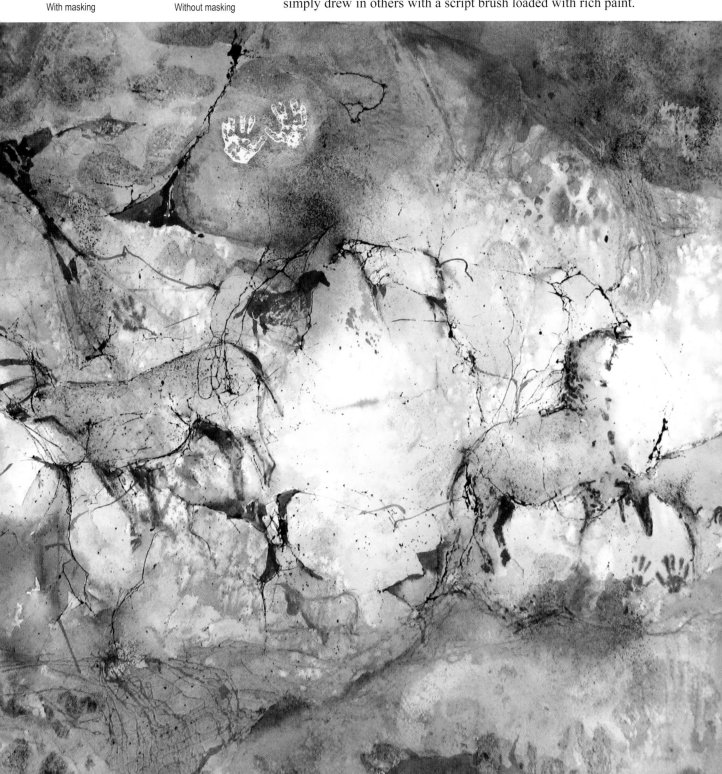

# Understanding Compositional Elements of Design

As artists, we need to create a compositional structure in our paintings, whether they are abstract or realistic, using the elements of line, color, value, movement and shape. Usually one or more of these elements will dominate the composition. This chapter presents a series of ideas that focus on one or more of the elements of design to help you find direction in your search for a fresh and spontaneous interpretation of your subject. While these ideas may provide you with some specific techniques, they are intended to act more as a catalyst to help you develop your own personal style. You still need to go beyond the suggested formats and express your feelings—use your intuition—take risks, and above all, have fun. Think about what you want to project in your painting. What design elements will send this message? What colors will convey the emotion you want to express? Should your shapes be organic or geometric? Do you want to express the essence of a subject or a revelation from your mind's eye? These lessons are designed to inspire or challenge you and once again should be used as a departure point for your own creative journey. Open your heart to working intuitively and spontaneously.

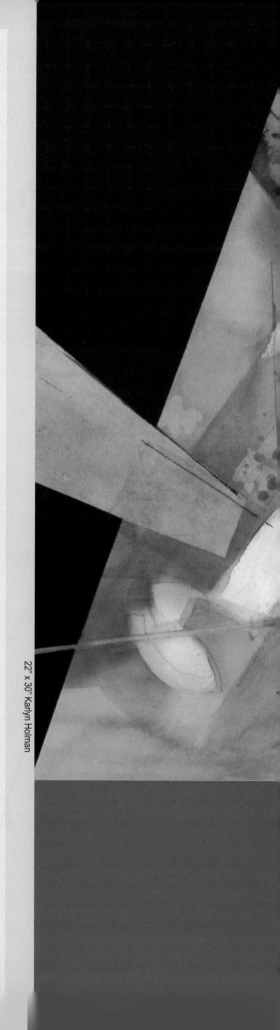

22" x 30" Karlyn Holman

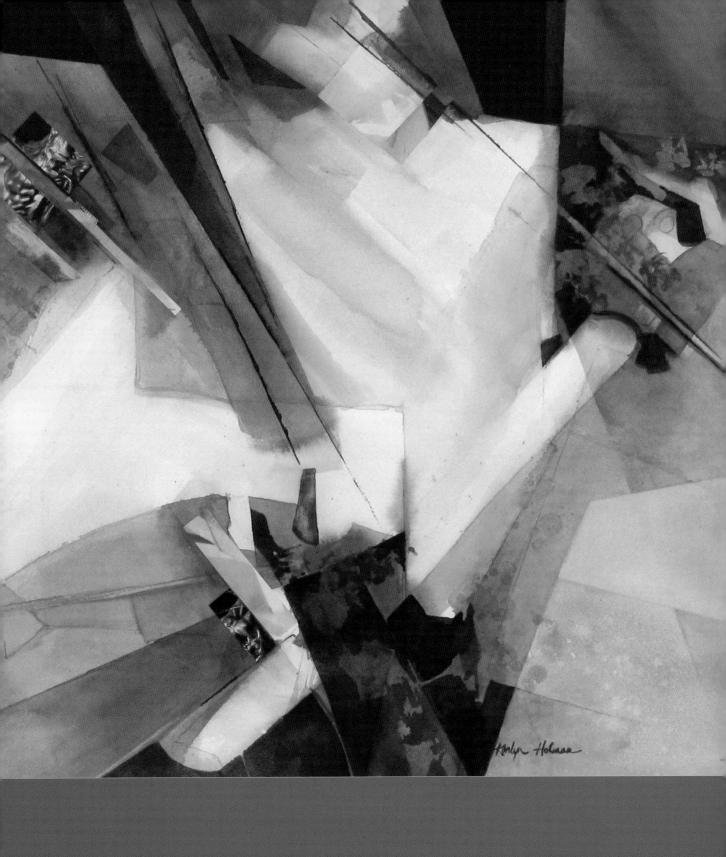

# Starting with a cruciform composition

*A cruciform composition is the old tried and true grid organization. This grid-like compositional tool adds order to any painting. It is the cross-like shape that gives your painting overlapping and intersecting lines of movement. Where the lines intersect, you create tension and drama.*

*As the artist, you have to make choices and it is essential that you choose a major directional movement. Taking the time to plan and formalize these lines of movement provides you with a solid departure point and gives you the confidence to spontaneously add color to paper.*

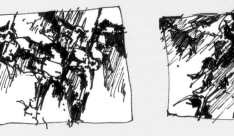

Because the cruciform composition is so reliable, it is easy to fall into a "success binge" and use the same design over and over again. To avoid repetition when using a cruciform sketch, try finding patterns in action photographs. Such photographs lend themselves to a wealth of new patterns that you may not have discovered on your own.

This sketch started with lines of movement in a grid style. The black shapes were added and then a 30% gray was added to create a three-value design sketch. These sketches empower you to paint in a spontaneous and confident way. This is the value-study used on pages 76-79.

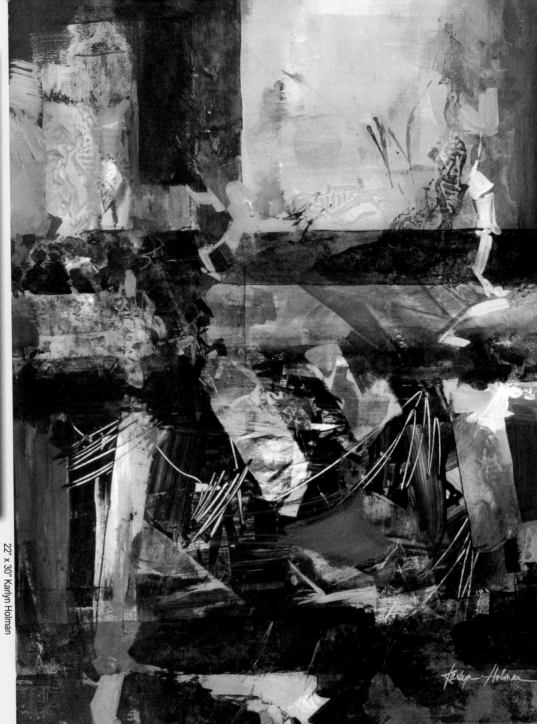

22" x 30" Karlyn Holman

This painting happened very spontaneously. Using liquid acrylics, I randomly squeezed color directly onto dry Arches® 140# paper. I also squeezed out matt medium in the same random manner to form the whites. Using a three-inch putty knife and light pressure, I pulled the knife through the colors and watched as the colors filled the page. My final death-defying act was to scratch in lines through the wet paint. Even though this painting has very static lines of horizontal and vertical movement, the overall feeling projected is very emotional and full of energy.

# Ending with a cruciform composition

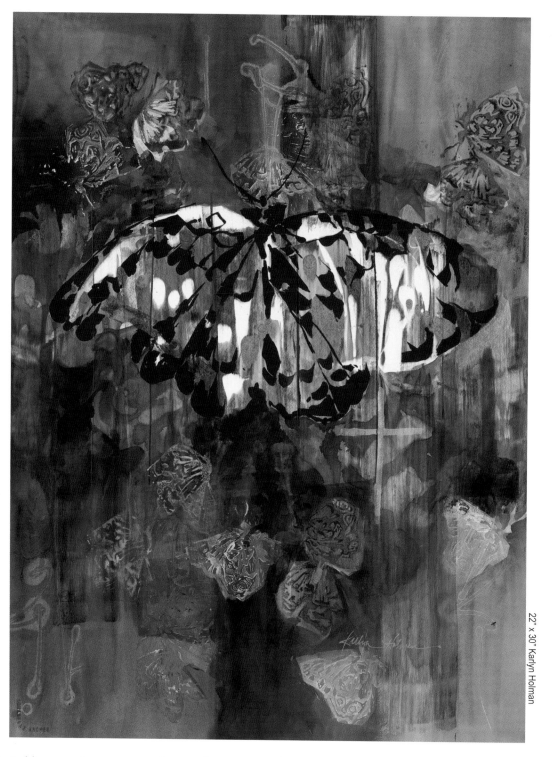

22" x 30" Karlyn Holman

A painting started in a spontaneous way often needs structure to pull it together. This butterfly happened quite by accident as I spontaneously squeezed liquid acrylic paints onto the surface of Arches® 140# cold pressed paper. I used a three-inch putty knife to draw through the paint and smooth out the colors. The suggestion of a butterfly appeared in the center of the painting, and by designing in some dark shapes, I was able to bring forth a butterfly image. To interweave the image with the background, I created an asymmetrical pattern of dark shapes behind the butterfly. The use of complementary colors simultaneously created tension and harmony. The stamping added a whimsical touch to a rather static cruciform composition.

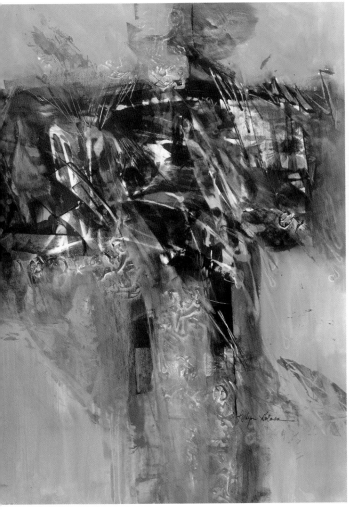
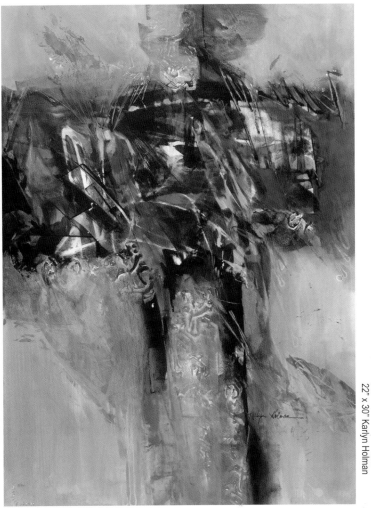

22" x 30" Karlyn Holman

I often keep paintings in a sacred pile, hoping that someday some magical inspiration will turn them into something wonderful. I think of these paintings as "incubating" and never think of them as failures. I have already put so much of myself into these pieces that maybe, after a rest, an inspiring moment will come along and help bring them to completion. This painting underwent many transformations, but finally came together when some areas were covered by an opaque blue and the bright areas were glazed with a warm transparent color. The bright colors were fighting each other and needed to be subdued. By glazing acrylic and watercolor over these bright areas, the painting became unified. Glazing a warm color over all these colors is the same technique used by fabric artists when they place yarn, thread or fabric into a common dye bath. Using a common denominator of color creates a harmonious effect.

# Finding a path of light

*A path of light shapes glowing from within your painting will structure your composition and form the basis for an exciting painting. This lovely painting by Susan Luzier was designed with a focal path of light as a primary motif. The subtle colors evolved as she layered many colors over this path of light (pages 138-141).*

*This series of lessons will show three approaches to help you find a path of light through your compositions. The first demo is a planned approach working from a reference. The second demo illustrates a random approach. The third demo is an intuitive, meditative approach by Bonnie Broitzman. Hopefully, these demonstrations will be helpful to you as you discover the importance of creating a path of light and moving energy that will help lead the viewer's eye through your composition.*

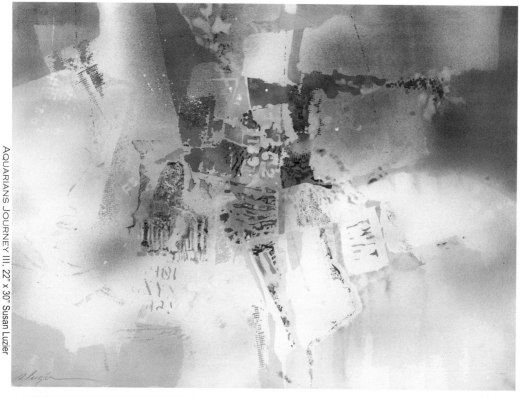

AQUARIANS JOURNEY III, 22" x 30" Susan Luzier

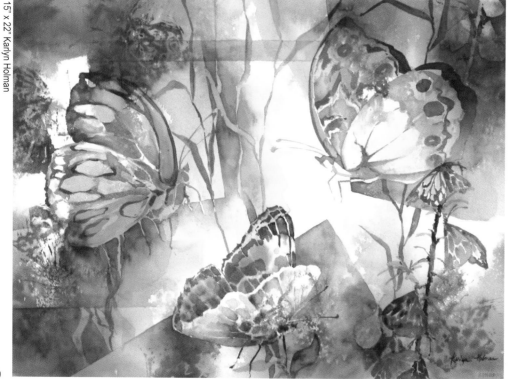

15" x 22" Karlyn Holman

This butterfly painting started as an abstract composition with a strong pattern of lights. The butterflies were designed to interlock with the composition by being partly in and partly out of this most important path of light.

# The planned approach

Look for the pattern of movement in a photo and document the shapes. This quick value study is an important design strategy to start your painting. By separating yourself from the realistic image, you are free to interpret your painting in a more spontaneous way. If you take time to plan a major movement of light shapes through your composition, you can be assured that your painting will have good structure. By looking at the pattern you have created and not the photo, this path of light will glow and vibrate throughout the entire painting process. Here are some suggestions to arrive at this value study.

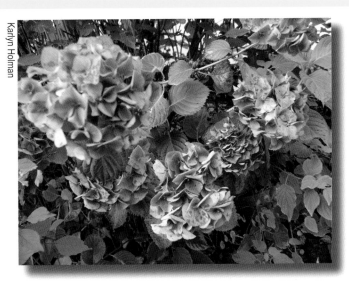

Karlyn Holman

Computer generated black and white

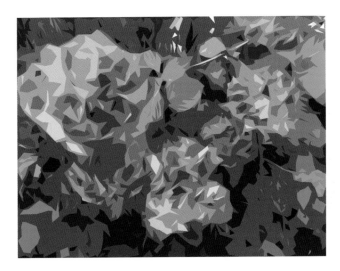

Computer generated with Adobe® Photoshop® "Cutout Filter"

Computer generated with Adobe® Photoshop® "Halftone Pattern Filter"

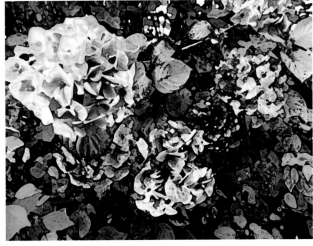

Computer generated with Adobe® Photoshop® "Fresco Filter"

61

This pen sketch drawn with a black marker and a 30% gray value marker created a three-value plan of the major configurations of light, mid-tone and dark shapes (page 76).

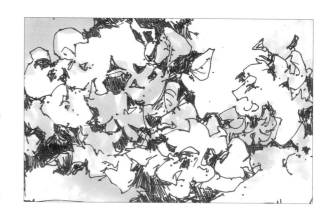

I. To begin, sketch your shapes on the paper. Wet the paper on both sides and begin circling your painting three times with your analogous colors. To guarantee a successful beginning for your painting, only allow harmonic colors to touch each other as you circle your paper. By always working in harmonic or friendly colors, you will not create any "mud" and the pure colors will resonate. As I circled the paper I used Winsor yellow; quinacridone gold, quinacridone coral and Antwerp blue.

2. Paint around the drawn shapes and allow the color to move on the surface. Determine the relative values of the colors you have chosen. Antwerp blue was my darkest value, so I used that color where my sketch had dark values. Winsor yellow, quinacridone gold and quinacridone coral were used to interpret my lighter values. In order to create a glowing and unified underpainting, always be sure the analogous, friendly colors are touching one another.

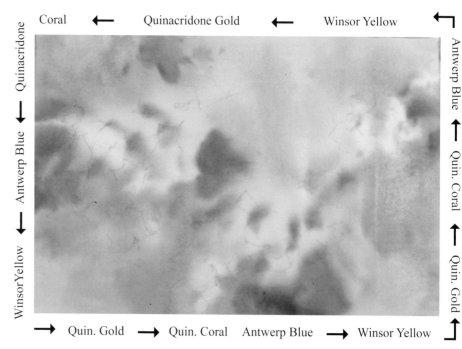

3. Lift away any color that may run into your white areas using a thirsty brush technique (page 156). Wet a stiff, flat brush with clean water and wipe away the excess moisture. With this slightly damp brush, lift away the color that has run into your white shapes.

4. You can use real leaves to stamp leaf shapes on your painting (page 155). Apply paint to the back of the leaf, place it on your painting and do not remove it until the underpainting dries.

5. Add 10-gram Unryu paper to form your dark patterns (page 153). The unryu will absorb the color and become quite dark. A variety of papers may be added to create texture. Spray these additions with your fine mister so they will absorb the colors and become the mid-tone shapes.

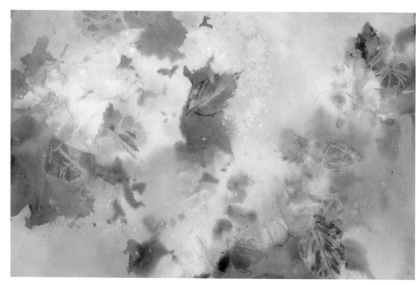

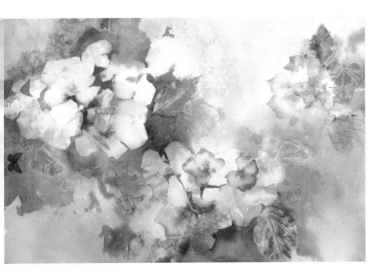

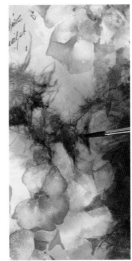

6. When the underpainting dries, remove the leaves and glue the collage papers in place with Yes! Paste™ (page 157).

*Using harmonic colors to create a glowing underpainting*

7. Design negative dark shapes around the light hydrangeas.

8. Against the light background, use dark values for the hydrangeas to emphasize their presence.

9. Finish the painting with the "push and pull" of negative and positive shapes, adding more collage paper if desired.

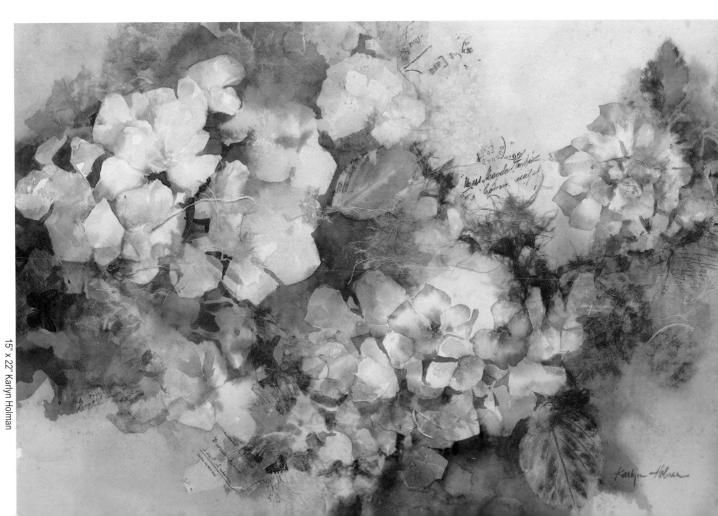

15" x 22" Karlyn Holman

# Path of light—white flowers

I began this underpainting using the harmonic colors of Winsor yellow, quinacridone gold, quinacridone coral and Antwerp blue. A sequence of these harmonic colors was repeated three times around the painting surface. While the paint was wet, 10 gram Thai, white unryu paper was pressed into the dark colors to form a dark pattern of movement (page 153). I used a fine mister to facilitate the absorption of color into the unryu paper. I next added color to the back of actual leaves and stamped them unto the surface (page 155). Salt was added in the light areas and the painting was allowed to dry. I removed the leaves and salt and glued the unryu paper in place with thinned Yes! Paste™ (page 157). I finished the piece with positive and negative painting to bring out the contrast between the lights and darks.

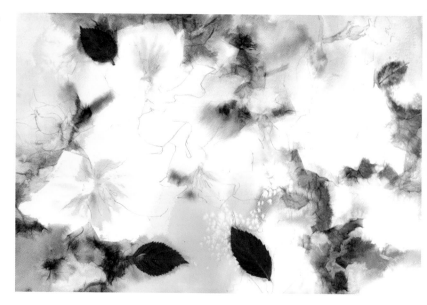

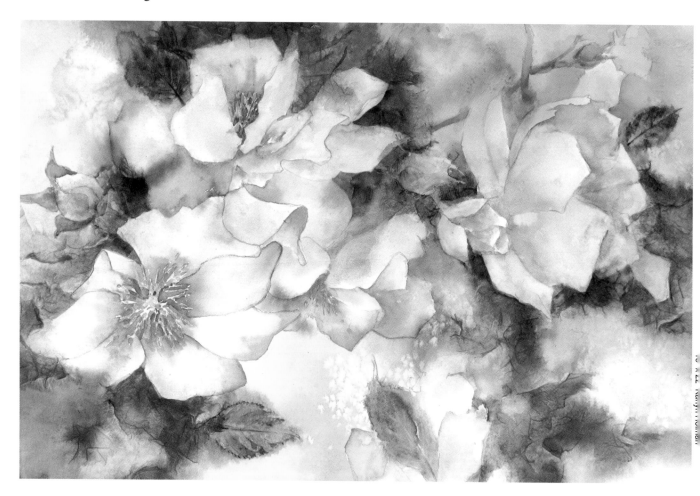

# Path of light—dark flowers

These flowers were painted in southwestern France during the peak of the spring poppies. The photo will give you some idea of the profusion of these flowers growing by the roadside. The wet-into-wet underpainting set the stage for the out-of-focus poppies and lupines. Manganese blue, aureolin yellow and permanent rose were used in the wet wash because these colors do not move much on a wet surface. The white shapes saved in the underpainting later became the red poppies.

I painted the poppies on dry paper. Each flower shape was selectively wet and color was added. Aureolin yellow, scarlet lake and permanent rose were chosen because these colors move very little on a wet surface and create a distinctive separation of yellow, orange, and red in the poppies.

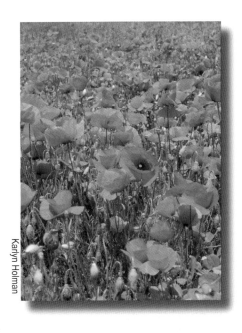

Karlyn Holman

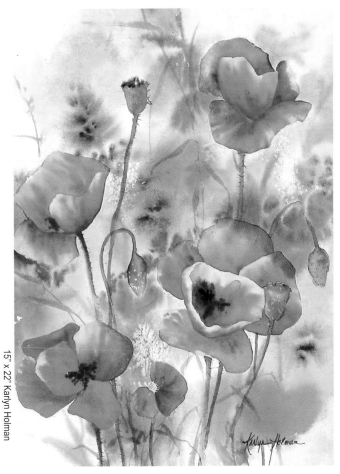

15" x 22" Karlyn Holman

65

# The random approach

Working from a photograph can be very limiting. Using a random approach can be a way of challenging yourself to try something unique. When you work from your own doodles, often you will find yourself repeating the same patterns of light movement over and over again. Finding a "perfect pattern" is very exciting, but consider breaking out of your success binge and pushing yourself in a new direction. My friend, Joyce Gow, a Minnesota artist, actually discovered this intriguing approach.

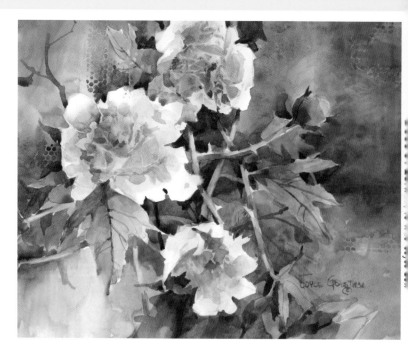

I. Close your eyes and randomly drop tissues onto the dry surface of your paper to form a white path of light through your painting.

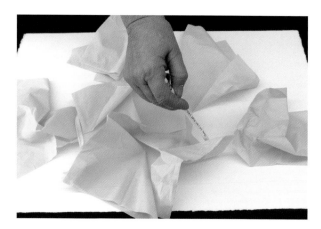

2. Make a quick sketch around this white pattern with a pencil.

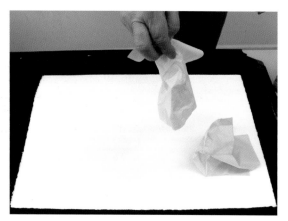

3. Remove the tissues and wet both sides of the paper. For this demonstration, I am adding color in the areas around the path of light using Winsor yellow, quinacridone gold, quinacridone burnt orange and permanent magenta.

4. While the paint is still wet, add plastic wrap to create random textures (page 154). Salt may be added in the light areas for transitional white shapes. When the paint dries, remove all the texturizing agents.

Close-up of the plastic wrap.

The painting with all the texturizing agents removed.

Close-up of salt.

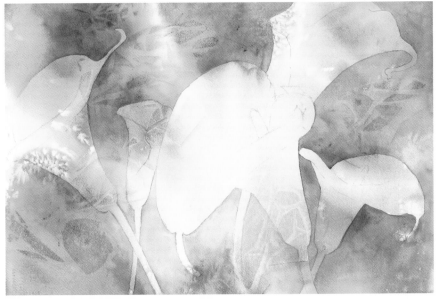

5. Examine your painting and look for images suggested by the light patterns. Once you decide on an image, begin to block in the large shapes.

6. Add final details on dry paper, remembering that less can be more. Try this approach using a variety of colors and texturizing agents. When you experiment with this random approach, you never know what exciting images may appear.

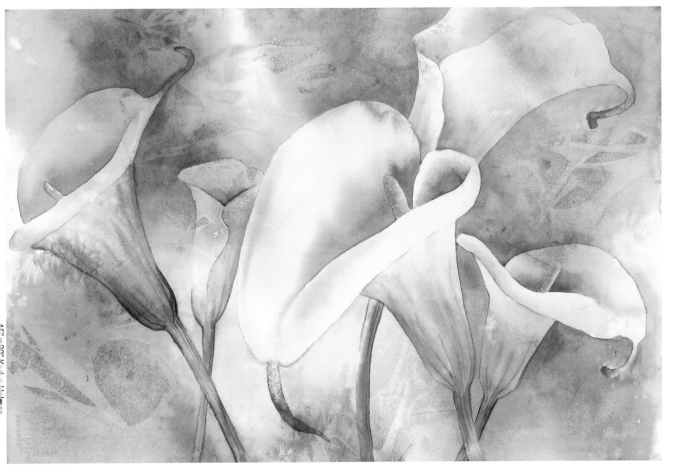

# Random Daisies

This painting illustrates another very spontaneous and yet challenging exercise designed by Joyce Gow. She drops random daisy centers onto her paper, using a large, round brush that is fully loaded with a rich mixture of paint. As the paint "splats" onto the paper, the magnificent centers are formed. Be patient waiting for the centers to finally release from the brush. The paint needs to develop into a large blob and drop when it is good and ready. The higher the brush is held, the better the "splat". The fun begins when you design a painting around the positions where the centers land.

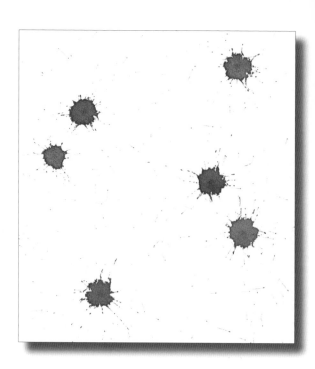

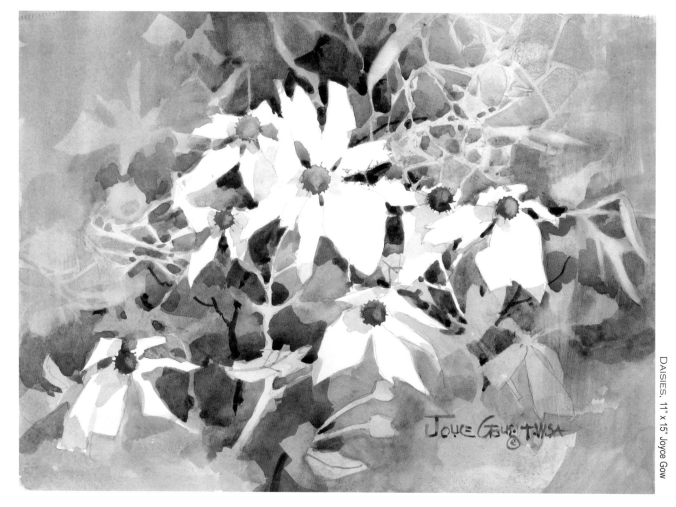

DAISIES, 11" x 15" Joyce Gow

The layers of skillfully designed negative painting are very obvious in this beautiful interpretation of daisies by Joyce Gow. The dark shapes behind the white flowers link gracefully to the edges of the paper. She created a three-dimensional quality by adding a delicate shadow under each dropped center and created the lovely fragmented shapes by using plastic wrap in the underpainting.

# Using gum arabic for a resist

*Pauline Hailwood, a New Zealand artist, painted these pears. Instead of using masking fluid, she uses gum arabic to save the whites and adds india ink for the darks. The combination of these two unusual materials, along with her choice of pigments results in exciting textural effects.*

Gum Arabic is an edible, natural substance used in the art world as a binder for our paint.

1. Draw your image using contour lines. Brush a thick mixture of gum arabic onto the positive shapes. Apply watercolor and generous amounts of india ink to the negative areas. Do not fret if the color moves over the areas with gum arabic. Allow the painting to partially dry and then gently run water over the surface. Most of the paint on the gum arabic will wash away.

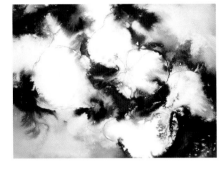

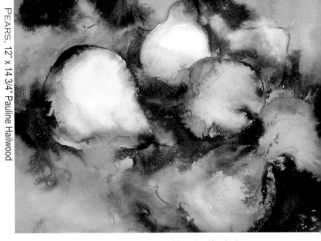

PEARS, 12" x 14 3/4" Pauline Hailwood

2. Continue to layer more colors to develop the positive and negative shapes in your painting.

3. Finish by adding darks and/or india ink as needed.

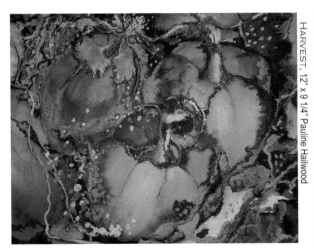

HARVEST, 12" x 9 1/4" Pauline Hailwood

This mixed media interpretation of fall vegetables illustrates luscious contrast between the watercolor and the oil pastel enrichment. The playful shapes and lost and found edges help lead the viewer through the painting.

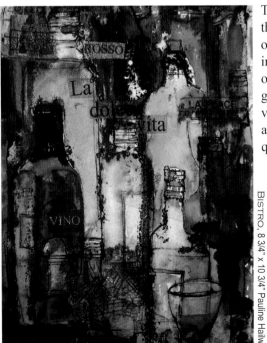

BISTRO, 8 3/4" x 10 3/4" Pauline Hailwood

The interplay of the dark ink and overlapping shapes in this collage of bottles and glasses projects a very spontaneous and entertaining quality.

# The meditative-intuitive approach

*Bonnie Broitzman is an accomplished artist who enjoys the spiritual experience of trusting the paint to reveal her inner voice through the use of line, shape and color. The fluid, free-flowing nature of watercolor is the perfect media for expressing her love of nature and the creative process.*

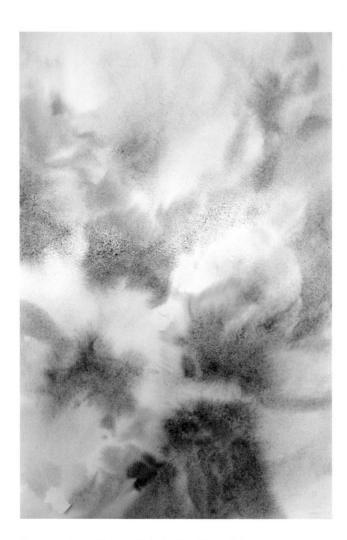

Bonnie started by wetting both sides of the paper to extend the time it takes to develop a sense of light and dark passages. Her own spiritual energy is expressed in the playful rhythm between the warm and cool colors.

At this stage, the dual themes of flight and roots became evident. Bonnie began to focus on the details so the viewer could enjoy the painting close up. She worked primarily in mid-tones to establish the shapes. She used the technique of wet line drawing to add soft white lines in the composition. She also used the thirsty brush technique to lift out larger white shapes.

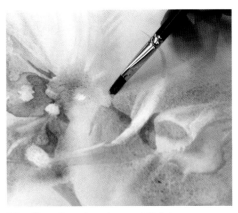

Wet line drawing (page 157) is accomplished by using a clean brush loaded with clean water and drawing directly into the wet surface to create soft lines. The additional water actually creates a miniature "bleed back."

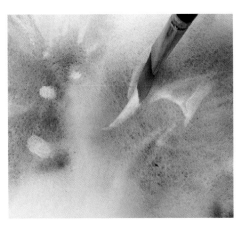

Lifting color with a thirsty brush (page 156) is a perfect way to create the delicate, flowing, and organic light areas in the painting.

Lastly, Bonnie concentrated on painting darks and developing negative shapes on the dry paper. The duel themes of flight and roots eventually surfaced through the meditation.

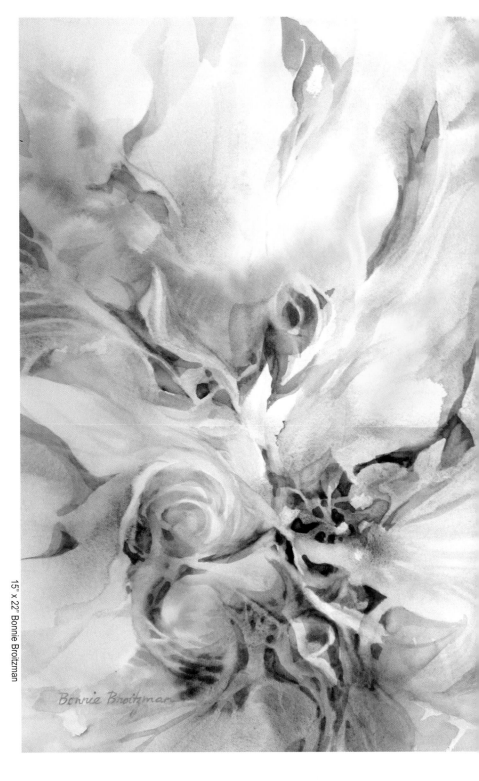

15" x 22" Bonnie Broitzman

*In Bonnie's own words: "As the theme of flight and roots became evident, I visually connected images that could be seen as opposites. Roots connect people to their place on earth, but the whole of earth rotating in a nourishing heavenly space, is common ground to all."*

# Flowering Peace

The natural beauty of flowers inspires artists and provides an endless variety of shapes and colors. Bonnie's ability to spontaneously bring forth a radiant visual bouquet comes from many years of painting flowers realistically.

In this painting, Bonnie artfully expresses her personal interpretation of the abstract concept of "peace."

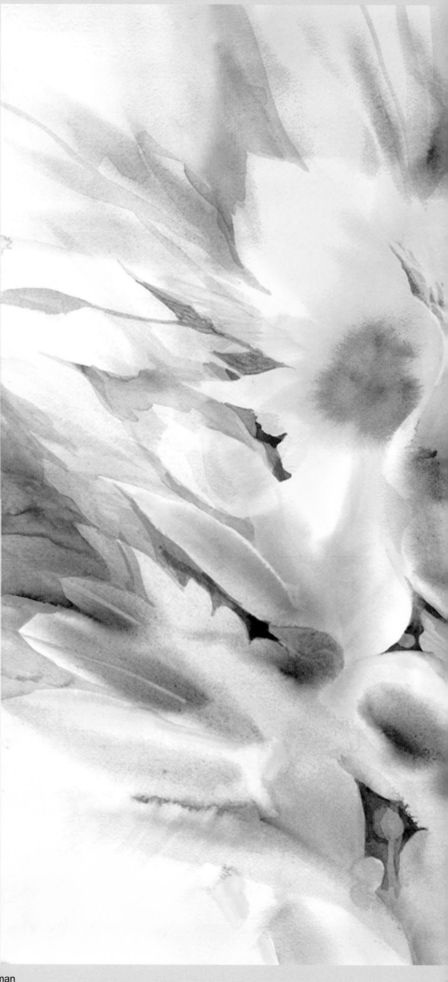

22" x 30" Bonnie Broitzman

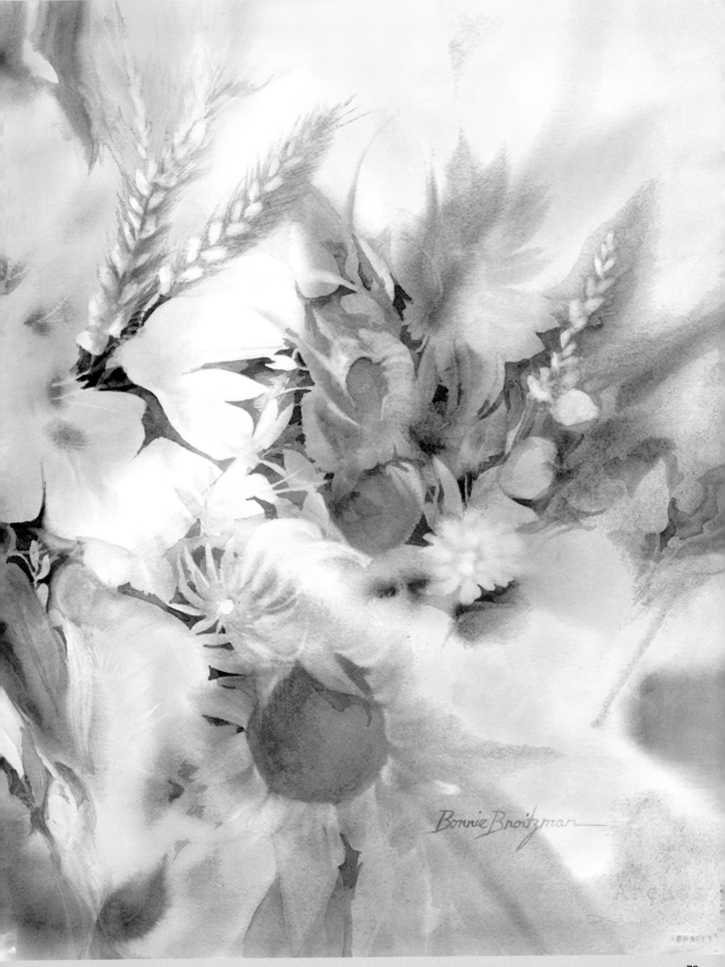

Bonnie Broitzman

# Universe Series

*The intensive study required to become a spiritual director became the creative impetus for these five full sheet watercolors. Working in a series allows an artist to investigate a larger theme. In these meditative experiences, Bonnie let go of any expected outcome and let the images come forth. This reflective style of painting is a type of prayer time, both mentally and emotionally. The following interpretations of each painting are in Bonnie's own words.*

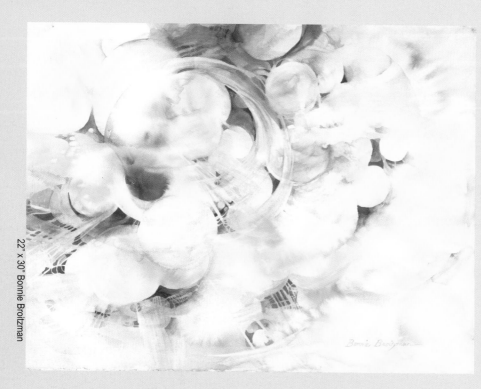

22" x 30" Bonnie Broitzman

COSMIC NIGHT SKY posed a huge challenge as I attempted to paint my view of the universe on the limited space of my watercolor paper. To express the quiet beauty of thousands of spherical bodies suspended in space, I used transparent hues that allowed the extra-white Arches® paper to glow as if lit by an invisible source. The planetary shapes fold and unfold into and out of each other, overlapping as if they could be seen by the naked eye-through billions of miles of open space. For the center of interest (the upper left quadrant), I attempted to capture an image of a womb, as a metaphor for the developing potentiality of the cosmos' first billion years of history.

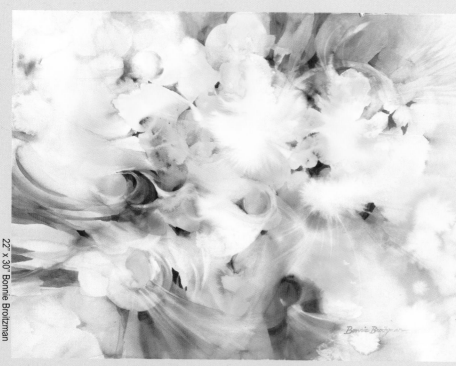

22" x 30" Bonnie Broitzman

COSMIC DAY, unlike the quiet of COSMIC NIGHT SKY, pulsates with staccato movements and spontaneous eruptions. I envision the primordial stages of life on Earth billions of years ago like an awakening event reminiscent of springtime, bringing forth life as a response to the sun itself. I complemented the warm earth-orange pigments with swirls of cool sea-blues simulating the moist, fluid and elemental nature of water lapping against the sand.

For LOVE ONE, I chose the primary colors (yellow, red and blue) to illustrate the abstract concept of the loving and generative energies that come together on the creative journey toward new life. Through the use of flowing and interwoven shapes, I had hoped to illustrate how we are all connected at this primary and universally beautiful experience.

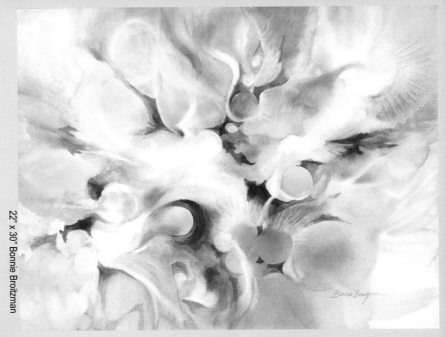

22" x 30" Bonnie Broitzman

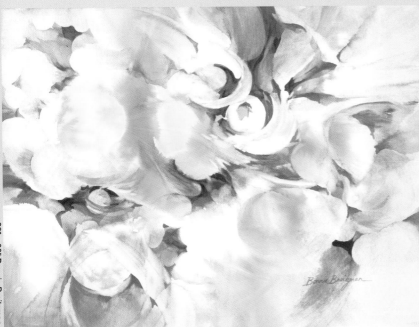

20" x 20" Bonnie Broitzman

In LOVE TWO, the secondary colors (orange, green and purple) are perfect for depicting new life after conception. The gift of the painting experience as a meditation was my little fetus-self (lower right quadrant). I had not intended to paint myself into this painting, but like being here in the world it happens through the generosity of others.

22" x 30" Bonnie Broitzman

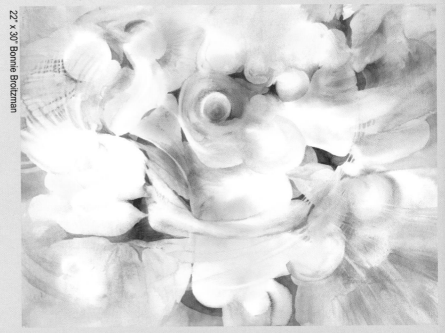

In LOVE THREE, like the planets and stars, the circle creates a perfect metaphor for any unit of life. After birth, each new life exists among others. I intended the center-of-interest circle to represent any individual who is separate and yet still universally connected to all. By using all colors, I have attempted to echo a larger more cosmic design.

# Planning your painting with values

*Consider starting your painting by establishing a planned pattern of values ranging from light, to mid-tone to dark. Using such a plan allows you to be free and spontaneous during the actual painting of the piece. These value studies only take a short time to do, but provide invaluable inspiration when you are facing that white sheet of paper.*

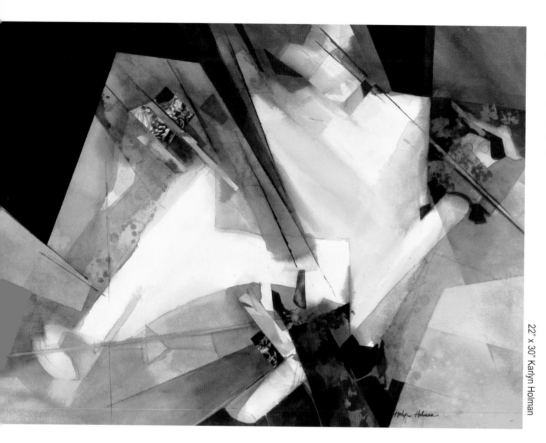

*This painting on cold press paper represents three distinctive value patterns with several very dark shapes anchoring the entire piece. The dark shapes lend emotional impact to the final composition.*

22" x 30" Karlyn Holman

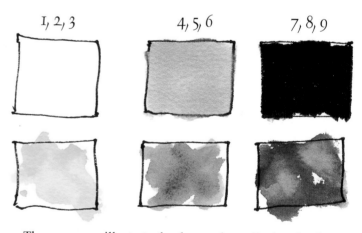

I, 2, 3      4, 5, 6      7, 8, 9

Starting your painting with a sketch will give you the confidence to use color freely. The information on cruciform composition (page 56) was helpful in designing this three-value sketch.

These squares illustrate the three values. Each value has a harmonic enrichment of two additional values. Select colors that are appropriate for these values and you are ready to start your underpainting with complete abandon.

For the white square (1-2-3 values), I began with Winsor yellow and then added a light version of quinacridone gold, while saving some white of the paper.

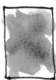

For the gray square (4-5-6 values), I started painting the shapes with quinacridone gold and then enriched the shapes with quinacridone burnt orange.

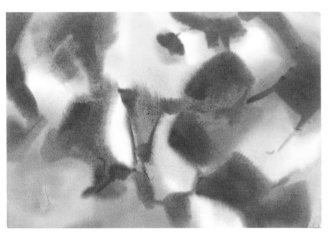

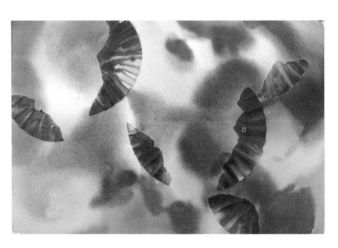

For the black square (7-8-9 values), I started painting the shapes with permanent magenta and then enriched the shapes using alizarin crimson. As you apply the colors, be sure to use your fine mister to keep the paper wet.

Now is the time to create textures and transitions between the light shapes and the dark shapes. Textural agents, such as coffee filters, wax paper, and gauze will be used in this lesson.

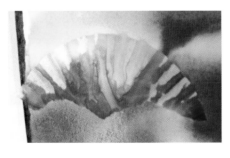 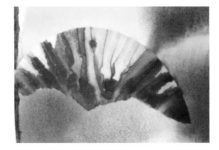 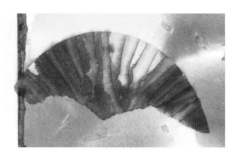

While the painting is wet, add pieces of ripped up coffee filters between areas of differing values to form transitional shapes. Be sure to keep the accordion pleats intact and connect the shapes to create a sense of continuity throughout the painting. Adding more color will help create these stunning textures (page 153).

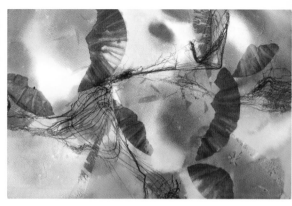

Pieces of cut waxed paper may be laid directly on the wet surface to add a unique textural effect (page 157).

Next add gauze to form connecting lines of movement (page 154). Allow all of these agents to remain on the surface until the paint is dry.

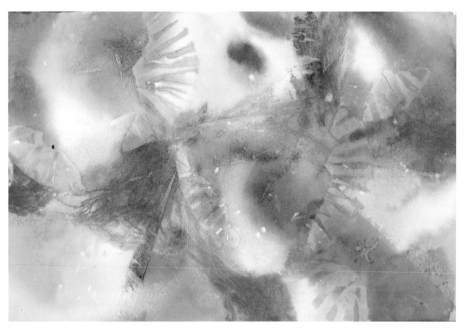

When the painting is dry, remove all the texturing agents and evaluate your work. You have created a full range of subtle mid-tone values and may now consider finishing the painting by adding a pattern of dark values. For this demonstration, acrylic paints were used to form the dark shapes. You may also use a rich, dark watercolor mixture.

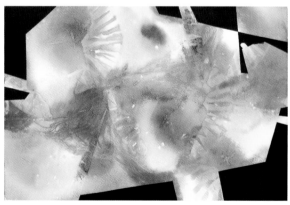

Select the placement of your dark shapes and place masking tape along these edges. This next step is critical to insure the formation of clean, crisp lines. Use a flexible piece of plastic, such as a credit card, to **burnish** the edges of the tape. This pressure will seal the edges and prevent the paint from seeping under the tape. Apply the acrylic paint or watercolor. If you use acrylic paint, remove the tape while the paint is still wet. If you use watercolor, wait for the paint to dry before removing the tape. For more informational tips on taping, see page 156.

To create more surface excitement, you can lift out lights or whites with a Mr. Clean® Magic Eraser™. I used two pieces of transparency and damp magic eraser to lift out these white shapes (page 156).

I used a credit card loaded with dark paint to create dark lines.

To add enrichment, I used paper napkins with similar colors. Remove the back layers of the napkin and glue only the thin top colored layer with Yes! Paste™ (page 157). Application of this single layer results in a transparent, luminous look.

*If you use paper napkins, it is important to seal the surface with matte medium or an acrylic spray with UV (ultraviolet) protection to make these non-archival additions archival.*

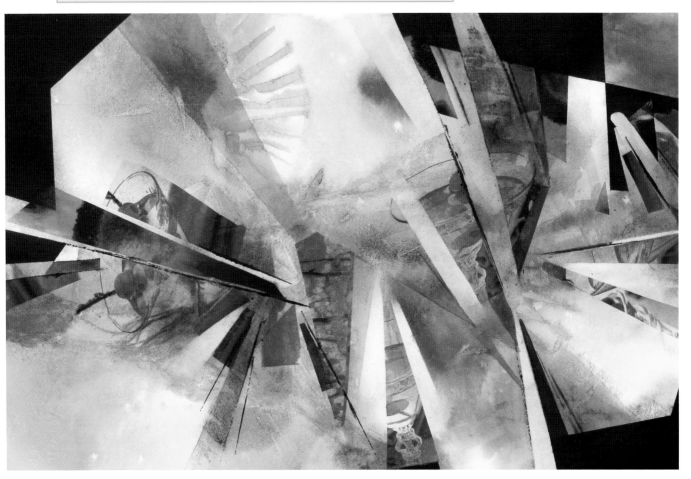

The finished painting is a combination of the subtle textures formed in the underpainting and the crisp, clean lines and dark values created by experimenting with the various techniques illustrated above. These spontaneous experiments provide exciting ways to challenge yourself as an artist.

# Using line expressively

A line is a continuous mark made on a surface by a moving point. If you emphasize these continuous lines, you create a linear composition. Line can be very expressive. You can vary the thickness, feather it out or leave the edges crisp. The variations are endless.

Drawing is usually a child's first attempt at artistic expression. I have always drawn pictures for as long as I can remember and my family's admiration of my drawings was the encouragement I needed to pursue becoming an artist. When you think about it, drawing is a primal instinct, one of your first attempts to express yourself. That is why it may feel perfectly natural to begin your painting with a drawing. Your unique way of drawing is like your personal signature, your special way of interpreting the world around you.

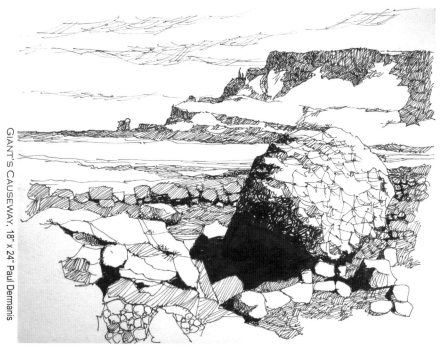

This expressive pen drawing by Paul Dermanis was completed *en plein air* at the Giant's Causeway in Northern Ireland. The variety of lines designed into this sketch, as well as the movement and the pattern of light and dark shapes make this rocky interpretation truly delightful.

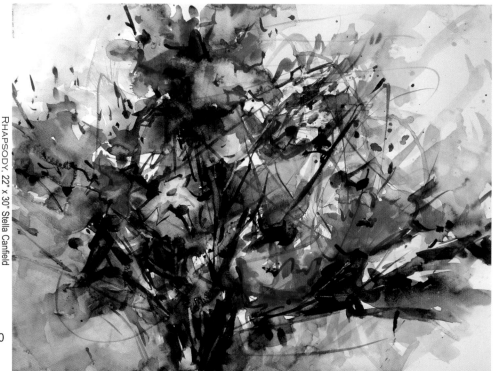

This dynamic painting by Stella Canfield is emotionally charged by her use of beautiful line work. She translates life into line either with a pencil or with paint. When you look at this painting, you become unconsciously involved with the energy and visual excitement she has created.

# Drawing—a language without words

When we draw, we use line as a means of intuitively translating our perception of what we see and feel. As children, we are not subject to the rules and inhibitions that we accumulate as we grow older. We used to be able to draw anything, but now, as adults, we tell ourselves we cannot draw. You **can** draw and drawing is critical to help you express yourself as an artist. There is no right or wrong way to draw an idea because whatever you create with line is interpreted using a visual language unique to only you.

These two pen drawing were sketched at the same time on location in Scheggino, Italy. Bonnie Broitzman's interpretation on the left, took in the entire scene including shadows, while my drawing, on the right, shows a vertical slice of the scene with very little shadow interpretation.

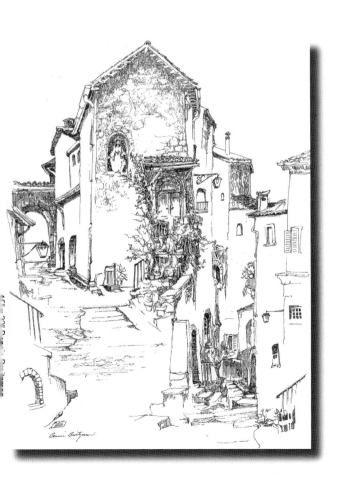

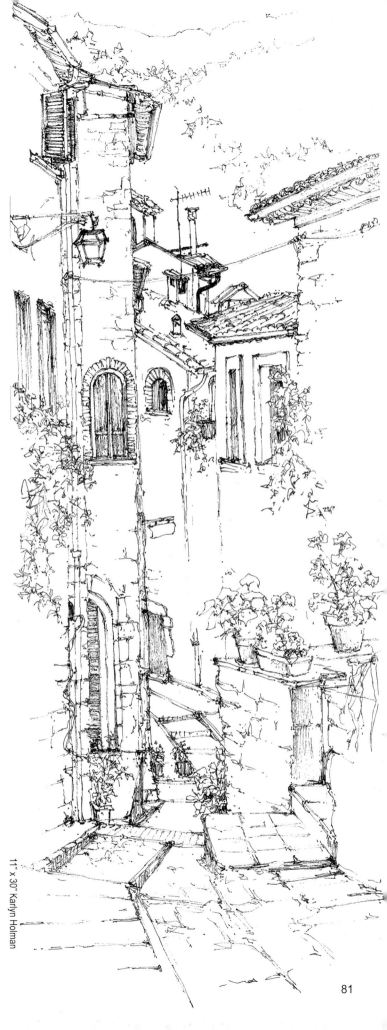

11" x 30" Karlyn Holman

# Line as color

*There are many medias that rely on line, such as pastels and colored pencils, just to name a few. My love affair with Caran d'ache® water-soluble crayons and watercolor pencils started when I used them to draw directly onto a wet surface for the first time. These watercolor crayons are a perfect marriage of line and color and provide you with a wide range of techniques to explore in your creative playtime.*

The following eight pages were all done on **hot-press paper**, a smooth slick surface that has a very distinctive personality. This paper resists absorbing the color and you will find the paint dries unevenly. Also, each successive wash rewets the underlying color, making it much easier to lift the paint. This surface is perfect for water-soluble crayons and watercolor pencils. The somewhat rough surface of cold press paper does not work as well.

Karlyn Holman

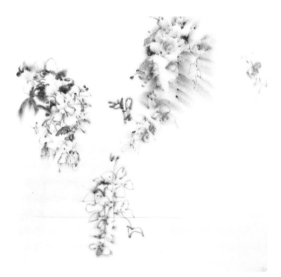

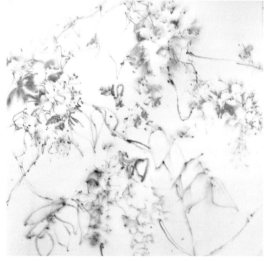

I. Begin by wetting the paper on both sides and drawing directly onto the wet surface. Watch the lines move as they melt and form rich, lovely patterns of color.

2. Use the colors of your subject as you develop your composition. Be sure to add harmonic enrichments.

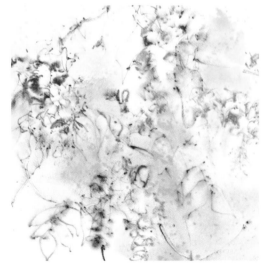

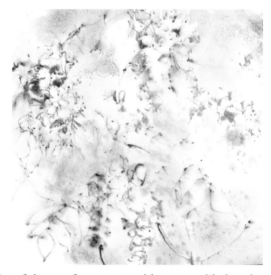

3. Winsor yellow was added to brighten up the background. Remember to spray with your fine mister as necessary to keep the surface wet.

4. A soft layer of manganese blue was added to the background for depth and color harmony.

**5.** This next step is the most important element in your composition. You must develop a **pattern of mid-tone darks** throughout the painting. I find it helpful to draw a quick value sketch for this pattern of darks and add the pattern while the colors are still wet. This is a good time to polish up on your negative painting skills and weave dark color in and out of the drawn shapes. You will be amazed at how little the color moves on the wet surface.

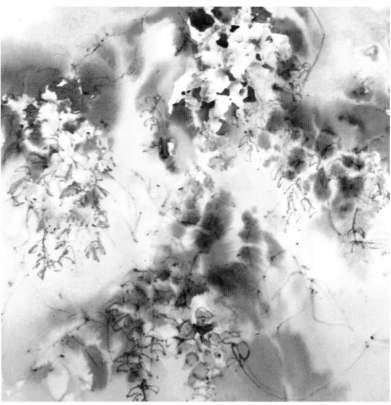

**6.** After your underpainting dries, you may add more lines with the pencils or the crayons on the dry surface. The opaque nature of some of the crayons may add an entirely new dimension to your painting.

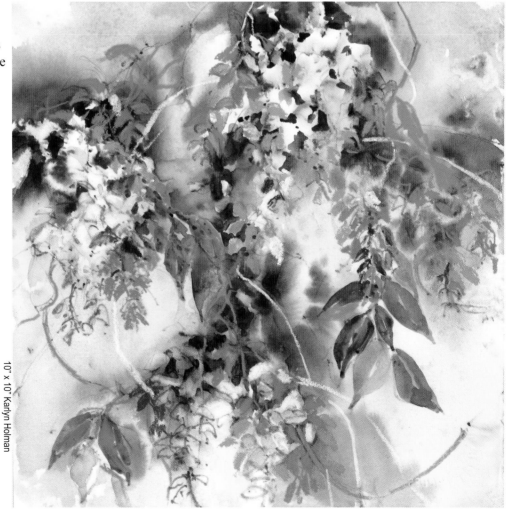

10" x 10" Karlyn Holman

# Liquid lines on wet paper

*The liquid lines mingle with the wet surface and evolve into an intriguing linear expression. Experience the pure joy of drawing in color as long as you want by using your fine mister to keep the surface wet. As you spray, use a wide sweeping motion.*

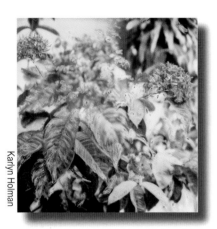

Karlyn Holman

This photograph is an altered image taken with an SL-70 Polaroid camera.

I. Wet a smooth-surfaced paper on both sides. Draw the outlines of the image you are creating directly onto the wet paper, using the actual colors of the image.

2. Add some of the colors of the flower into the background and continue to develop a mid-tone dark pattern of movement throughout the painting.

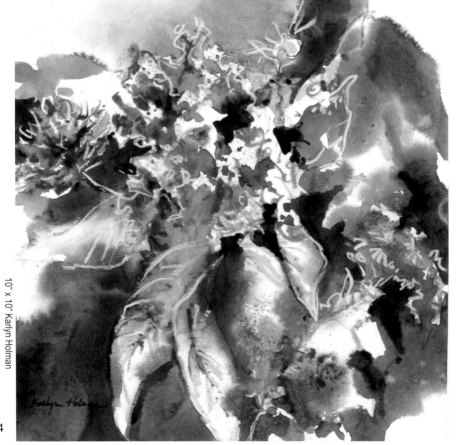

10" x 10" Karlyn Holman

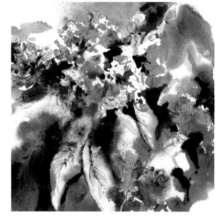

3. Continue alternating lines and colors as you develop the painting.

4. Finish the piece on dry paper. Usually a pattern of dark shapes will complete the composition. If you want to intensify the crayon colors, simply wet the dried crayon areas with water. The white lines were drawn over the dry surface using a white Caran d'ache® crayon.

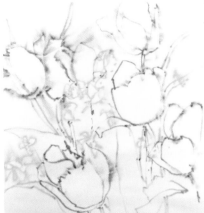

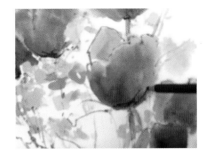

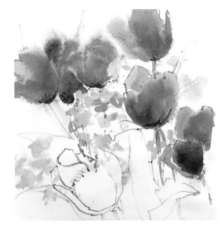

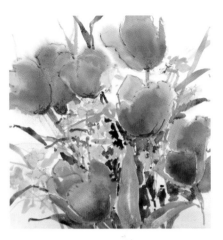

**1.** Wet the hot press paper on both sides and draw the outlines of the image you are creating using the actual colors of the flower.

**2.** Next, add a variety of harmonic watercolors directly onto the wet surface as you develop the flowers. I used Windsor yellow, scarlet lake and permanent rose for the tulips.

**3.** Develop a pattern of mid-tone darks in the background.

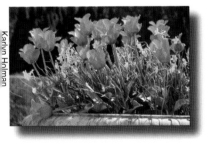

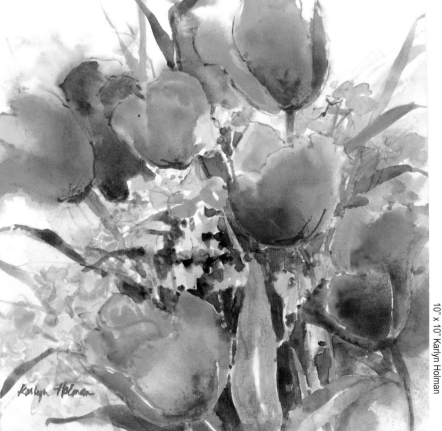

**4.** Soften or lose some of the edges in the background to finish the painting.

10" x 10" Karlyn Holman

# Color Sanding

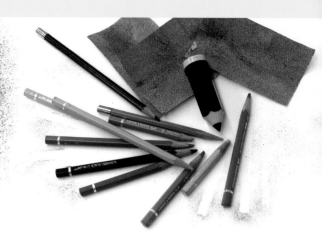

*This technique of sanding color on either a wet or a dry surface is truly the ultimate "fun and free" approach to using color in water. I first read about this technique in Shirley Travena's book, Taking Risks With Watercolor published by Collins Publishers. She calls the technique speckling, but I call it "color sanding." You apply water (either with a slight color added or without any color) and then, by rubbing a watercolor pencil on medium sandpaper (e.g., 100 grade), you watch, as the color becomes "liquid". The color actually melts onto the surface, sometimes leaving a delicate speckled appearance and other times melting into a smooth color.*

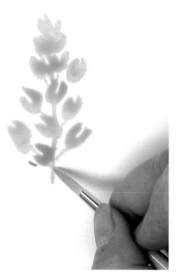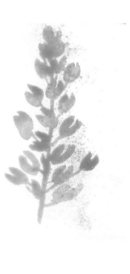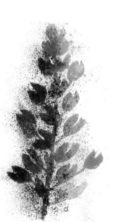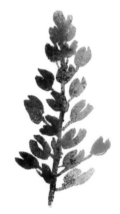

These lupines were painted with a slightly toned color on dry hot press paper. Be sure to make the patterns of water very wet. A yellow watercolor pencil was sanded into the sun side of the flower. Next, a red pencil was sanded into the shadow side of the flower. Lastly, a purple color was sanded again into the shadow side to add depth of color to the lupine. The extra sanding that fell onto the paper was then blown away.

You can also use the technique of color sanding to add to a work in progress. This application of color can provide the perfect finishing touch for your painting. Simply wet the entire surface and sand the color where you want a speckled look. This technique works on hot or cold press paper and adds a lovely soft effect that cannot be matched by brushwork. A word of caution…every time this area is rewet, the color will reactivate. This successive rewetting can cause the colors to become muddy, so it is important to remember to use this technique close to the final wash.

# Color sanding on dry paper

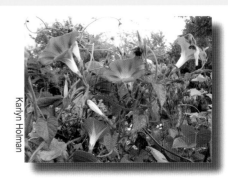

Karlyn Holman

Draw the flowers with pencil on hot press paper. Begin by loading a brush with water and painting the leaves and stems in a carefree manner. Shave the watercolor pencil directly into the wet lines and blow away any extras shavings. As you watch the watercolor melt into the wet surface, continue to experiment by adding several variations of harmonic colors.

Add a pattern of warm or cool colors by applying wet color on the dry surface and softening the edges with clean water. Try to connect this pattern of color to the edges of your painting.

Add a pattern of mid-tone colors throughout the composition.

When the paper dries, draw more lines to accentuate the details in the painting.

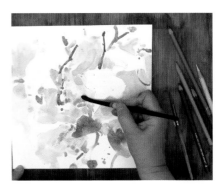

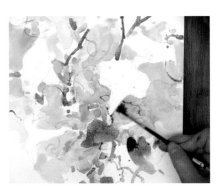

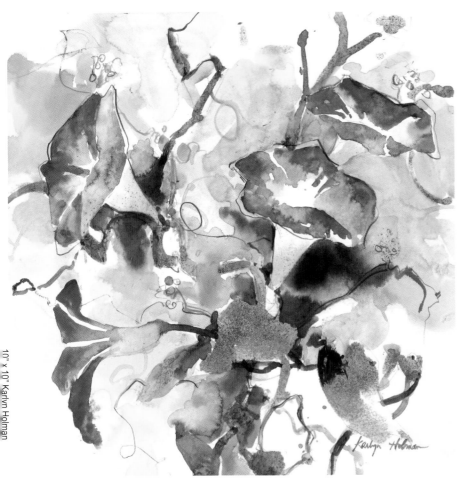

10" x 10" Karlyn Holman

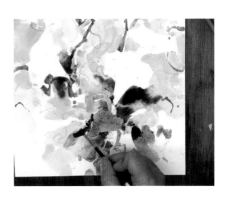

87

# Watercolor pencil lines on dry paper

*The inspiration for this painting came from a friend's garden in New Zealand. She brought the garlic bulbs to my watercolor workshop, and we were all intrigued by the shapes and cast shadows. The subject was perfect for drawing with watercolor pencils and for using color sanding for the cast shadows.*

Dry          Wet

1. Simply draw your image on smooth, dry, hot press paper and add liquid masking (page 154) to save some whites for the fuzzy roots. I used a warm purple watercolor pencil to draw the garlic.

2. Wet the entire drawing and watch the image move on the slick surface. The hot press paper does not hold water evenly, so you will automatically observe a "lost and found" look as you add more color to the wet surface.

3. I chose the complementary colors of primary yellow, quinacridone gold and quinacridone burnt orange to paint the garlic and then allowed the painting to dry.

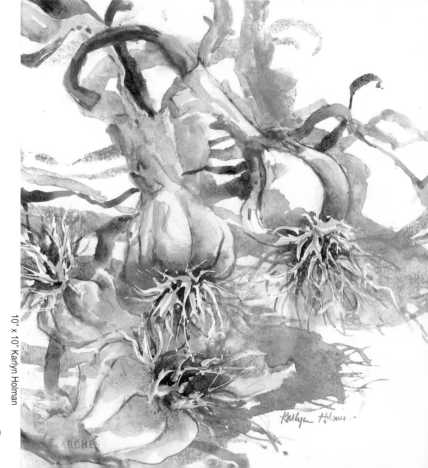

4. On dry paper, wet the selected areas to represent the cast shadows and then color sand them. Because these shadow areas must be very wet to activate the colors, do only small areas at a time. When the shadows dry, remove the masking and tone the roots if desired.

10" x 10" Karlyn Holman

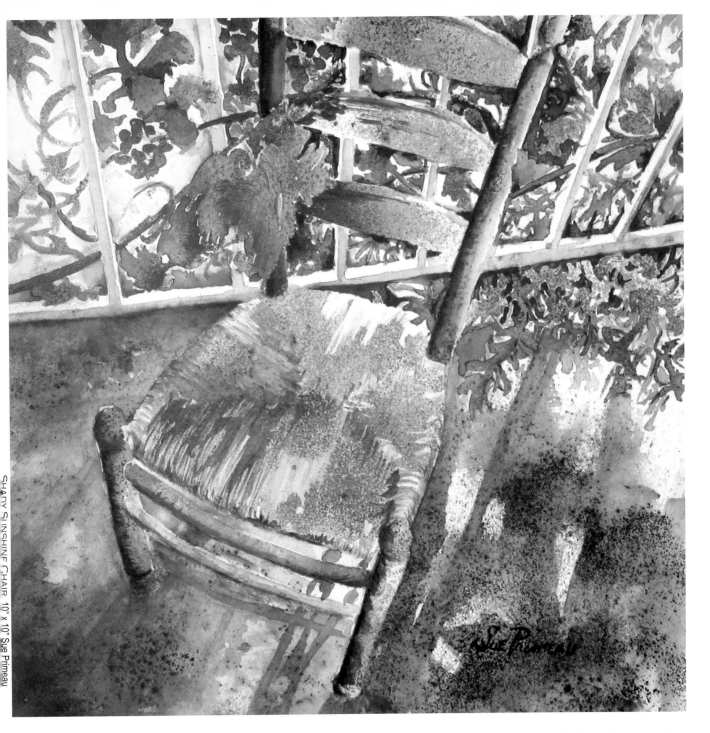

Sue Primeau painted this fresh, exciting watercolor. She color-sanded most of the surfaces on hot press paper.

"I snapped this photo of a wonderful rush chair as it sat in the brilliant afternoon sunlight. The striking contrast of light and dark in the scene really caught my eye, and looking down on the chair presented a challenging perspective. I chose color sanding to interpret the subject because of the lovely textures created by this technique. I think the secret to success with this technique is to sand a number of different colors to create the overall color you hope to achieve, rather than grabbing only one or two that closely match your intended end color. For example, when sanding the rush seat, I started with yellow, orange and red. Next, I used blues to create the shadow areas. To create subtle variations and shadows throughout the painting, I used some purple, dark brown and black. Because I wanted to capture the strong darks and lights of the scene, I made sure to preserve the white of the paper in all the areas where the sunlight was the strongest. A word of caution; avoid wetting the white areas because invisible dust particles created by color sanding will invariably reactivate and add tone to the very areas you want to keep white."

# Line as energy

*Douglass Thomas loves using line to create a sense of movement in his work. Douglass has developed a unique style of working with pastels that involves criss-crossing lines filled with energy. Many of his students have said that his unusual technique reminds them of the methods used by Jackson Pollack, "but under control." By mimicking the fresh, simple, scribbling of a child, Douglass creates the foundation for his pastel paintings. When using this technique, the artist needs to realize that none of the final details will appear until the painting is almost finished. Most beginners, for example, will paint the water first and then add the rocks under the water. His method is the opposite; the rocks will be laid in first followed by the water over the top.*

Douglass Thomas

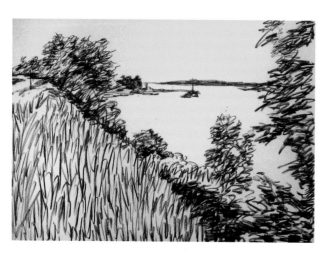

He starts the layout of each pastel using charcoal to distinguish light areas from the darks. Note the variety of lines creating separation between objects.

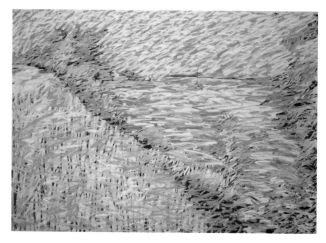

For the second step, he uses the brightest, most florescent colors in his palette, and with criss-crossing lines, he establishes the colors of each object without defining the borders of the object.

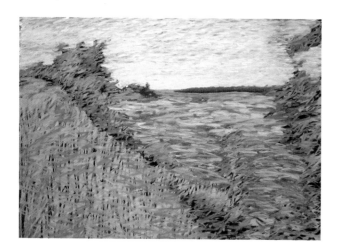

In the third step, he adds lighter and darker colors in each of the areas to define their characteristics. In the sky, see how the lighter colors of the clouds push the blue back into the picture and how the exposed blue areas give depth to the sky. Each time he adds a new color to an object, he uses the previous color to push the new color

into the image instead of having the colors sit on top of the surface of the object, thus softening and blending each new layer. Dark purple is added in the ground area to establish contrast between the light sky and shadows in the landscape.

In the foliage, dark and medium greens are added to define individual plants.

As the foreground progresses, it becomes isolated from the sky. Reflective colors are added in the sky to merge the clouds to the ground.

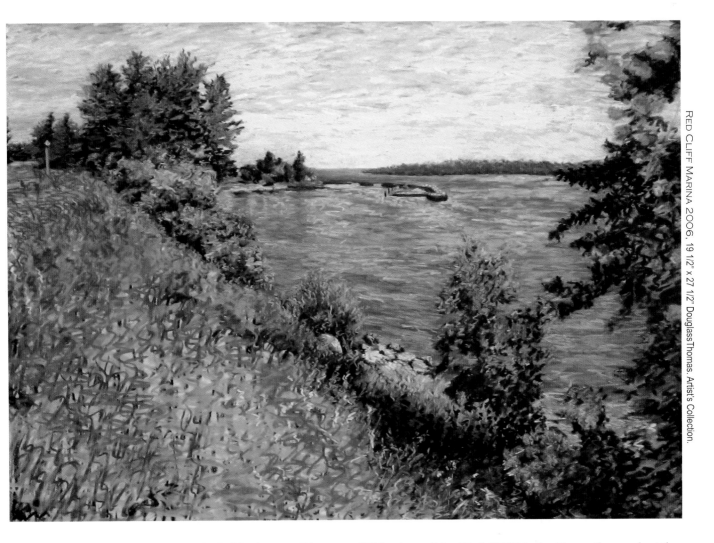

RED CLIFF MARINA 2006, 19 1/2" x 27 1/2" Douglass Thomas. Artist's Collection.

Final colors are added to complete individual areas. Blue in the sky creates separation from the clouds. Warm greens set the mood of sunlight on the trees and grass. Finally, light and dark colors are added to complete the road, rocks, bushes and grasses.

"This view of the 'Red Cliff Marina' is another peek at the scenery showing the different vegetation, terrain, islands, water and sky. Because there are no viewing areas near these locations, most people only catch a glimpse of them while passing by."

"When I approach a new image for a pastel, I want to give an artist's glimpse of the local scenery to visitors and area residents. Visitors to the Bayfield, Wisconsin area often bypass local hot spots such as the 'Washburn Island,' a great swimming hole for locals. For a landscape artist, this scene has everything; a big sky, water, brownstone and trees."

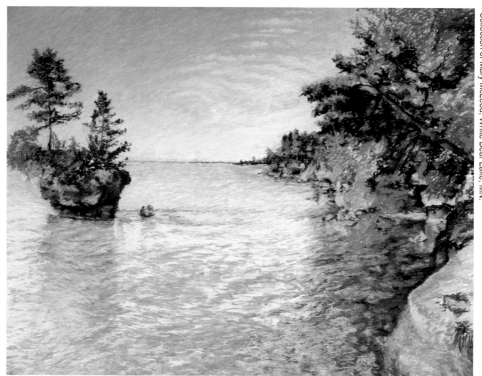

WASHBURN ISLAND 2004, 30" x 38" Douglass Thomas. Collection of Mary McLeod, White Bear Lake, MN.

MONET'S GIVERNY GARDEN 2005, 18" x 24" Douglass Thomas. Collection of Marge Oakley, Glenview, IL.

"This painting of 'Monet's Giverny Garden' is dedicated to a very close aunt who supported my early art career. Her support has inspired my search for the beauty that surrounds us here in Northern Wisconsin and the beauty I have experienced during my European art ventures."

"Fishing has been a great tradition on Lake Superior and the 'Boat Yard' reflects those families who have supplied whitefish and trout to local residents over the years"

BOATYARD 2003, 38" x 30" Douglass Thomas. Collection of Kent and Donna Olson, Bayfield, WI.

FIRST SNOWFALL 2005, 8" x 20" Douglass Thomas. Collection of Patrick Cronin, North Oaks, MN.

"The 'First Snow Fall' was a photo moment no one would want to miss. The clouds opened up to blue sky creating the dark contrasting snow clouds. The composition of this landscape reflects the driver's view of the scenery."

# Expressing emotion with line

Stella Canfield is a passionate and uniquely creative artist. Her paintings are fresh and spontaneous because they are painted in a fast and loose, very intuitive, *ala prima* style.

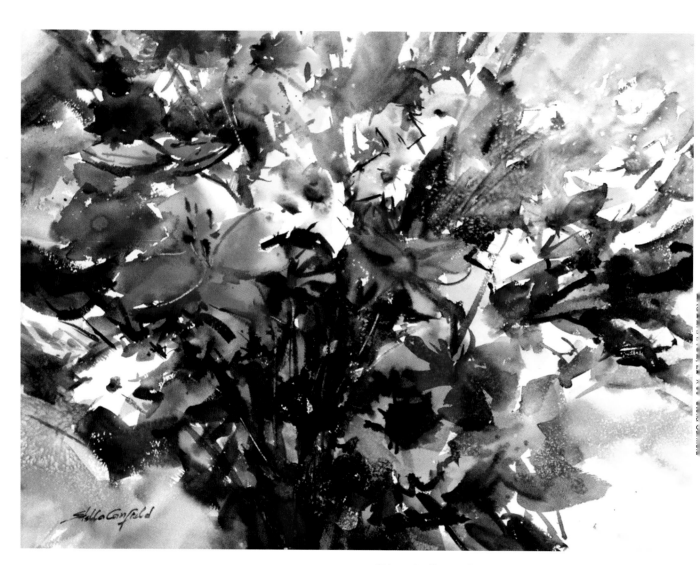

When Stella applies wet paint on paper, every stroke counts. All the emotions she feels are translated from within her and communicated in her painting through line and color.

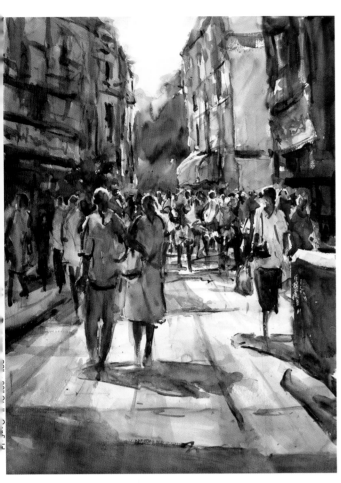

Stella's approach is expressive, bold and very direct, whether she is creating *en plein air* or in her studio. Stella paints the "spirit of the place" she is visiting. Instead of intellectualizing over every detail; she simply lets intuition and spontaneity have their way.

Stella and I team-teach on location travel adventures together, and her direct style is a perfect complement to my more layered approach (pages 18-19).

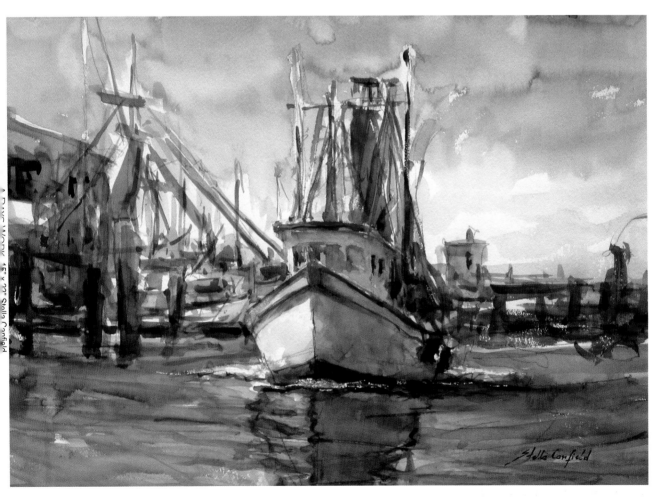

# Designing your composition with shapes

*Consider designing your composition using shapes. Adding linear or organic shapes to your composition offers an opportunity to explore the placement of dark and light patterns and provides an exciting departure from a more traditional approach. As you develop your shapes, it is important to create breaks and reversals that allow the viewer to move around and within the composition. If this is your first time composing shapes, an easy compositional ploy is to design the subject as the positive shapes and the background as the negative shapes.*

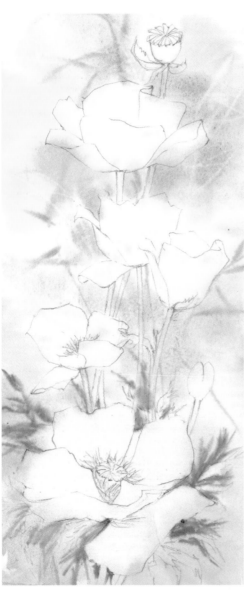

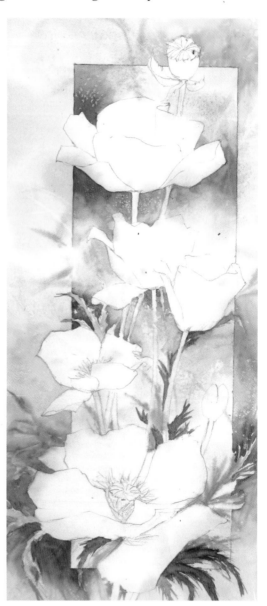

Start your painting by drawing the positive contour shapes of your subject. Wet both sides of the paper and select colors for your wet-into-wet background. This soft, out of focus underpainting sets the stage for a loose interpretation of the subject. Paint negatively around the shapes you drew and do not paint any of the subject. After the painting dries, use your intuition to dissect the flowers to best show off their placement in the composition. You can make the border a different width on each side. You want some shapes "breaking out of the lines" and others "contained within the shape." Remember to design some interlocking shapes, as well as a star of the show. When you begin the negative dark patterns in and around the shapes, the real fun begins. To make the composition exciting, try to make the stems light against dark or dark against light, or make a dark shape inside the line and later reverse the dark shape to the outside of the line. The warm poppy colors were intentionally repeated in the background to echo the color of the poppies

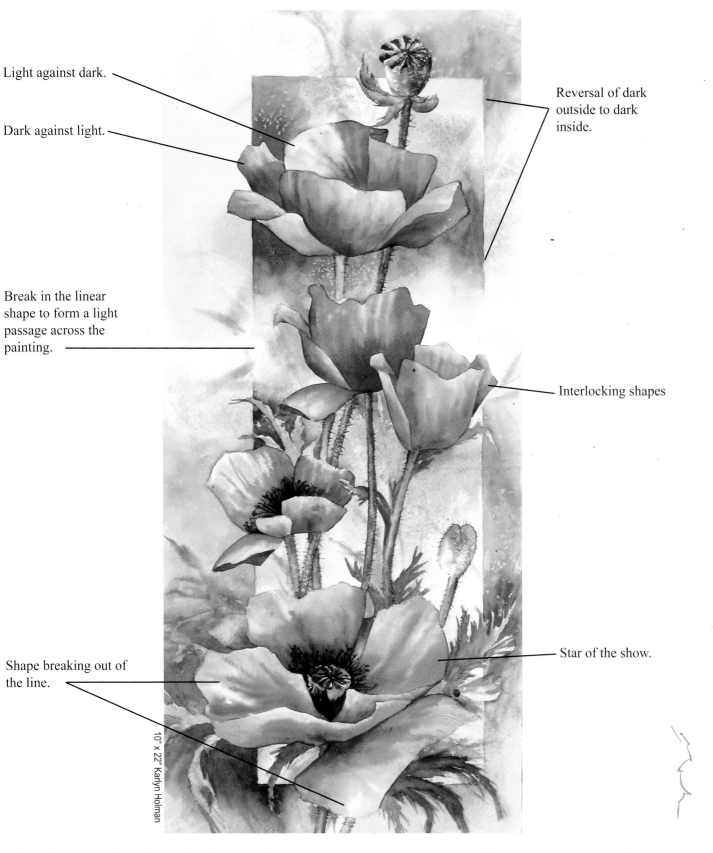

Light against dark.

Dark against light.

Reversal of dark outside to dark inside.

Break in the linear shape to form a light passage across the painting.

Interlocking shapes

Star of the show.

Shape breaking out of the line.

10" x 22" Karlyn Holman

After all the shapes have been painted. the positive shapes of the poppies were painted on dry paper. Each shape was wet and the harmonic colors of aureolin yellow, scarlet lake and permanent rose were added to interpret the petals. These colors were selected because they do not move much in water. Alizarin crimson and phthalo green were used to make the blacks. This red/green color theme creates visual contrast with the complementary colors (pages 110-113).

# Designing your composition with asymmetrical shapes

To begin, draw your image using only contour lines and do not draw in the asymmetrical shapes yet. Choose your circle of colors to fit your image choice. A warm dominance was a challenging choice for these hot chili peppers. As you go from Winsor yellow to quinacridone gold to quinacridone coral to magenta, you create a harmonic sequence. However, when you go from permanent magenta to yellow, you create a complementary sequence. To solve this problem, I simply left white between the yellow and magenta, which also created a path of light into the painting.

I. Wet the paper on both sides and begin creating your color transitions. Paint negatively around the shapes you have drawn. Use this creative playtime to add out of focus shapes to the wet underpainting.

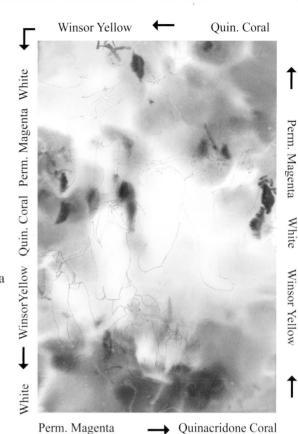

Winsor Yellow ← Quin. Coral

White · Perm. Magenta · Quin. Coral · Perm. Magenta · WinsorYellow · White

Perm. Magenta · White · Winsor Yellow

Perm. Magenta → Quinacridone Coral

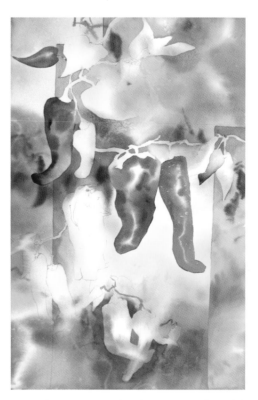

2. When your painting is dry, establish the asymmetrical shapes with a HB pencil. Be sure to design some of the asymmetrical shapes so the some peppers break in and out of the lines and some are contained by the lines. Now have some fun. Begin painting on one side of a shape and then reverse this process and paint on the other side of the shape. As the painting progresses, sometimes you will paint the subject (positive) and sometimes you will paint around the subject (negative). Keep thinking dark against light and light against dark. Zig and zag your way around and through the painting.

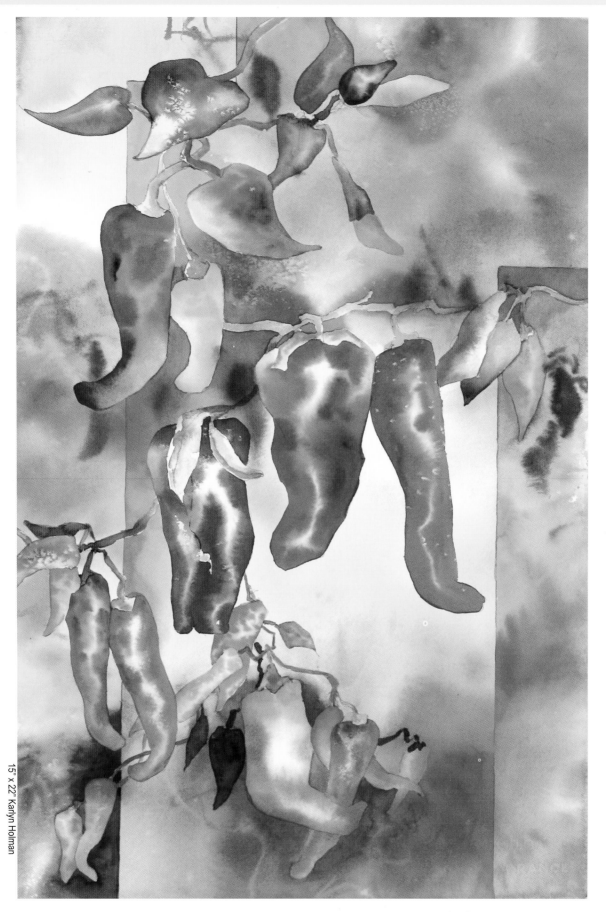

15" x 22" Karlyn Holman

**3.** Refine the final interpretation by pushing the dark and light contrast.

# Combining geometric and organic shapes

*Karen Knutson loves the combination of watercolor and collage. Design is very important in her paintings and she is a firm believer in planning a distinct light or dark pathway. To achieve that pathway, she constantly does design sketches using only two values. Watercolor allows her the freedom to paint with reckless abandon in the beginning stages, while collage gives her the option to create the tiny shapes and colors that add textural interest. She also enjoys creating acrylic paintings using intense color and often uses combinations of geometric and organic shapes in her work.*

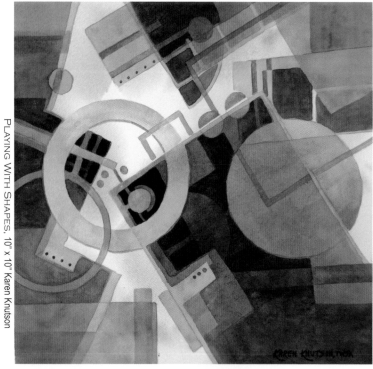

PLAYING WITH SHAPES, 10" x 10" Karen Knutson

"This watercolor painting has gone through many phases. I started by floating blue and pink colors on the wet paper, and then I glazed over most of the blue with layers of yellow and green. In the beginning, I worked with only three simple shapes and gradually broke those big shapes into circles and squares by negative painting within the big shapes. My goal was to repeat and vary shapes and colors, as well as go from negative to positive wherever possible."

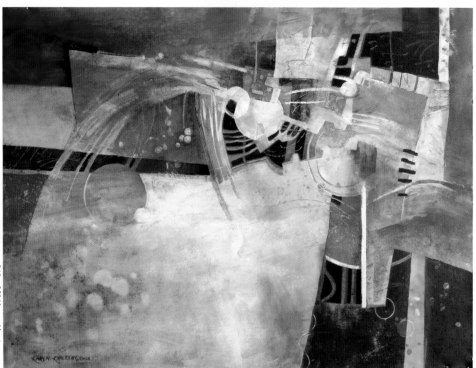

WHEELS OF TIME, 21" x 29" Karen Knutson

"I started this acrylic painting with lots of bright colors, starting very wild and free, and then looking for direction after the first coat was complete. I challenged myself to have more circular shapes in this painting. Many of my past paintings had mostly straight lines; I try to constantly change and grow in my artwork. I worked from a design sketch that I had drawn after the first coat. Another challenge in this painting was to work with opposite colors, red versus green, and orange versus blue."

"This watercolor painting is one of many in my women series. I start with an abstract design, and when the main shapes become evident, I negatively paint the person wherever she fits into the design. I want viewers to be drawn to my paintings by the design. Only when they get close will they discover a woman in the painting. Collage adds excitement, texture and fun to the painting. I titled this painting, "Scent of a Woman" because the curved lines suggested a fragrance in the air."

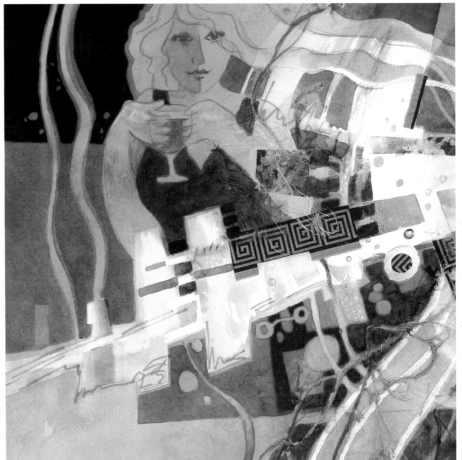

SCENT OF A WOMAN, 14" x 14" Karen Knutson

"This acrylic painting actually started out very busy, with no clear center of interest. I wiped out large areas, using rubbing alcohol to simplify the shapes. When I did that, the two figures showed up, so I painted around them. It reminds me of a computer age, where the two people are going into a time machine. This painting has been accepted in many national shows, and proves that you shouldn't give up on a painting in the early stages. Simplify your design, and you could have a real breakthrough!"

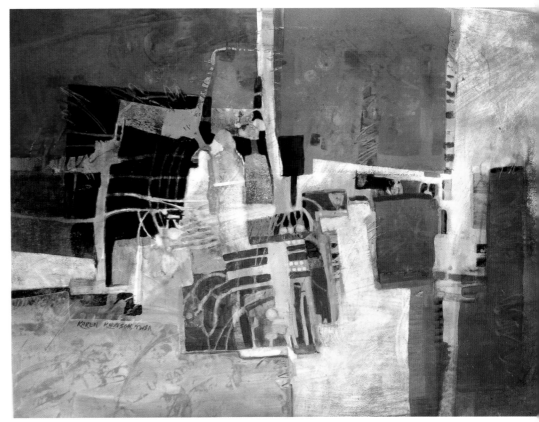

COMPUTER AGE, 19" x 26" Karen Knutson

Karen Knutson painted this beautiful watercolor titled "Magnolia Collage".

"This watercolor painting was a breakthrough for me. I discovered the power of using bright colors in the early layers of a painting and allowing them to glow through the final interpretation. I particularly like the mood and the textures that this painting projects. I used a musical motif in the collage to help create a romantic mood. When I developed the "path of light," I tried to extend these whites to the edges of the painting".

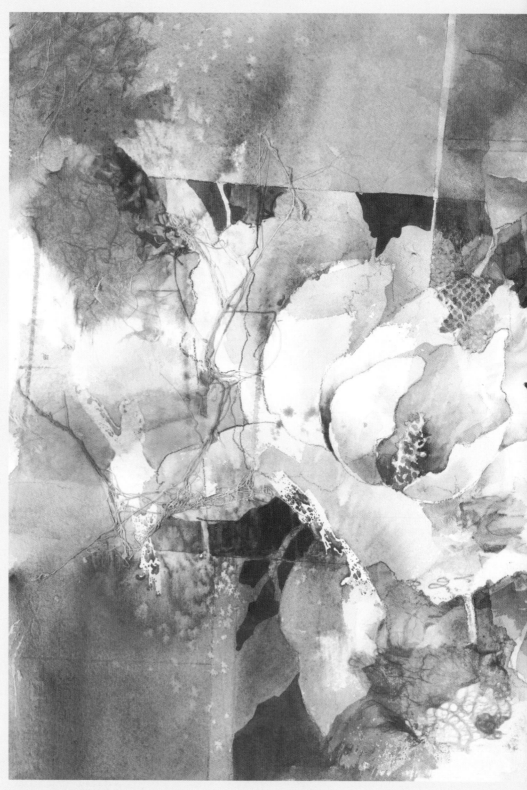

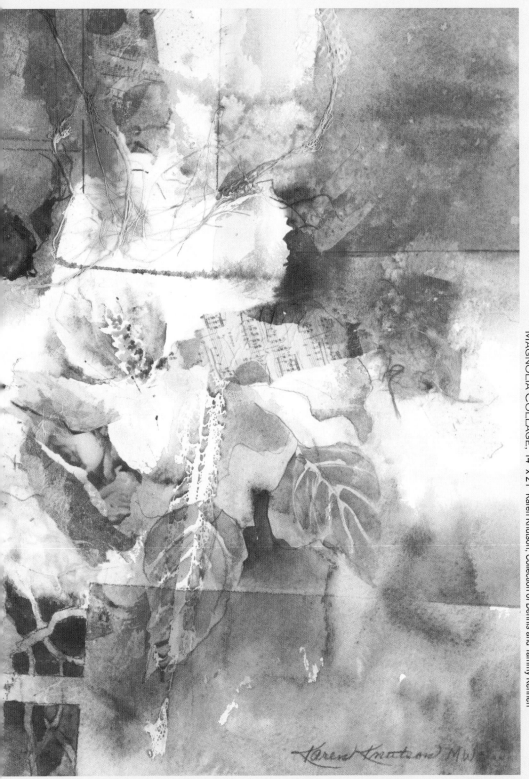

MAGNOLIA COLLAGE, 14" x 21" Karen Knutson, Collection of Dennis and Tammy Kennen

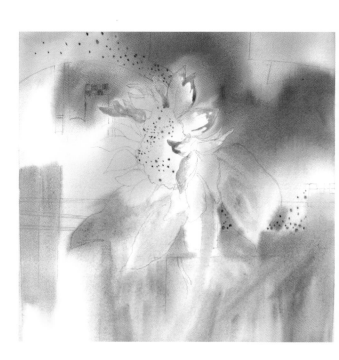

I. Karen always starts her paintings by doing a two-value design sketch, thereby simplifying the design and connecting all the same values to create either a path of lights or a path of darks.

2. After masking some of the highlights, she wets the whole paper and floats in watercolor emphasizing the darker values drawn in her idea sketch (masking page 154).

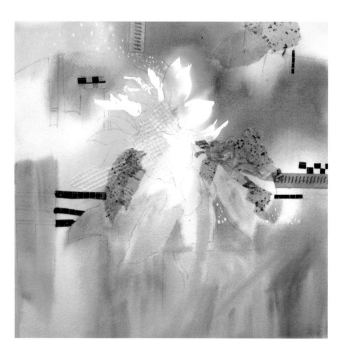

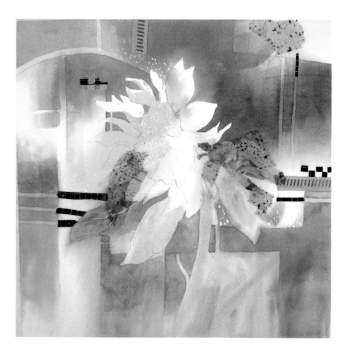

3. Once the paper has dried, she removes the masking fluid, and using acrylic matte medium or Yes! Paste™, she glues down the collage fiber papers to create interest and texture. By choosing colors of paper that are analogous to the paint colors, she insures that the papers will "melt into the background." Karen enjoys busy designs and uses them to point to the center of interest.

4. Karen concentrates on keeping the light pathway connected by adding illusionary glazes and building up the darks. Every time Karen adds a layer, she saves something from the layer before, thereby adding depth to her painting. Negative painting is her favorite way to paint.

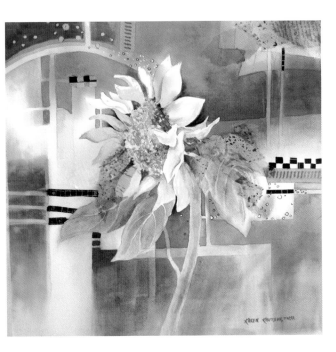

5. Karen enjoys little shapes, so she often masks some dots that resemble "magic sparkles". She then glazes more layers to increase depth in the medium values.

6. When the painting is almost finished, Karen turns back to her original design sketch and draws in the darkest values, providing her with a guideline to better emphasize the area that has evolved into the center of interest.

7. Using this guideline, she finishes the painting by layering the final dark shapes of color.

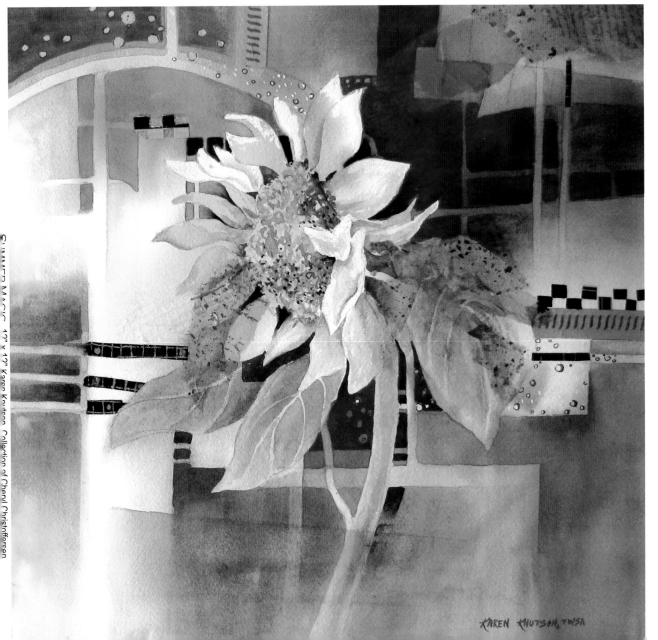

# Gallery of paintings using shapes

This painting started with three equal rectangles. I challenged myself to use the design motif of butterflies to soften the geometric shapes. The butterflies were intentionally designed to break out of the rectangles and lines were added to help create a sense of unity. The Yin Yang colors added visual excitement and strengthened the harmony of the composition.

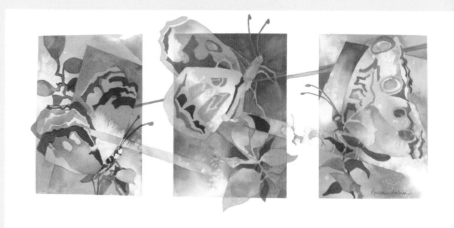

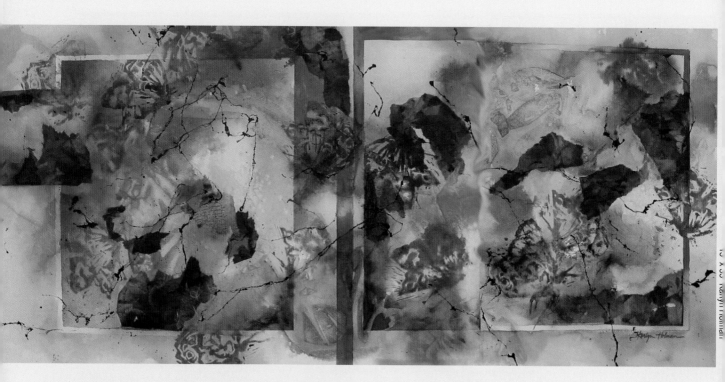

This painting started with a wet-into-wet underpainting. After the painting dried, the shapes were penciled in. The colors were intentionally limited to Antwerp blue (cool) and quinacridone burnt orange (warm). This simple combination of colors creates a beautiful green. The real fun started when I began to use the butterfly stamp spontaneously throughout the composition-inside the shapes, outside the shapes and overlapping the lines. I then began to experiment with reversing and repeating the warm and cool colors.

In Sue's own words: "My main color triad for this piece was quinacridone gold, alizarin crimson and Antwerp blue. I had just acquired quinacridone gold and I loved the moody, mellow results this color offered. I wanted to challenge myself to create actual "breakouts" within the format of the painting resulting in unexpected surprise elements. The horizontal close-up of the grape vine provided this excitement, as did the unusual shapes extending beyond the geometric background. When I used blended colors and salt, the upper right hand corner exploded into lost and found edges. I balanced this energy by allowing the grape bunches to appear and disappear off the left edge of the painting."

This elegant watercolor by Sue Primeau illustrates a beautiful blend of organic and geometric shapes. The horizontal breakout of the grape vine adds a perfect element of organic movement in contrast to the crisp edges of the composition.

# Designing three white corners

*An easy formula for designing your composition is to save three white corners of your paper.    The variations resulting from this design concept are endless. When designing the white corners, remember that it is essential that your composition flows into these areas.  Feel free to "color outside the lines." All the paintings on these pages have an asymmetrical background.  (The step-by-step instructions for painting in this design format can be found in my Watercolor Fun and Free book on pages 66-75.)*

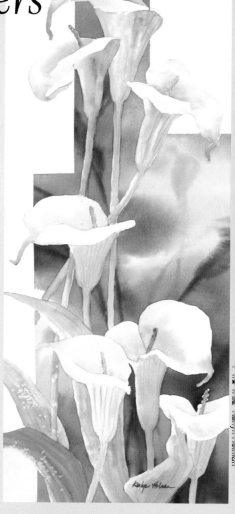

This long half sheet (11" x 30") is one of my favorite formats to design into three white corners.  The stark contrast of flowers breaking onto a white surface provides a natural space for additional drawing to enrich the surface.

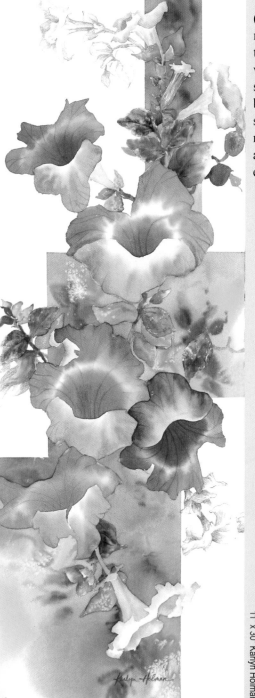

Slender lilies fit perfectly into this long narrow painting, 7 ½" x 22".

11" x 30" Karlyn Holman

Peppers are a popular subject.  The challenge in this painting was to portray hot, red peppers using the same colors as those used in the background.  Keeping a close eye on value and transposing lights against darks and darks against lights helped to solve the challenge.

11" x 30" Karlyn Holman

This painting reminds me of how expressive sunflowers can be; they all seem to have personalities that jump off the page. My goal in this painting was to paint these flowers as though they were all instructed to face the same direction, but some weren't willing to cooperate. The asymmetrical shapes were drawn in after the sunflowers were drawn.

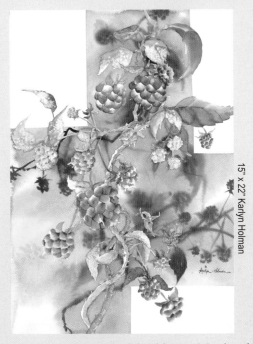

15" x 22" Karlyn Holman

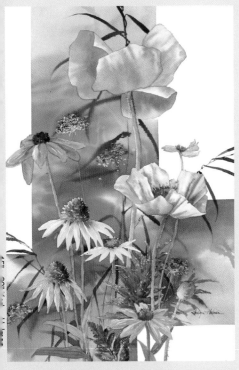

Fruits and vegetables are wonderful subjects. My daughter Renee, an innovative chef and restaurateur, and I are in the process of planning a cookbook celebrating art and food. This endeavor has inspired me to paint subjects such as raspberries, garlic and cherries.

The interlocking lines created between the art work and the white spaces are a good place to feature your center of interest. The lower pink poppy was intentionally placed with two straight lines dissecting it. The lower yellow flower was also intentionally placed on a dissecting corner shape. The larger pink poppy was placed breaking partly in and partly out of the white shape.

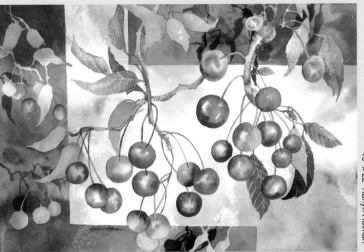

15" x 22" Karlyn Holman

The three white shapes can be reversed to three dark shapes. I had a great time painting these cherries using dark shapes in the light center and light shapes in the dark corners.

# Creating visual contrast with complementary colors

*When you choose colors that are opposite each other on the color wheel, the resulting contrast–the Yin and Yang–creates visual excitement.*

Select a subject and draw the image on your paper. For this painting, I purposely chose garlic as a subject because it has very little color. This means that all the color in the painting is derived from the dynamic wet-into-wet action of the background colors. When complementary colors are mixed on a palette and applied to the paper, they often become very muddy, but when you mix these same colors on the wet surface of your paper, your brush develops a flair for eloquence.

11" x 15" Karlyn Holman

This painting started with a line drawing. Next, the garlic bulbs were painted and masked. The geometric shape behind the garlic was created using masking tape. After I applied and burnished the tape (page 78), I masked the parts of the garlic inside the tapelines. The background was painted wet-into-wet as a contrast to the crisp edges of the garlic. (This lesson is in my book Watercolor Fun and Free on pages 60-63.)

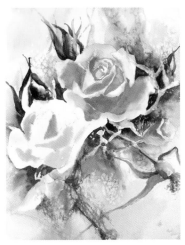

The yellow roses were chosen as a subject to complement the warm violet background. I wanted dramatic contrast, as well as soft transitions of harmonic color. I started the painting by wetting both sides of hot press paper and painting Winsor yellow and quinacridone coral into the background.

In order to obtain a diffused and softened look, while the surface was still wet, I used a deeper value of Quinacridone coral to suggest the shapes in the roses. Gauze was stretched to form a vertical passage behind the roses. Salt was added when the wetness was about to leave the paper.

The edges of the roses were popped out with a dark mixture of alizarin crimson and Antwerp blue. When these colors dried, the rose was carefully rewet with clear water, and Winsor yellow was floated on the wet surface, creating a subtle contrasting glow.

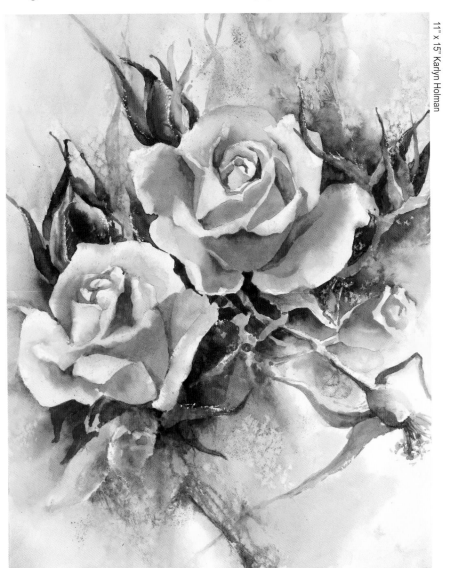

11" x 15" Karlyn Holman

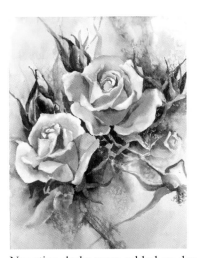

Negative darks were added on dry paper to refine the details.

Some "white sparkles" were created by scraping a razor through the paint down to the white of the paper. Do not paint over these damaged areas because the paper will readily absorb any subsequent colors and turn dark.

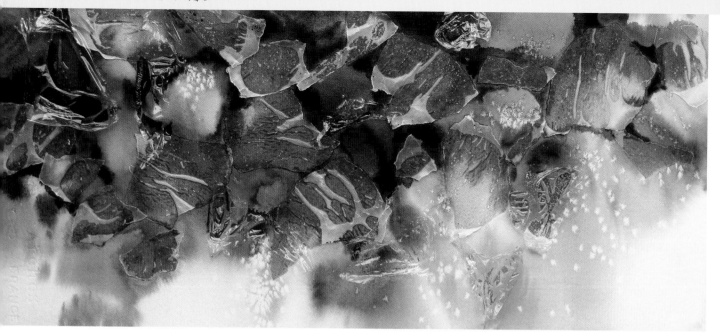

# Creating visual contrast with Yin Yang colors

*A simple subject such as rocks can take on new energy and excitement when you use complementary colors.*

I chose orange and blue complements to paint these rocks. By placing these complementary colors next to each other, each color becomes intensified. They actually appear brighter and more vivid. I painted the colors in a patchwork of shapes, varying the range from a golden orange to a deep orange and used Antwerp blue for the complement.

Pieces of ripped up waxed paper were placed on the red shapes to create the rock-like textures. I tipped the paper to let the blue flow under the waxed paper. The salt was added in only a few of the light values to form a transitional texture.

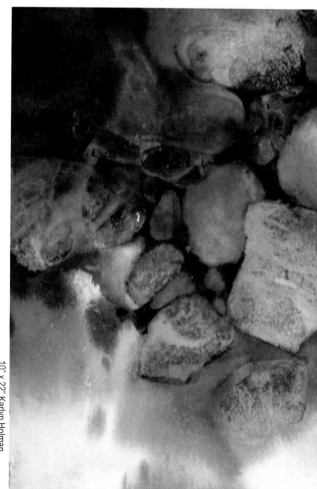

10" x 22" Karlyn Holman

Karlyn Holman

Karlyn Holman

The same image digitally altered into red and green and yellow and violet.

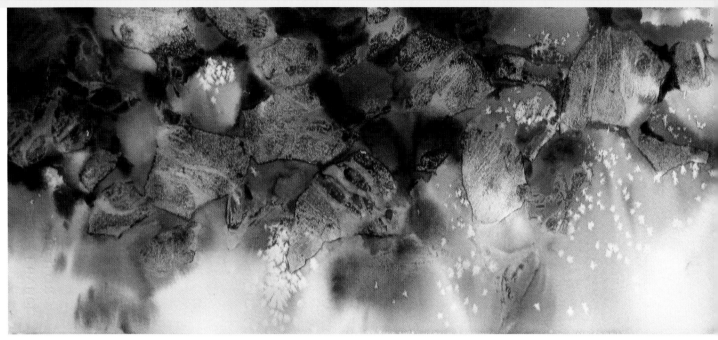

When everything dried, the waxed paper and salt were removed.

To finish the painting, negative shapes were added to define the rocks. You can carry the Yin Yang idea of contrast into more than the color selection. You can contrast soft edges against hard edges, dark values next to light values, intense color next to grayed color or detail next to undefined areas.

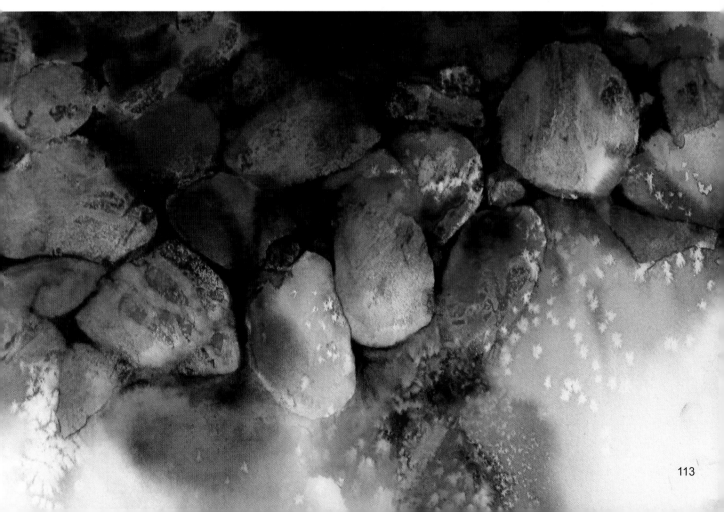

# Capturing mood through atmospheric perspective

11" x 30" Karlyn Holman

*Color is probably one of the most potent tools for creating mood. Gray days allow a creative opportunity to paint mood and atmosphere. Mood is suggested by your choice of subject matter and the sequence of colors you use. For example, by creating grays, you can suggest the peaceful feeling of a rainy afternoon in France. Sometimes capturing a gray day is a welcome challenge and a change from always capturing the light and shadows dancing on a subject (layering color on pages 22-23).*

*If you are an en plein air painter, one thing you can count on are those flat days when there is no sun. One of the most effective ways to capture this gray feeling is to use all the primary colors at once, allowing them to mix on the paper until they only retain the essence of their original colors and glow into a tonal gray. You could achieve a gray feeling by limiting yourself to only complements, but using all three primaries means that you have all the complements on the paper at once. The key to this lesson is working on very wet paper and tipping the paper to encourage the colors to blend until they are as **gray as the day.***

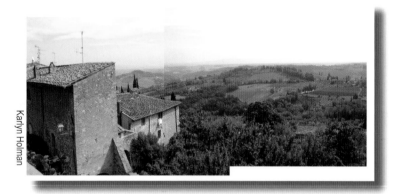

Karlyn Holman

This particular day in Tuscany, we had a few moments of sun, but basically the day was totally gray.

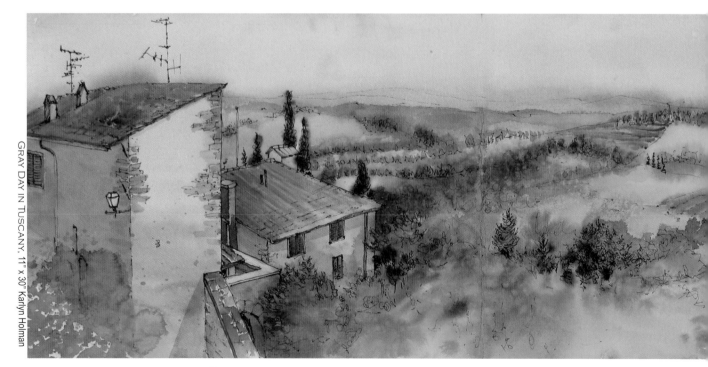

GRAY DAY IN TUSCANY, 11" x 30" Karlyn Holman

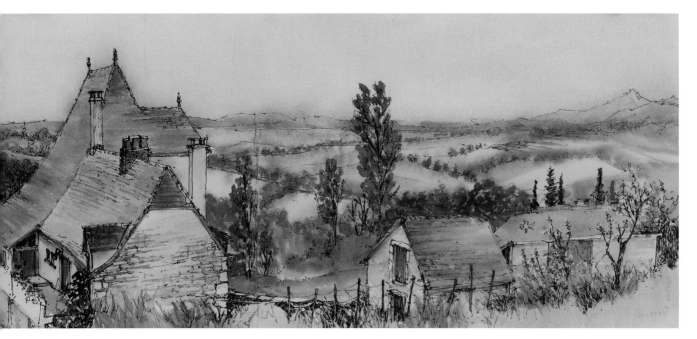

On the day I painted this scene of a little town in Southwestern France, the sun was not even thinking about coming out. Trying to capture this gray, moody day provided a welcome alternative to painting the usual sunny scene. This long rectilinear shape is absolutely perfect for capturing a panoramic subject. Simply tear a full sheet of watercolor paper in half (11" x 30").

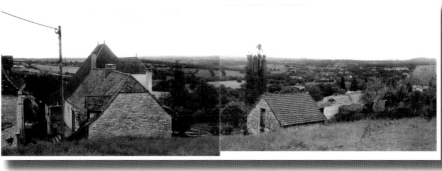

Karlyn Holman

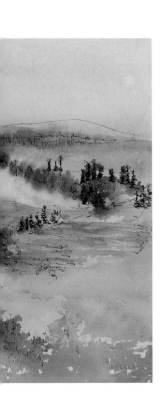

The triad of primary colors used in these paintings was aureolin yellow, quinacridone coral and cobalt blue. After wetting the paper and blending these colors into a gray, I used this simple formula to achieve atmospheric perspective. Starting with the farthest background, use only blue with a little red to create a cool, atmospheric blue or blue-violet. As you move into the middle ground, the reds and red-violets will begin to appear along with some dark greens. Finally, as you paint in the immediate foreground, the greens and yellow-greens will predominate.

# Using your memory to interpret color

Sunny days also provide a great opportunity for creating mood. Color can capture the joy you feel when experiencing a beautiful day at a great painting site, such as this bright and cheerful scene at the busy seaport town of Vernazza in Cinque Terre, Italy. We carefully chose a restaurant with an incredible view, ordered our first round of coffee and put pen to paper. As our drawings progressed, we ordered several appetizers and then a medley of seafood and some wine. To buy more time and prolong the fun, we even ordered dessert and more coffee. At last, we had to leave, and we reluctantly headed home to our studio. Later, when we painted our drawings, we had to rely on our memories of the colors surrounding us on that beautiful day, resulting in fresh and playful interpretations unrestricted by the reality of the actual scene. We applied pure color directly, letting only harmonic colors mix. As the paintings developed, we relived the sounds and smells of the scene and all the fun we had sharing our lunch together on that wonderful day.

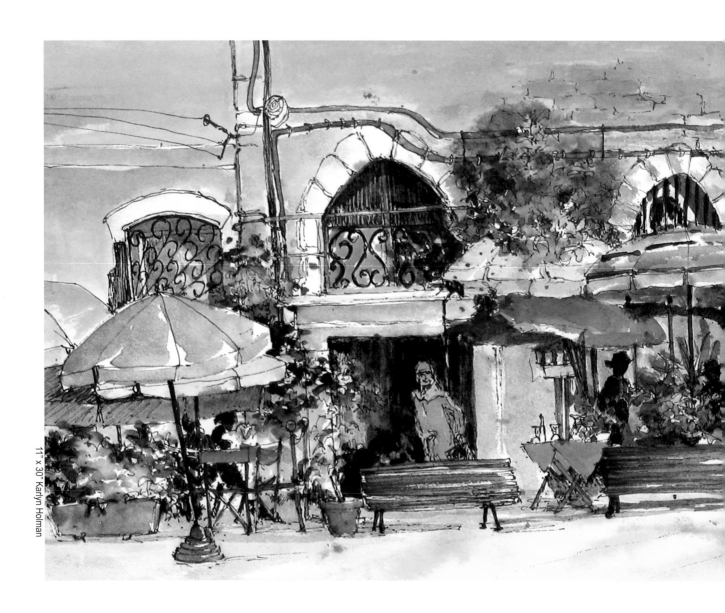

11" x 30" Karlyn Holman

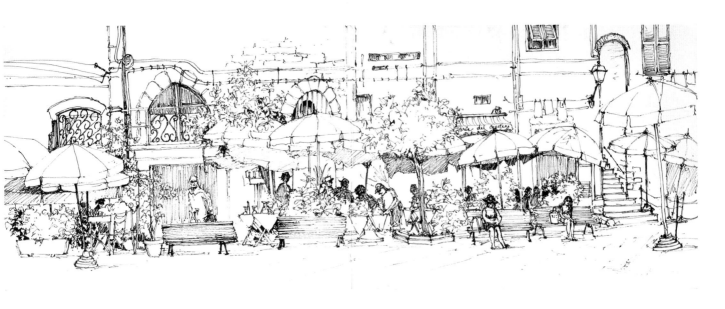

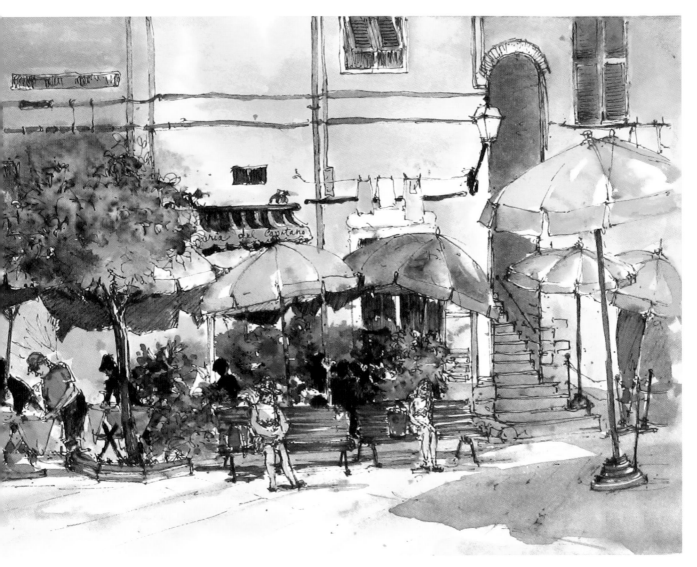

# Painting from two perspectives

*There are two perspectives, linear and aerial (atmospheric). This painting of a rainy day in Venice illustrates a perfect example of both types. Using both linear and atmospheric perspectives together is ideal for interpreting wet, misty subjects that have few hard edges and a fusion of colors. Because the colors are so diffused in this scene of St. Marks Basilica, I chose to draw the subject with a permanent pen, providing linear perspective. To create the atmospheric perspective, I placed the painting in an upright position and applied many layers of color onto the dry paper.*

1. Use pen lines only in the foreground and avoid using them to describe distant elements such as mountains. The hard lines will look out of place in the soft background.

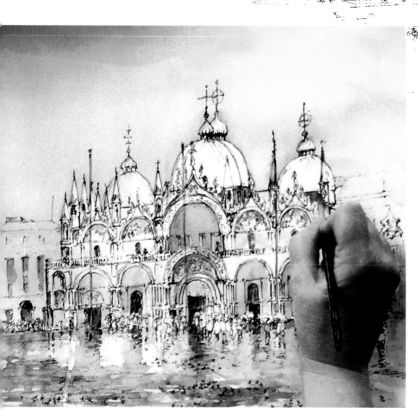

2. It is difficult to figure out where to start painting a subject that has such diffused color. I placed the dry paper in an upright position and started by layering warm colors and cool colors in the sky and foreground. When the colors dried, I directly painted the hues of burnt orange and gold over the doorways of the Basilica. These rich colors were painted on dry paper to simulate the medieval mosaic decorative exterior of the building. Use color freely and playfully during this step. This was the perfect time to interpret the cast shadows.

Even on a misty day, there would be shadows in the doorways and windows and those cast by people with umbrellas.

Karlyn Holman

3. To enrich the warm, atmospheric mood, I continued adding more layers of color with the paper still in the vertical position. When your paper is in this position, gravity will pull the paint downward, forming a bead of color that you can slowly manipulate with the movement of your brush. You will be amazed how easily you can change color from warm to cool or dark to light; the transitions are magical. Remember, your paper should be dry, making it easier for you to pull the color around the areas where you want to save the lights in your painting. Continue layering until you achieve the atmospheric look you like.

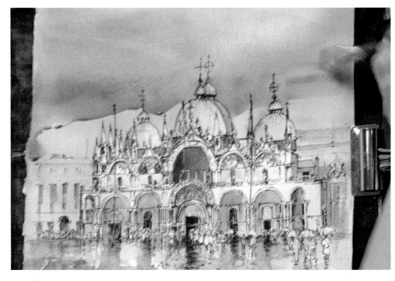

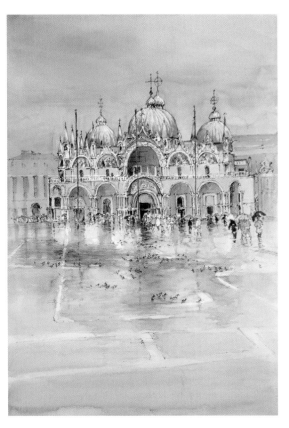

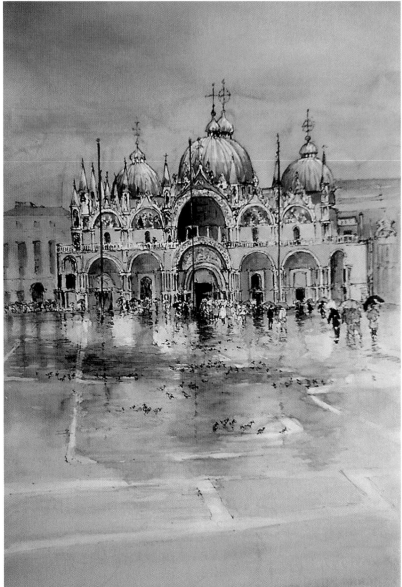

4. The final step was to layer deeper value colors over the skyline, through and around the shapes in the Basilica and throughout the immediate foreground to create dramatic light and dark patterns.

15" x 22" Karlyn Holman

# Painting in a vignette style

*A vignette relies on leaving some areas around your subject less finished. This fosters a fresh and spontaneous look in your paintings, as well as keeping the emphasis on your subject. It is very important to remember that these "less finished" areas are just as important as the "finished" ones. There seems to be no clear definition of what constitutes a vignette. Some artists feel a vignette must be surrounded by white, but to me, a vignette simply means softened edges. I hope the following examples and ideas will be helpful in your pursuit of the mysterious "vignette."*

There are many ways to soften or melt edges into a vignette style.

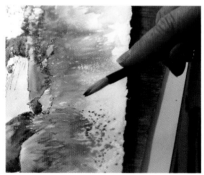

Gently spatter paint (page 155) to form spots of color, slowly thinning out the spots as you approach the edge of the paper.

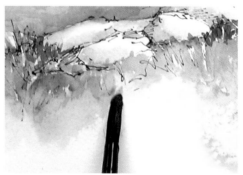

Simply wet the edges of the wet pigment and soften the edge. Keep adding clean water until the pigment is dissolved into the white paper.

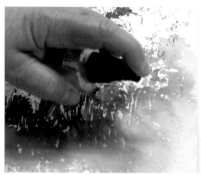

Spraying an edge of color with a fine mister (page 155) is my favorite way to vignette a subject because the color softens in slow motion. The first spray appears to do nothing, but gradually the paint moves from one fine mist spot to another and forms a softened edge.

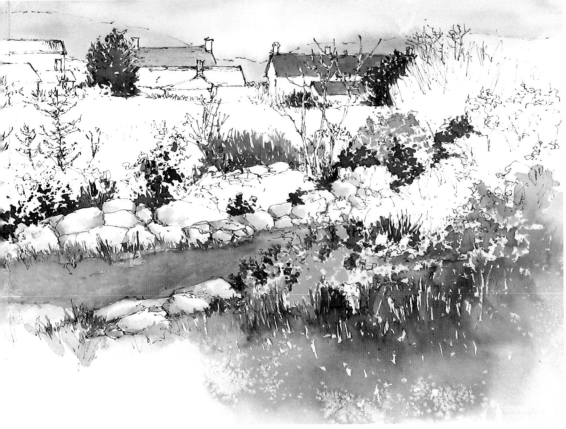

The gorse bushes were painted by tapping the color onto dry paper with a natural brush (page 156). A sable or oriental brush will release the color and form spots on the paper. Mix the colors of the flower and, with a tapping motion, you can create a lovely, textured pattern that resembles the flower itself. If the spots are too small, use your brush to tap in clear water to expand the size of the shapes. Add harmonic enrichment to the flowers and use contrasting darks to finish. Keep the crisp whites in the main composition, and as you approach the edges of the paper, melt the whites into the greens with your fine mister.

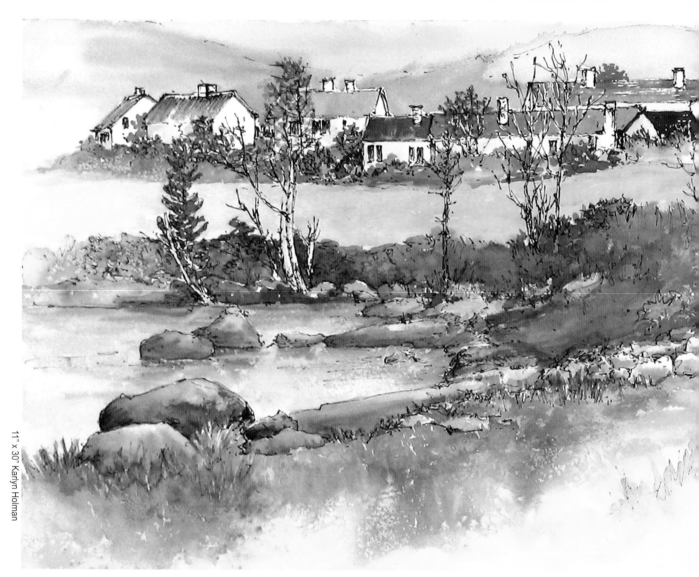

This panoramic vignette evokes a perfect memory of our host village of Sneem, Ireland. Our *en plein air* painting group spent four days painting the sites in this quaint, tranquil little village of three hundred people and eight pubs.

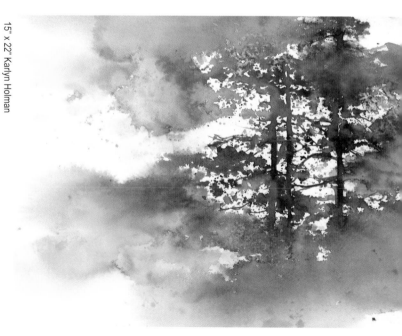

In this impressionistic vignette, I relied on a fine mister to direct and melt the colors and allow them to find their own path of movement. I applied the colors by tapping them onto a dry surface using an oriental brush. The reason I worked on dry paper was so I could save some crisp whites. The crisp white pattern of light zigzagging through the composition provides a great contrast to the lost vignette edges. I continued to add more intense color until the paper dried.

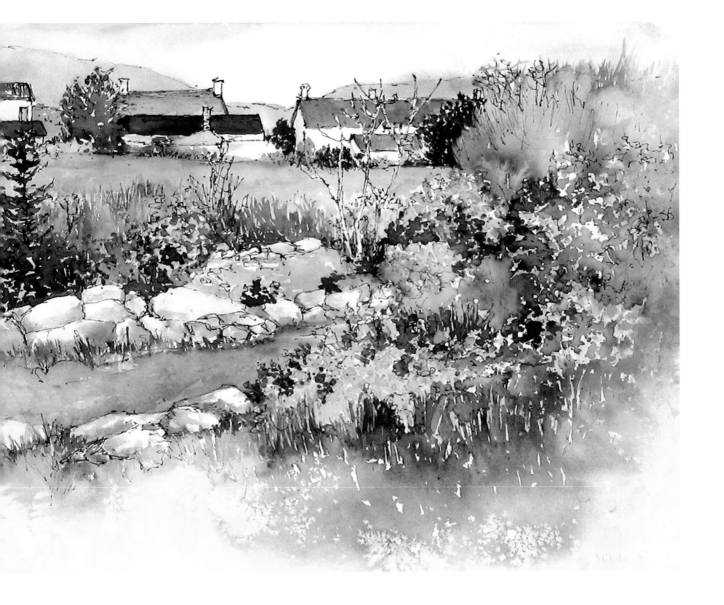

This interpretation of deep woods in autumn is impressionistic in that I did not try to paint every leaf, but merely tried to capture the feeling of the season. I applied the colors by tapping them onto a dry surface using an oriental brush. My goal was to create a crisp pattern of light and dark in the center of interest with soft vignette edges. A fine mister carefully sprayed into the edges of the wet paint gradually softened the color. A painting of such a busy subject relies on soft edges for visual relief. If an entire painting is "in focus", the viewer does not know where to look.

15" x 22" Karlyn Holman

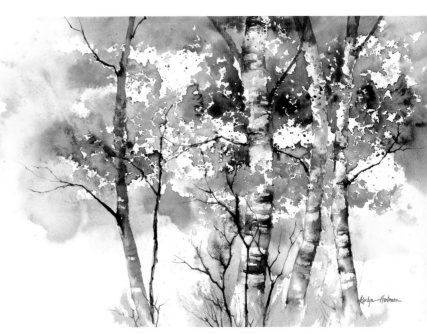

A simple way to vignette a painting is to wet the paper selectively. These flower paintings were wet to within one inch of the edge of the paper. This provided an "instant vignette" because the color only moves in the wet areas. These paintings were also painted on hot press paper and the uneven drying helped create a random vignette look. Try this technique on any wet-into-wet underpainting by either taping the edges or just "winging it" and leaving an edge of the paper dry.

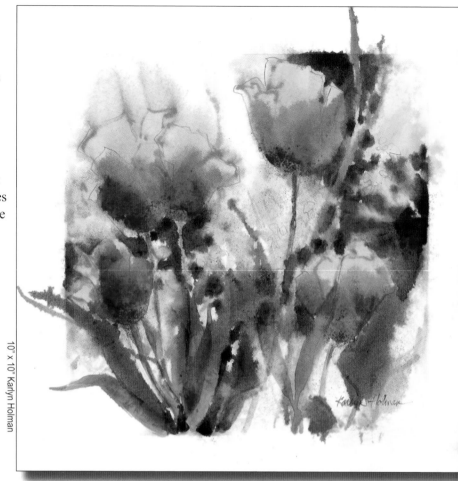

10" x 10" Karlyn Holman

Flowers are a favorite subject to vignette. Generally, light shapes are used to form the less finished areas but dark shapes also will work. The dark shapes in this painting form the important connecting links to the edges of the paper.

*Using a vignette style for a loose and free look*

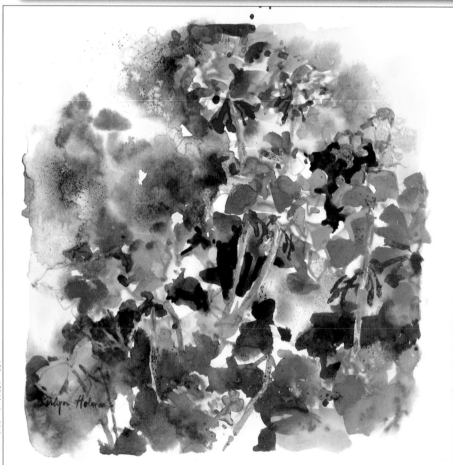

10" x 10" Karlyn Holman

Landscapes are so much more appealing when the edges are softened. This keeps the viewer more focused on the subject and makes your art more expressive and less photographic.

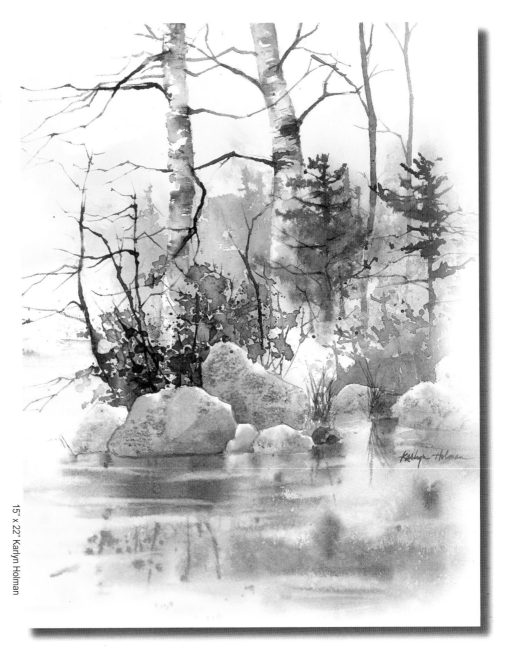

15" x 22" Karlyn Holman

Beverly Dehn created this lovely pen drawing of her dog, Willie, by working in a pointillist style. This dot technique forms a variety of edges and values. The more dots that congregate, the darker the value. The dots literally thin out and disappear into the white spaces.

Beverly found Willie on the highway in a snowstorm and from that moment on, he has been her constant, well-loved and well-behaved canine companion.

WILLIE, 8" x14" Beverly Dehn

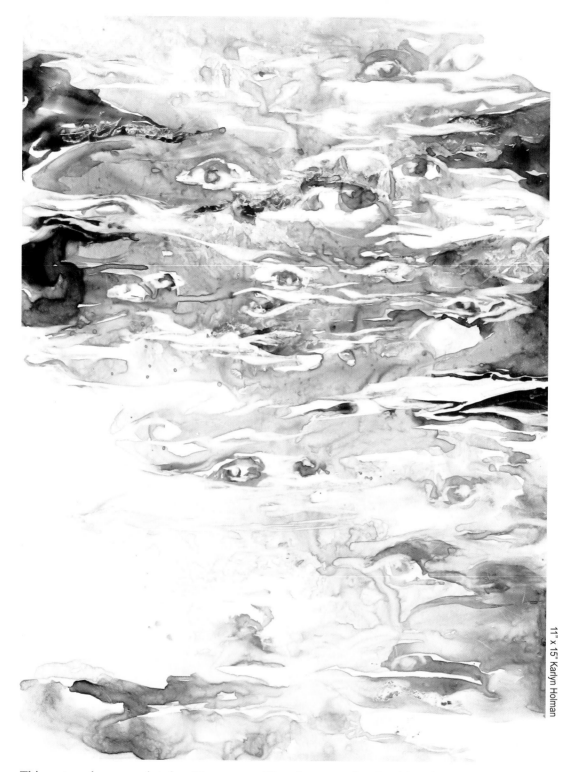

11" x 15" Karlyn Holman

This watercolor was painted on Yupo paper. The vignette style of melting the edges helped make the subject look like water. The white shapes in the water and the background are the unpainted parts that link the painting to the edges of the paper.

The image was painted after I participated in a meditation where "I became the water." All my life I have had a fear of water. I lost two childhood friends to accidental drowning, one at age seven and the other at age twelve. I finally learned how to swim as an adult. This meditation helped me remember my lost friends and helped me understand why I fear water. I was amazed that the movement in the water turned into watchful eyes.

# Designing white shapes that link to the edges of the paper

Bridget Austin is a master at designing white shapes throughout her compositions. These carefully selected unpainted areas illustrate a perfect vignette style of working. The white shapes move gracefully throughout her compositions and link to the edges of the paper. Intuition, spontaneity and skillful planning play a strong role in Bridget's design sense.

These computer-generated black and white illustrations dramatically point out the skillful planning used to link the carefully designed white shapes. Notice how the dark shapes are anchored to the edges of the paper on all sides.

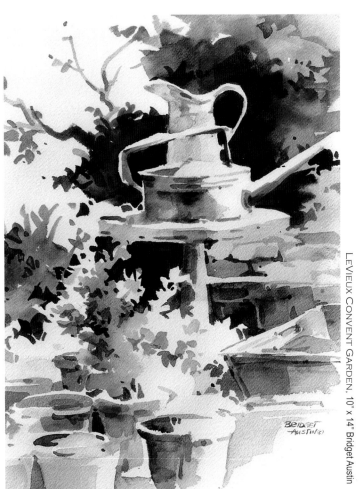

LEVIEUX CONVENT GARDEN, 10" x 14" Bridget Austin

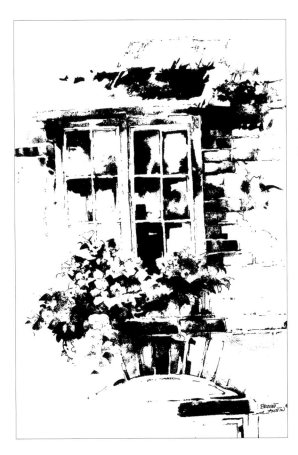

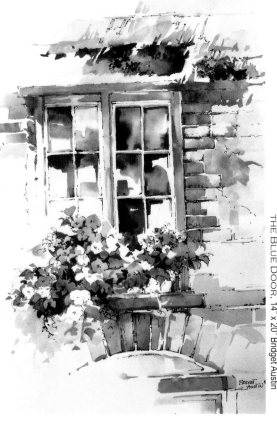

THE BLUE DOOR, 14" x 20" Bridget Austin

These paintings were all painted while staying at Le Vieux Couvent in Southwestern France. This 17th century former convent has been transformed into an inspirational art school. The school offers daily excursions to colorful medieval villages to paint *en plein air.* Students may then return to the well-equipped and beautiful large studio space to contemplate and work on their creative adventures.

This picturesque village of St Martin de Vers has a beautiful river running through it and offers a perfect painting site. Bridget uses the freshness of the white and soft gray shapes to suggest movement throughout the painting.

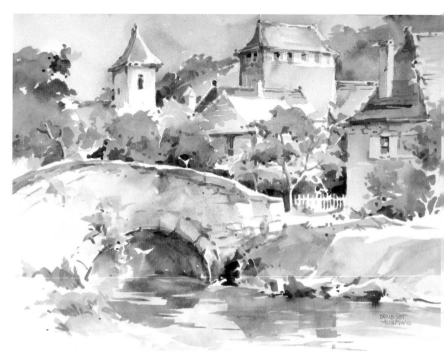

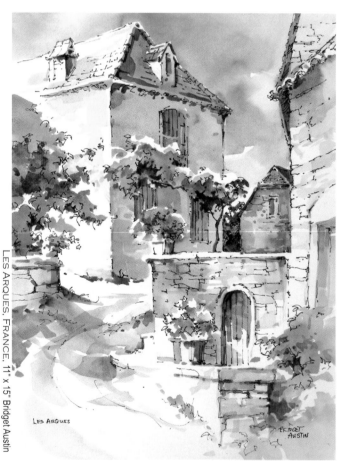

LES ARQUES, FRANCE, 11" x 15" Bridget Austin

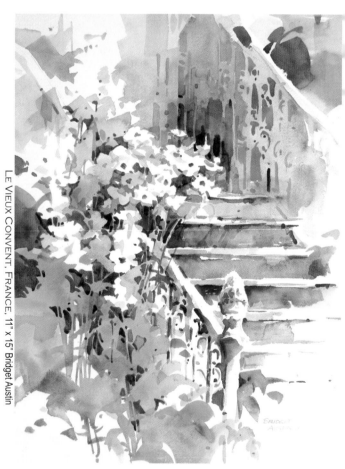

LE VIEUX CONVENT, FRANCE, 11" x 15" Bridget Austin

This is the little hamlet of Les Arques, the small town made famous by the book; *From Here, You Can't See Paris* by Michael Sanders. Bridget wanted to save large, simple shapes for a quick, on location study. The ink lines and some additional paint detailing provided a finishing touch.

The light on this stairway to the studio at Le Vieux Couvent was compelling, but the repetitive detail was a problem. By vignetting the subject and just suggesting the railings and flower detail, tedious work was avoided and a fresher look achieved. When I teach at Le Vieux, we often stay on site because the Couvent offers a wealth of subject material—beautiful gardens, grape arbors, seven koi ponds and so much more.

By taking some of the emphasis off the repeated shapes of the windows and concentrating on the door and adjacent window, Bridget was able to bring forth the real subject of this painting- the colorful pub and patrons.

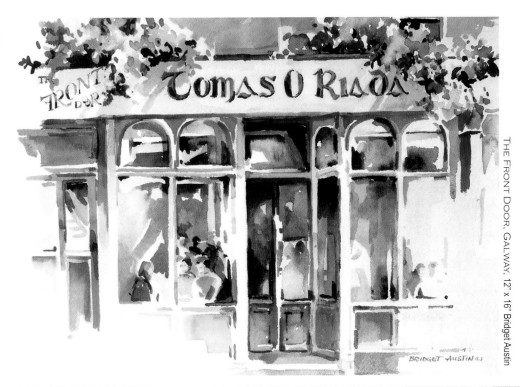

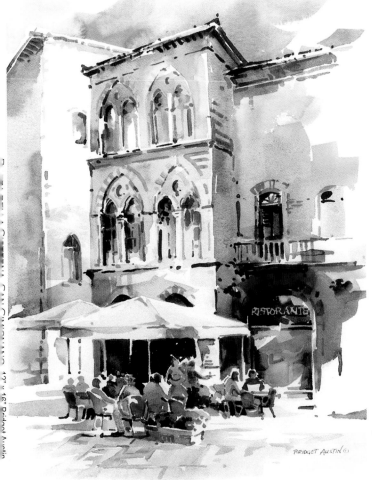

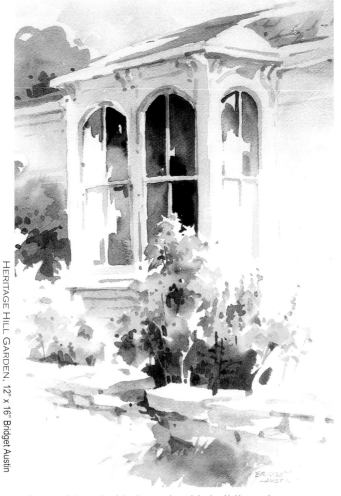

This pleasant café and the building areas right next to it are filled with detail. The buildings on either side are simplified and literally fade into the edges of the paper, illustrating a perfect vignette style.

When Bridget decided to paint this building, she saw three solid black windows. By simplifying the dark windows into light shapes, losing the edges and perking up the color, Bridget actually draws the viewer into her painting.

# Creating a focus of light

*Learning to create a focus of light can intensify interest in your paintings and add excitement to your work. While strolling though a green house in Florida looking at flowers, I came across these koi in a pond. The light played a major role in capturing my interest in the subject. I have always enjoyed these colorful fish, but never had any desire to paint them until I was intrigued by the playful patterns of light on this particular day.*

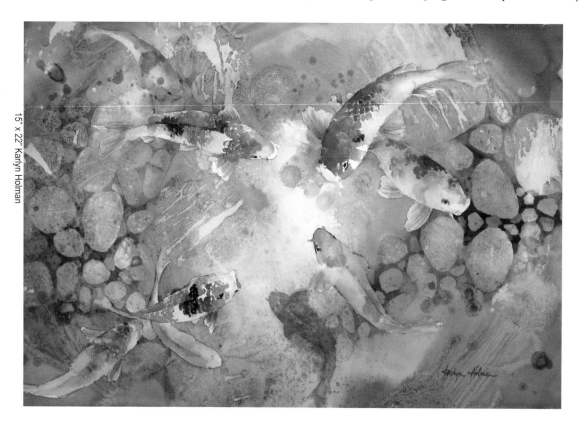

15" x 22" Karlyn Holman

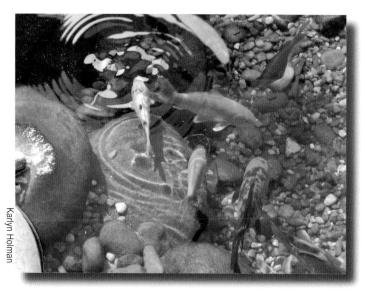

Karlyn Holman

Approach this lesson spontaneously by drawing only a few fish and placing them in a focal position. Starting with only a few fish allows you to make creative choices as you paint. Mask them with a clear maskoid (page 154). Using the method for making paper dolls, fold waxed paper several times and cut out a variety of rock shapes.

Select a triad of non-staining primary colors. I chose aureolin yellow, permanent rose and cobalt blue. Wet only the front of the paper because you do not want to wet the back of the areas that are masked. Begin by painting a spiral shape with your yellow, continuing with a spiral of rose and lastly a spiral of blue. Save some whites in the center. A spiral shape is preferable to a "bulls eye" because the spiral creates an echo of color beyond the circle. Keep spraying water with a fine mister and tipping and turning the paper until the colors melt together into a continuous graded wash.

Place the waxed paper shapes on top of this wet underpainting. Think about your pattern of movement as you select areas for placement of the rocks. The rocks should be placed in a counter movement to the fish (cruciform composition on page 56). Be sure to leave some areas of rest. Stretch some medical gauze over the waxed paper shapes until it forms a linear, circular movement over and around the rocks.

Select a color dominance of warm or cool colors. I chose a cool dominance using phthalo green, Antwerp blue and ultramarine blue. I carefully painted on top of the waxed paper rocks and the gauze. Continue to mist the paper to keep everything wet. Try to save some of the original warm underpainting to maintain the inner glow. Keep misting and tipping the paper to allow some of this cool color to go under the waxed paper and into the gauze. A little salt carefully placed in the light areas creates a watery impression.

When the painting dries, remove the waxed paper, salt and gauze. Select the placement for more koi and with a cutout stencil, simply dampen a Mr. Clean Magic Eraser® and remove the color from the surface. Be sure to place the additional koi in a counter movement to the rock shapes (cruciform composition on page 56). Vary the sizes of the fish to create the illusion of depth.

Now it is time to practice your negative painting skills. Select a variety of dark colors to accentuate the rock shapes. Be sure to leave some edges, lose some edges and melt the color into the background.

Practice your positive painting skills by painting the koi and a few rocks. To paint the koi, wet the fish shape and add harmonic colors. Finish the koi with some crisp colors to simulate the scales.

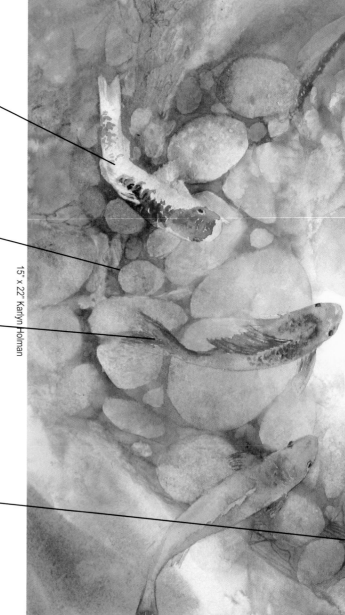

15" x 22" Karlyn Holman

As this painting progressed, the rocks that I painted as positive shapes suddenly looked like someone was mooning me. A carefully placed fish eliminated this unfortunate circumstance.

If you used Arches® paper, you can let the painting dry thoroughly and then rewet the entire piece, adding some washes of color to make the fish and rocks appear to be underwater. Other papers may reactivate the under colors, resulting in muddy, less vibrant hues.

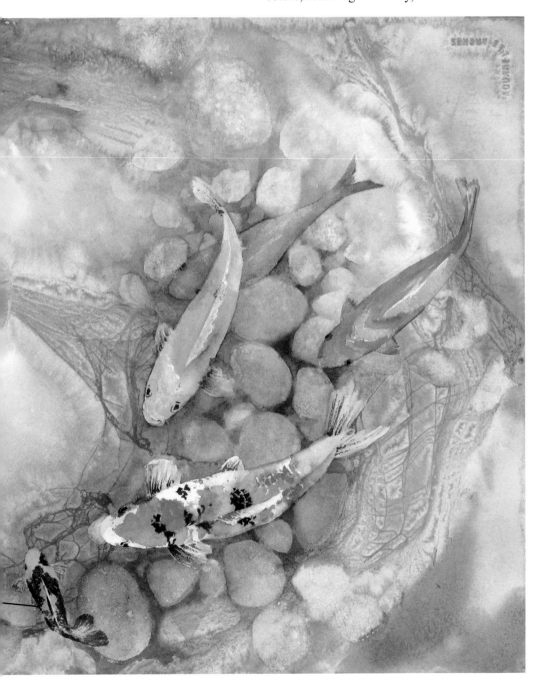

# Helpful tips with Mr. Clean Magic Erasers®

*Mr. Clean Magic Erasers® are very handy for lifting color on an overworked painting. As hard as we all try to save our lights or whites, sometimes it becomes necessary to take drastic measures to reclaim these lost white areas. This overworked painting of artichokes kept getting darker and more layered until there were no soft edges left on the shapes. A damp Mr. Clean Magic Eraser®, a sponge readily available at your grocery store, saved this painting. By simply moving this damp sponge over the surface, the color lifted and softened and eventually linked those valuable lights to the edges of the paper.*

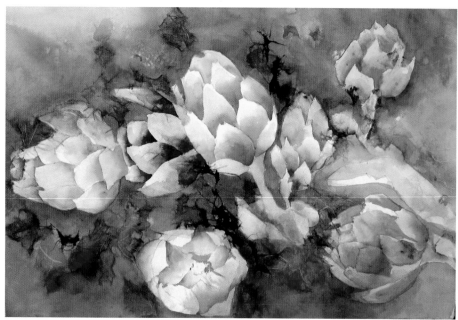

Before

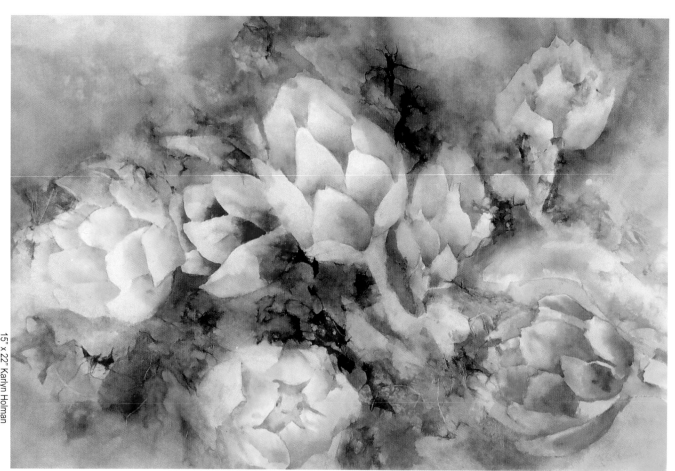

15" x 22" Karlyn Holman

After

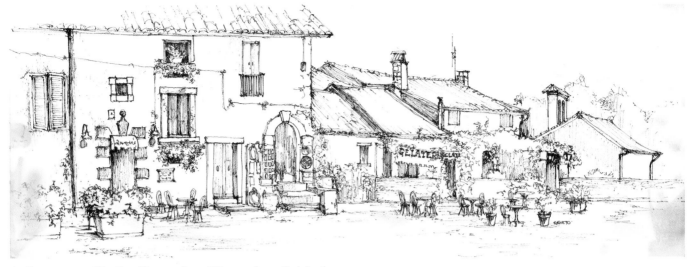

A disastrous spill of coffee ran into fifteen of my finished drawings. Weeks and even months after the incident, a Mr. Clean Magic Eraser® lifted the coffee stains and not the permanent ink from my artwork.

11" x 30" Karlyn Holman

This underpainting was prepared on hot press paper using real grape leaves as stamps and cut out waxed paper for the grapes. (*Searching for the Artist Within*, pages 142-143.)

A transparency with a cutout grape shape was the perfect solution to use for a stencil. A Mr. Clean Magic Eraser® enhanced the painting by gently lifting highlights on the grapes. To finish the painting, I added collage paper and connected the darks.

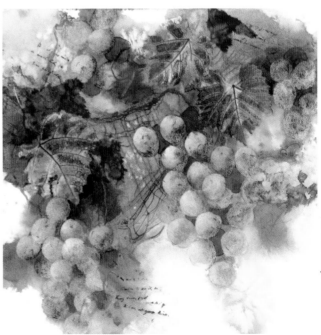

10" x 10" Karlyn Holman

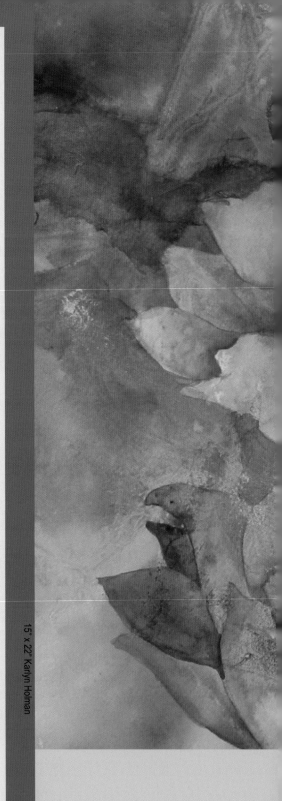

15" x 22" Karlyn Holman

# Pushing the boundaries of traditional watercolor

**M**oving into the realm of spontaneity is often frightening. You are leaving the comfort of working with a great deal of control and entering into the new arena of spontaneous imagery. Be courageous and allow your paintings to take on a life of their own.

Maintaining a balance between expressing your artistic creativity and displaying technical mastery is a real challenge. You need to understand and master the technical side of media, but you do not want to get bogged down with technique. Technique should be used as a departure for your painting. You are not trying to copy a photograph; you are trying to put a little piece of yourself in each painting. When you allow yourself to interact freely with color and composition, you are actually sharing a part of yourself and inviting the viewer into a more intimate experience. You are not just pleasing the eye, you are pleasing the soul—your soul as well as that of the viewer.

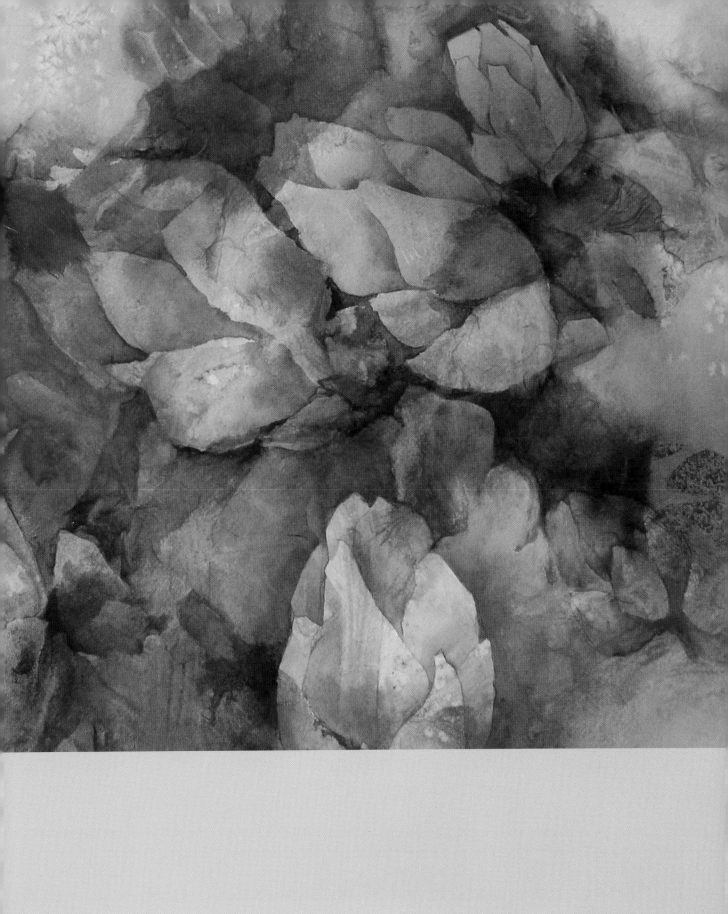

# Layering—from color to concept

*The term layering does not refer only to the application of color over color. Although you can use layering to neutralize or intensify color, enhance or cover up color, or make a color more subtle or dynamic, you can use this technique to accomplish so much more. You can invoke the magical mysteries of life by layering mystical signs, hidden images, and ancient or sacred symbols within your works. Layerists frequently work in mixed media. They, glue, digitalize, weave, stamp, paint, draw—whatever it takes to express their ideas. Layerists know no boundaries when attempting to interpret profound subjects.*

Susan Luzier is a master of layering. The colors she uses are determined by the mood or the message of the painting. The glowing and soft edges in her work are the result of as many as thirty layers of color.

"Layering is a way for me to become intimate with my own creative process. It allows me to step back, consider options and techniques, wait and listen for that intuitive voice to guide me. When I layer I feel like a facilitator; the painting has a life of its own as it speaks to me, encouraging me through the process. I love not knowing how my painting will turn out…just trusting…the more we trust, the more the answers will come…as in life"

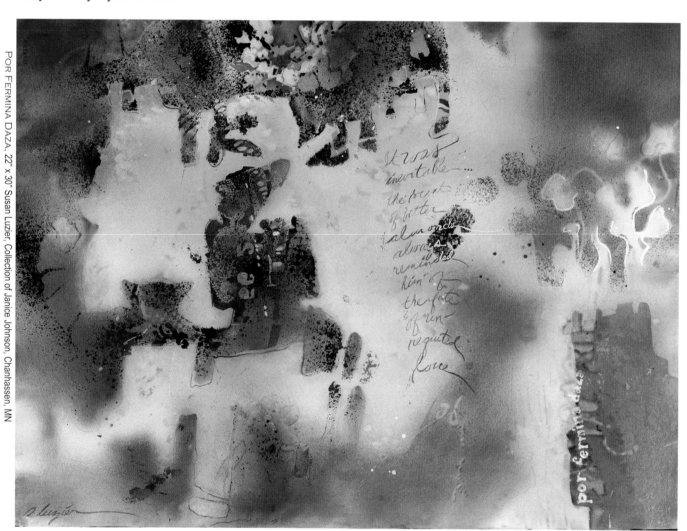

"My specific goal for this piece titled Por Fermina Daza was to honor the characters of my favorite novel, *Love in the time of Cholera,* by Gabriel Garcia Marquez. Throughout the painting process, I focused on my feelings about the novel hoping to capture a sense of the exotic and the whimsical nature of love. The script in the painting is the opening line of the book".

"Paradigms makes use of the written word, your personal language can be literal or it can come from symbols. Here it is combined with a splash of patterns and some quiet areas to set it off. The painting emerged from a simple still life of an airplane plant on a table."

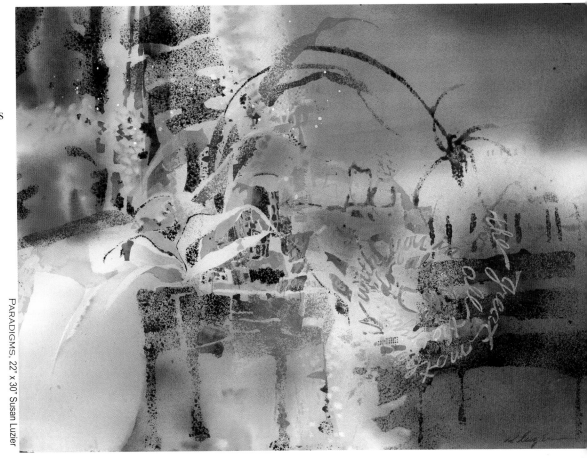

PARADIGMS, 22" x 30" Susan Luzier

"My Aquarians journey series is about letting go of things in my life and eliminating notions that restrict me in my painting. Keeping that thought in mind, I tried to say as much as I could using as little effort as possible. These paintings please me because they feel free and unrestricted."

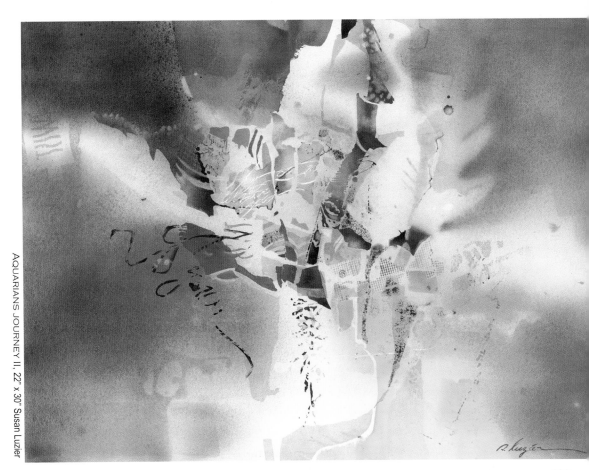

AQUARIANS JOURNEY II, 22" x 30" Susan Luzier

The first layer sets the stage for the pattern of white shapes. Susan rips paper and lays down cut stencils and objects to create a visual playground of texturizing agents. She uses Arches cold press paper because as she rewets each layer, the successive layer does not reactivate the previous colors. Once she has established a pleasing pattern of light, Susan chooses an area to develop by selecting an area of white into which she slowly builds a center of interest. Using colors and symbols that are meaningful to her, she interlocks and overlaps subsequent areas using a wet into wet technique or layering, creating mood, pattern and shape.

After the colors dry, each successive layer is accomplished by thoroughly wetting the paper and using a roll of paper toweling, like a rolling pin to take away the excess moisture. This toweling technique leaves a slightly damp surface that softens the color when it is applied, resulting in a glowing effect.

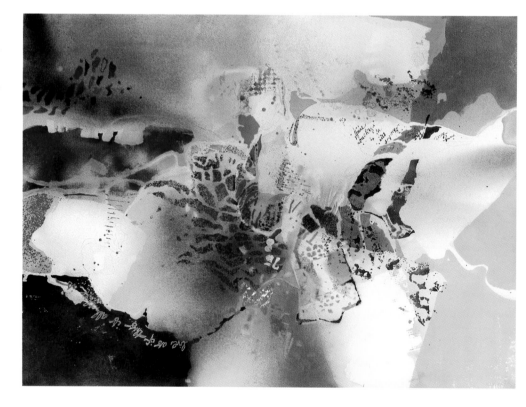

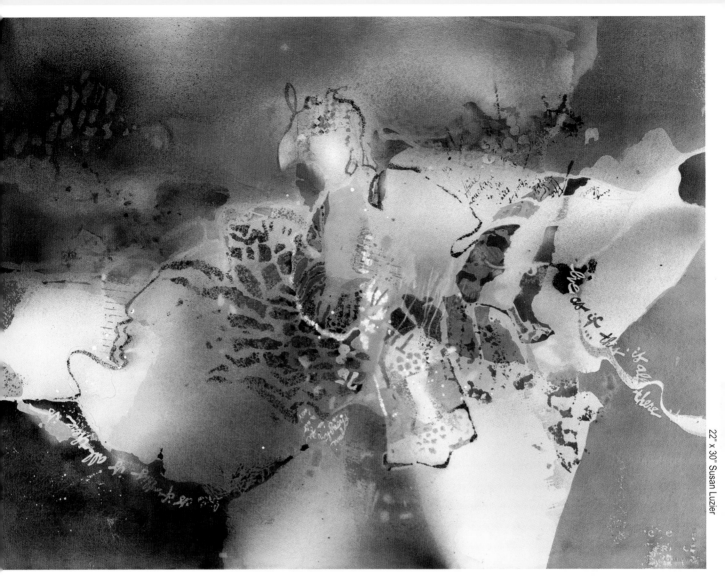

22" x 30" Susan Luzier

As a pattern painter, Susan uses many ways to embellish the surface. One of Susan's favorite patterns is the vibrating marks made by spraying color with an atomizer into cut out shapes on vellum paper. These lovely edges are so appealing and it would be difficult to capture the same look with a brush.

Susan continues to develop the painting with the mood always uppermost in her mind. All the techniques she uses are integrated into the dynamics of "mood".

# Creating textural surprises or "planned accidents"

*Experimenting with the paper surface before you begin painting is an exciting option. You are creating an "accident on purpose." When you apply paint to this enhanced surface, the color absorbs into the surface unevenly and many surprises appear. You are setting the stage for unpredictable and spontaneous effects to happen. What could you add to induce a "planned accident?"*

*For this demonstration, I chose artichokes because they are a perfect subject for a textured painting. These lovely vegetables are one of the oldest foods known to mankind. These exotic, colorful and highly textured vegetables first caught my eye while I was browsing through an open air market in France, and I was inspired to use them as a subject.*

"Eating an artichoke
is like getting to know
someone real well."
– Will Hastings

In the 16th century, eating an artichoke was reserved only for men. Women were denied the pleasure because the artichoke was considered to be an aphrodisiac and was thought to enhance sexual power. There is also a legend that the artichoke is effective in assuring male offspring.

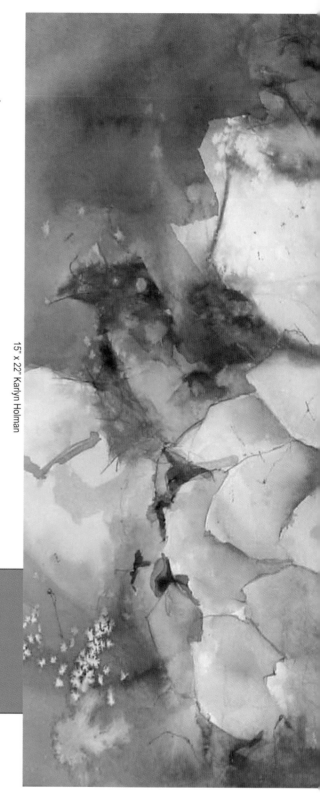

15" x 22" Karlyn Holman

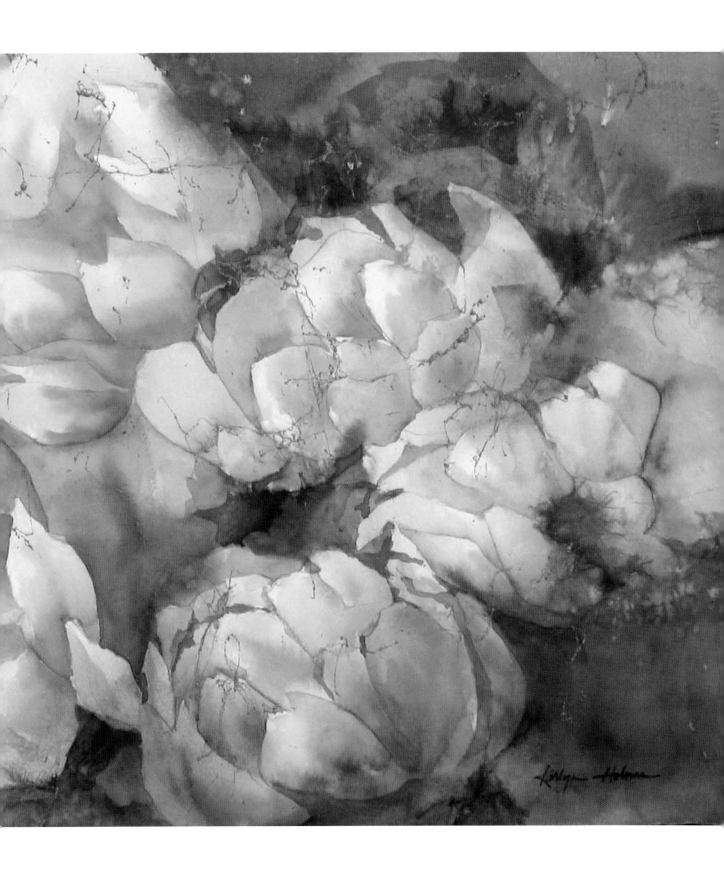

I. The first thing you need to do is create the textured surface by using an assortment of oriental papers such as chiri, kinwashi, and unryu. For this demonstration, I glued the papers on Arches®140# cold press paper with Yes! Paste™. This glue leaves a workable surface that allows me to paint over the papers with watercolors and not experience any resist. Gel medium also can be used as a texturizing device and can be applied with a brush or a palette knife. Gel medium acts as a resist and is best used with acrylics. Allow these texturizing devices to dry.

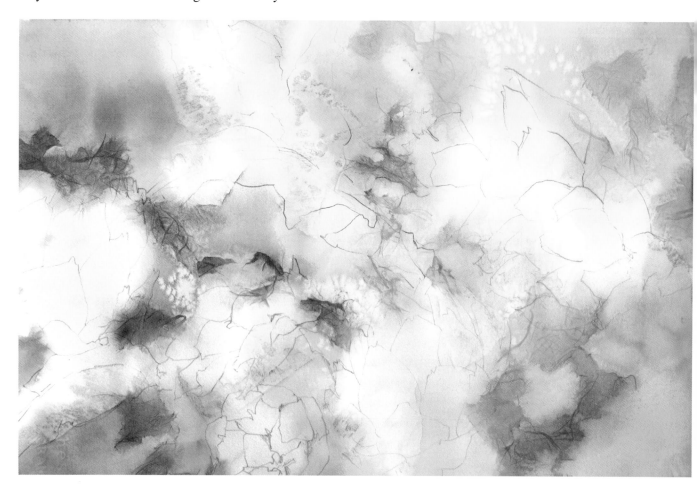

You are now ready to begin your drawing on the somewhat bumpy surface you have created. Hold the artichoke in your hand, turn it around and upside down and concentrate on drawing only the contours and some of the inside shapes. Look at it from the top and every which way you can to give a new perspective on the textures. After you have interlocked, overlapped and touched the edges of the paper with these intriguing shapes, you are ready to wet the paper and play. Remember, you are already setting the stage for a spontaneous experience just by changing the scale and inventing your own design.

Select your colors, keeping in mind that color creates emotion. Using harmonic colors and allowing them to mingle and drip on your paper is pure joy. I chose the colors of Winsor yellow, quinacridone gold, quinacridone coral and Antwerp blue. Wet your paper and circle your paper several times with these colors, being careful to only paint around the shapes that you drew. Enjoy the textural effects that just happen. Tip the paper, spray into it, throw on more color, and even lift color. Try whatever works to help the paint move over and around the textures.

2. When your underpainting dries, layer more color to develop a movement of dark shapes until you are pleased with the results.

*Water and pigment always have fun together*

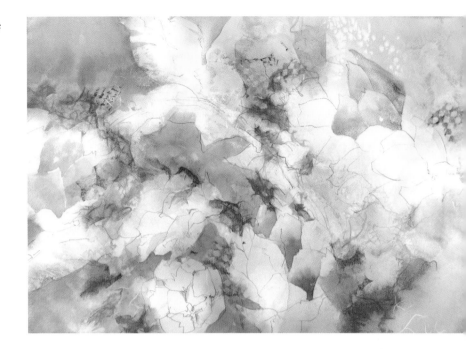

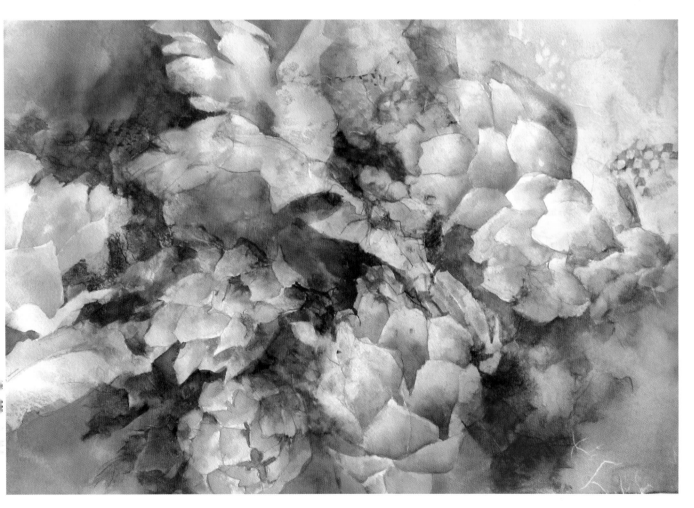

3. As you finish your painting, think of various ways to add breadth and depth. Take the liberty to layer warm colors over cool and cool colors over warm, soften some edges, and add more collage paper. The paper has a mind of its own and now is the time to play and experiment on this unique surface.

145

# Capturing the essence of your subject

*This lesson will focus on capturing the essence of a recognizable subject by starting with a spontaneous, free approach that later pulls in a bit of realism. We will start by selectively wetting the paper and throwing the color onto the surface and finish by pulling the painting into some degree of realism. The objective is to "push and pull" the tension to arrive at a semi-abstract interpretation. We will use analogous colors, directional movement and lost and found edges.*

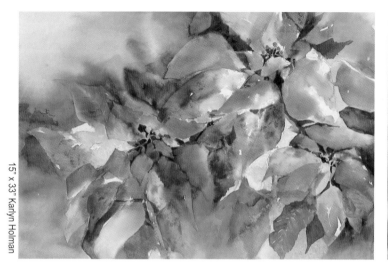
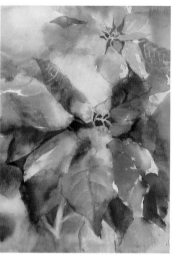

15" x 33" Karlyn Holman

This poinsettia was painted using the technique outlined below. The complementary colors of red and green add visual excitement to the subject.

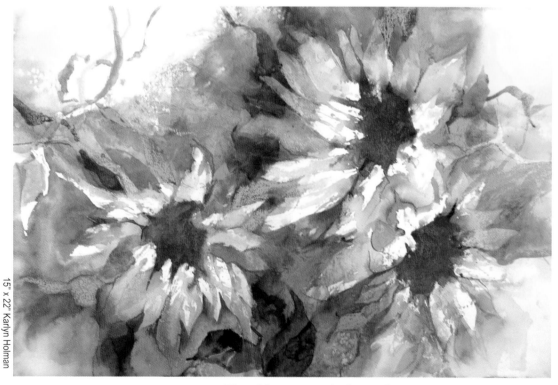

15" x 22" Karlyn Holman

The white patterns in the sunflowers were all saved by this random approach of throwing the color. Additional linear shapes and opaque color were added with Caran d'ache® crayons drawn directly on the surface.

I chose sunflowers for this demonstration. Sunflowers in a field generally face the same direction but this photograph of a bouquet of sunflowers offers many directions, which makes it much easier to design interlocking shapes. Using a pencil, sketch a very loose interpretation of the sunflowers.

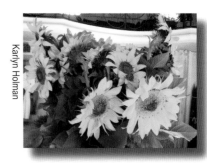

Karlyn Holman

**I.** Start on dry paper, and using a natural fiber brush, spatter random rich yellow color into the petal shapes. The natural fibers of a sable or oriental brush release the paint, whereas a synthetic brush will not release the paint at will. The dry shapes within the petals will remain white. Try to throw the paint in the direction the petal is facing.

**2.** Continue adding harmonic colors and do not worry if some of the color lands in the background area. If the thrown shapes are too small, simply throw in more water to expand them into a larger size.

**3 & 4.** Next, brush some of the color in the petals to meet the edges of your drawn pencil lines, being extremely careful not to lose any precious white shapes.

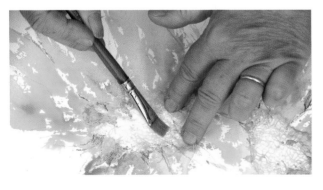

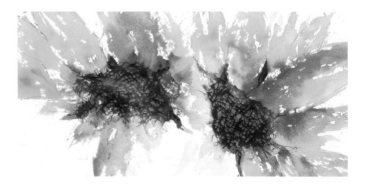

**5.** Wet the sunflower centers and cut and place a single layer of medical cotton gauze to fit the shape.

**6.** Paint very rich warm colors over the damp gauze. Remember to avoid a perfectly round center and try to create as much variety as possible.

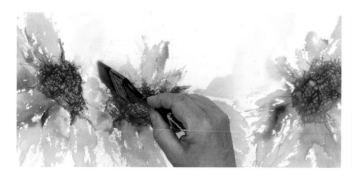
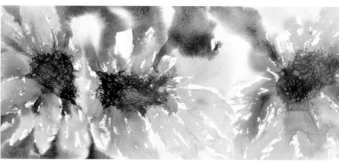

7. Wet the background area only and start moving harmonically around the dry/wet petals.

8. For this demonstration, I chose Antwerp blue and permanent magenta to start the wet-into-wet background.

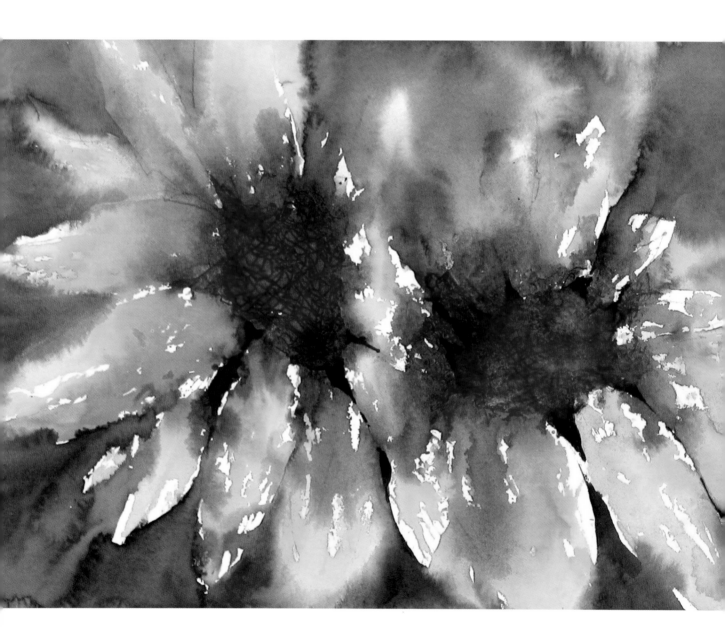

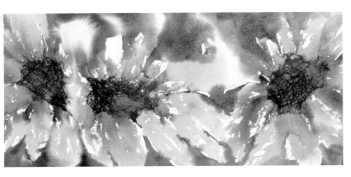

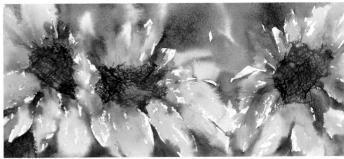

9. When some of the wet petal color touched the Antwerp blue, blended greens were formed.

10. Permanent magenta was added for harmonic enrichment.

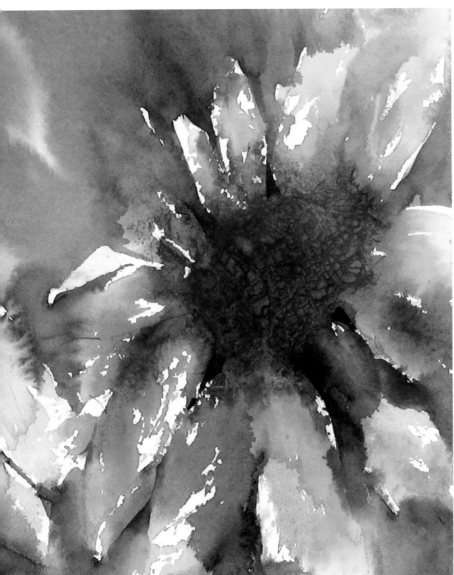

11. When the painting dries, remove the gauze. Finish the painting by adding carefully planned crisp darks on the dry paper. This is when you can actually feel the push and pull of going between realism and abstraction. Saying more with less is a good mantra to follow. Intensify some of the colors and darken some of the negative areas, being careful not to add too many hard shapes. A good rule to consider is "when in doubt, fuzz it out", meaning, simply lose any edges that are making the painting too defined. A variation of this style of painting can be found on page 7.

10" x 22" Karlyn Holman

# Exploring mixed media as a departure point

*Combining the spontaneity of wet-into-wet watercolor with collage and mixed media is a winning proposition. The visual excitement created by adding toned or metallic papers, colored pencils, photographs, crayons, pastels, image transfers, rice papers, or just about anything that catches your fancy is an exciting departure from traditional watercolors. Mixed media offers a marvelous array of choices that allows you to intuitively explore color, pattern, texture and shape with incredible freedom of expression. Mixed media is easy, adaptable and spontaneous and literally invites you to play.*

These playful and imaginative paintings by Barbara McFarland exhibit humor, tropical colors, a sense of wonder and curiosity resulting in a very personal interpretation. She loves using vibrant colors and exciting collage textures to capture one of her favorite subjects, the animals of the Southern Caribbean.

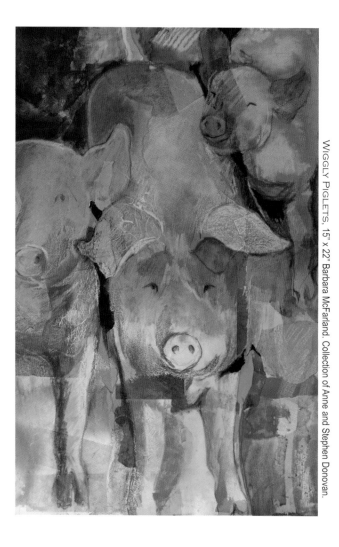

WIGGLY PIGLETS, 15" x 22" Barbara McFarland. Collection of Anne and Stephen Donovan.

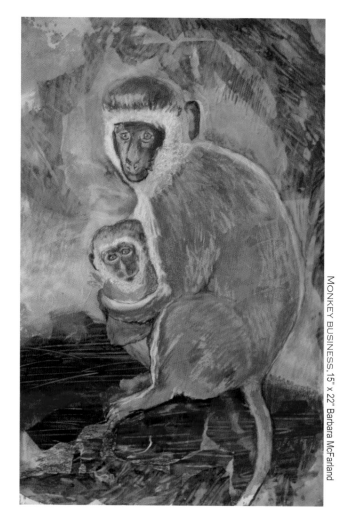

MONKEY BUSINESS, 15" x 22" Barbara McFarland

# Nevis Donkeys

Barbara usually starts her paintings by wetting heavy paper and then pouring liquid acrylics onto the wet surface. She builds up layers of intense color, allowing each layer to dry before applying more pigment. The acrylic paints seal the surface so that whatever water-based mediums she uses over the surface may be washed off while the original background remains untouched.

Next, Barbara applies collage papers with matte acrylic medium, using both complementary colors for vibrancy and harmonious colors for transitions. She also uses oriental rice papers for textures, building shapes into her final composition.

Barbara's last step is to add details and subtle values with watercolor crayons to complete the mood of the piece. To make the colors more intense, she often brushes over the crayon lines with water.

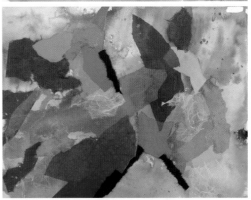

To complete the painting, you should use an archival varnish or an acrylic medium to seal the surface. This final transparent coat will also protect the surface from damage and form a uniform gloss or matte finish. An acrylic varnish with UV (ultraviolet) protection is most desirable.

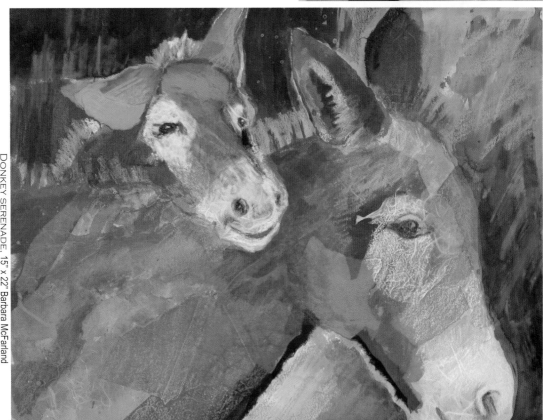

DONKEY SERENADE, 15" x 22" Barbara McFarland

151

# Conclusion

Paintings do not just happen; you have to create the energy and keep it flowing as your work progresses. Your uniqueness will emerge with each painting and reflect your personal point of view. Work alone or invite an artist friend to share creative time. Try to find the most energizing way to unleash your creativity. Maintain a sense of adventure and keep an open mind as you work. Give yourself permission to take risks. Never give up the joy and freedom you are embracing.

Be patient, continue to dream and believe in yourself, but be willing to laugh at yourself along the journey. The ideas presented in this book are only a starting point. Explore and experiment and most of all remain enthusiastic. If you open your heart to working intuitively and spontaneously, you are well on your way to establishing your own artistic voice.

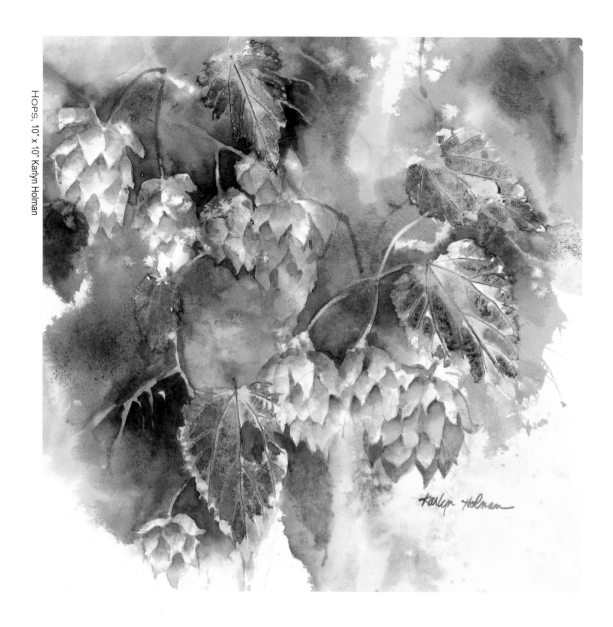

HOPS, 10" x 10" Karlyn Holman

# Directory of Techniques

## Bubble wrap:
This product comes in many sizes. Bubble wrap has a flat side and a puffed out bubble side and both create distinctive textures. Simply place the bubble wrap onto a wet surface. More paint may be added while the bubble wrap is still in place. Tipping the paper will allow the paint to run under the wrap. Leave the wrap in place until the paint dries.

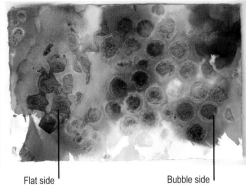

Flat side          Bubble side

## Coffee filters:
These absorbent filters make fanciful transitional shapes when used as a texturizing device. By placing them onto a wet-into-wet wash between a mid tone and a light value, they will form an intricately textured pattern of shapes. Ripping them into interesting shapes and keeping the accordion pleats intact, press them onto the wet surface. Add more color to the dark side of a shape and allow it to bleed into the light side of the shape to form a transition. Leave the filter in place until the paint dries.

## Collage:
My favorite collage paper is Thai white fibered paper. Add various pieces of this paper to a wet wash and watch as the color absorbs into the paper and creates a mid-tone dark value. When the paper dries, simply glue with thinned Yes! Paste™ if working in watercolor or with acrylic medium, if working in acrylics. The last image shows additional collage paper that has been added and glued onto the dry paper, as well as the addition of black webbing spray.

## Color sanding:
Wet shapes selectively on dry paper and shave a watercolor pencil on a piece of sandpaper (medium grit) and allow the fine particles to drop into the wet areas. Blow away any dry particles left on the dry paper.

Color sanding can also be dropped into a wet-into-wet wash. A word of caution: if you paint over these colored particles later, you may destroy the soft effect you created.

# Gauze:

A non-sterile, cotton medical gauze, the kind used to set broken bones, works very well. Unwrap the gauze so you are working with a single layer and stretch the dry gauze into an interesting shape and apply to a wet surface. Spraying the gauze with your fine mister to soak up the existing color will result in subtle lines. Painting more color on the gauze will result in more defined lines.

Sprayed with a fine mister    Paint added over the gauze

# Isopropyl Alcohol:

Add this liquid while the paint is wet by either dropping it from the end of your brush handle, squeezing it out of an oiler boiler (small plastic bottle with a needle extending out of the cap) or spraying it from a bottle. Use caution when spraying. Alcohol vapors are very dangerous to your lungs.

# Masking fluid (liquid frisket):

This is a form of resist used to save the white or the existing color of the paper. This liquid is applied onto a dry surface, and after the frisket dries, you may paint a darker value color over the top. You can apply the frisket on the white paper or over areas that have already been painted. When the masking fluid is dry, you can remove it by using a maskoid remover, an eraser or your clean finger. Do not remove the masking if the paper is damp. You should remove masking fluid as soon as possible, because leaving it on for an extended period of time could result in the fluid permanently adhering to the paper surface. Masking fluid can be applied with a brush, a stick or a painting knife. Use only synthetic brushes to apply masking fluid. Adding soap to the brush before dipping into the masking fluid will keep your brush from "gumming up."

# Plastic wrap:

Plastic wrap comes in a heavy or a cling weight; each imparts a very different look. When the plastic is applied directly onto wet color, a characteristic dark, textured shape is created. When the plastic is applied to wet, white paper and color is allowed to flow under the plastic, the white of the paper is preserved and dark lines are created. When using plastic wrap, be aware of the edges and try to design them into an interesting shape. Allowing the straight edges of the plastic to touch the paper often results in creates boring, straight edges.

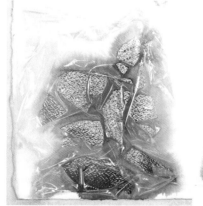 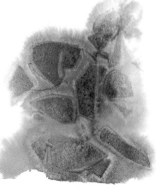  

## Salt:

**Salt:** There is nothing cutting-edge about salt. The use of this particular texturizing agent needs discretion. I only use salt to form a transition between a light area and a mid tone area. I avoid using salt in dark areas because it diminishes the dark values. In order to create small, white shapes, salt should be added when the wet glisten begins to disappear from the paper. Adding the salt too soon will result in a melted look. Salt can be added on successive layers, but the resulting color will always be the last paint color applied to the paper.

**Spattering:** This technique can be used on wet or dry paper and adds an exciting random texture to almost any painting. A natural bristle brush works well for throwing spatter onto a surface. The natural fibers release the paint, whereas synthetic fiber brushes hold the paint.

**Spraying:** A fine mister is an essential piece of art equipment. This handy tool can soften edges, move color, eliminate color and best of all, and keep your wet-into-wet painting wet. If you put color in the bottle, you can even apply color. When spraying your painting, do not point and shoot the mister or you will create puddles of water and bleed-backs. Use a smooth, sweeping motion to assure a soft even mist of water.

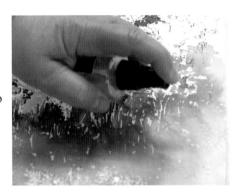

**Stamping:** Stamping is a popular art technique used to enrich paintings. Color is applied to a stamp's relief surface and pressed onto an absorbent surface, making a mark. Stamps are available in stores or you can create you own using simple carving tools.

Found objects also can be used as stamps. For example, a real leaf can be used as a stamp to create foliage in a floral painting. Place the leaf on a flat surface and apply color to the back of the leaf, where the veins are more prominent. Use rich color and try to coat only the veins and not the spaces between the veins. Place the leaf paint side down on the paper surface (wet or dry) and leave the leaf in place until dry.

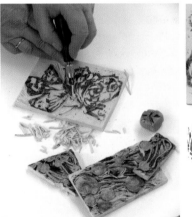

Using a cork as a stamp

Painting on underside

Paint side down

After background was added and dry, peel away

## Stenciling: Stenciling is a lifting

technique. Cut a design out of transparency film, hold it against your dry painting, and using a damp sponge or magic eraser, lift the color back to the white of the paper.

## Taping. To form a crisp, clean edge, use

lightweight masking tape instead of white artist's tape. Always apply a piece of tape to a small area of your painting first to insure that the tape will not lift the surface color when removed. If the color does lift, apply the tape to a piece of cloth or paper before applying it to the painting. This step will remove some of the tape's tackiness. When you create a shape with making tape, the most important step to remember is to burnish the edge with the firm, steady pressure of a flexible piece of plastic, such as a credit card. If you use acrylic color, remove the tape before the color dries. If you use watercolor, allow the color to dry before removing the tape.

## Tapping: This easy technique produces a texture

similar to foliage. Load a natural bristle brush such as squirrel, sable or ox hair with paint and tap the brush to release the paint onto a dry paper surface. Direct the paint to form patterns of color that resemble foliage. If the tapped patterns are too small, simply tap in more water to expand them. Once the patterns are set, additional harmonic colors can be added for enrichment. For example, starting with yellow and adding blue will result in shades of yellow-green to blue-green, rather than one shade of premixed green.

## Thirsty brush: Use this lifting

technique while your painting is still wet. Wet a stiff, flat brush and wipe away most of the moisture. The resulting "thirsty brush" is the most effective tool for absorbing and lifting the surface color back to the white of the paper. Often, the color will run back into the wetness of the paper. You must be patient and continue to lift until the shapes you are creating remain stable.

# Waxed paper:
This texturizing agent produces a characteristic look similar to a rock-like surface. To obtain the best results, allow the paint to settle on the surface before adding the waxed paper shapes. Remove the waxed paper when you achieve the desired results. Removing the paper at an earlier stage will result in a softened effect. Leaving the paper on until the paint dries completely will result in a crisper look. You can also tip the painting and allow paint to seep under the waxed paper.

Before          After

# Webbing spray:
Webbing spray forms random, lacy lines that are always unique. To create these lines, it is important to shake the can well and us sweeping, smooth strokes. Always do a practice run. If you spray too closely to your painting, the lines become tight and lose their spontaneity.

# Wet-line drawing:
Any size brush dipped in water and drawn onto a wet surface will create a white line. The water parts the color and leaves a soft line, forming a miniature "bleed-back".

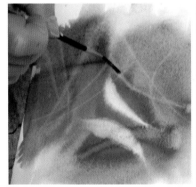 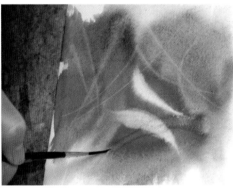

# Yes! Paste™:
To use Yes! Paste™ effectively, you need to prepare the glue so the consistency will accommodate the thickness of the paper you are using. Right out of the jar, Yes! Paste™ is very thick and can be used to adhere very heavy papers. However, with a little patience and a small amount of water added to the surface of the paste in the jar, you can slowly thin down the top layer of the paste to a smooth, creamy solution. I use a one-inch flat brush and slowly rub the surface of the paste until the water blends with the paste to become slurry. Do not rush this step and do not dig into the paste; just activate the top layer. If you have any excess mixed glue in the jar, simply allow it to soak into the rest of the glue. The next time you need thinned glue, the glue will activate in a short time.

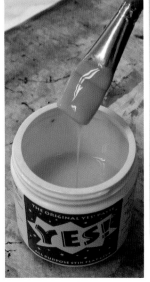 

# Index of artists

# Index

# Books and instructional DVD's by Karlyn

*Watercolor - The Spirit of Spontaneity and Companion DVD*

The companion DVD has fourteen hand-on demonstrations to introduce you to spontaneous approaches to begin your paintings. Join Karlyn in this fun-filled visual exploration of watercolor and mixed media.

*Searching for the Artist Within*

This 184-page book is an inspirational, visual guide to help you with your ongoing search for new techniques and artistic identity. Learn to stretch your creative boundaries in thirty-six innovative visual demonstrations and be inspired by experiencing the art and thoughts of over thirty accomplished artists.

*Watercolor Fun and Free*

This 160-page book is a visual approach to color and design with seventeen demonstrations and many watercolor techniques designed to help you loosen up your painting style and find your own personal expression.

## Children's books illustrated by Karlyn:

## Other Instructional DVD's:

*To order Karlyn's books and DVD's contact us at:*

Karlyn's Gallery
318 West Bayfield Street
Washburn, WI 54891
Phone 715-373-2922
E-mail: orders@karlynholman.com
Website: www.karlynholman.com

Karlyn's Gallery Publishing
www.karlynsgallerypublishing.com

*Check Karlyn's web page for watercolor workshops and travel itineraries.*